VIEW CAMERA TECHNIQUE

VIEW CAMERA TECHNIQUE

Leslie Stroebel

Third Edition, Revised

THE FOCAL PRESS

LONDON and NEW YORK

© **THE FOCAL PRESS LIMITED**

ISBN 0 240 50901 3

First Edition 1967
Second Impression 1968
Third Impression 1970
Second Edition, Revised 1972
Fifth Impression 1973
Third Edition, Revised 1976
Seventh Impression 1978
In Italian
Il Castello, Milan, 1973

Printed and Bound in Great Britain by
A. Wheaton & Co. Ltd, Exeter

CONTENTS

View Camera Characteristics

Focusing and Camera Movements

Using the Bellows

Films and Filters

Exposure and Exposure Meters

Control of Image Density

View Camera Types

Evolution of the View Camera

Applications of View Cameras

Index

1

VIEW CAMERA CHARACTERISTICS

To the photographer who is attempting to select the one camera that will best meet his needs, the vast variety of cameras offered by numerous manufacturers can make him feel that he is faced with an impossible task. Catalogues and other descriptive camera literature often attempt to bring order to this confusing situation by categorizing the cameras. There are categories based on the size of the film used or the negative format, such as sheet film cameras, roll film cameras, 35mm cameras, and subminiature cameras. This system does not completely clarify the situation, since some cameras have provisions for using two or more film sizes, and cameras having such diverse characteristics as 35mm still cameras and 35mm motion picture cameras obviously cannot be placed in the same group.

Other camera listings are based on the way the camera is intended to be used (portrait, aerial, underwater, press, identification, sequence, copy, etc.) or on some distinguishing feature of the camera (rangefinder, single-lens reflex, twin-lens reflex, stereo, motion picture, etc.) The name "view camera" has little significance in relation to the various methods of classifying cameras. View cameras are recognized, however, as an important type of camera and are usually listed either under a separate heading or in conjunction with "press" cameras.

No attempt will be made to define rigidly what a view camera is. Instead, the major features that are normally associated with the name "view camera" will be listed and considered briefly here, and then discussed in a more thorough manner in following chapters. It will be obvious to most readers that view cameras do not have a monopoly on the following four features that characterize them:

1. Adjustments in the positions of the lens and film (camera movements).
2. Interchangeable lenses.
3. Long bellows.
4. Large film.

Versatility, and high quality of the resulting photographic image are advantages of view cameras that attract many photographers. In the competitive race among camera manufacturers, we find view-camera features being adopted by a variety of other cameras. This is not a one-way street, however.

While some view cameras have remained essentially unchanged for many years, other view-camera manufacturers have not only incorporated refinements in the basic view-camera features, but have also borrowed ideas from hand-held cameras. This increases the difficulty of drawing lines of demarcation among the various types of camera.

In this book we are primarily concerned with conventional view cameras, but attention will be given to cameras having some view-camera features even though they are not normally classified as view cameras.

Camera movements

A quick look at the four characteristic view-camera features provides clues to help us understand why view cameras have earned a reputation for versatility and the ability to produce photographs of exceptional quality. The adjustments in the positions of the lens and film enable view camera users to exercise considerable control over the image, including

1. The elimination of convergence or the exaggeration of convergence of parallel lines in the subject,

2. The alteration of the plane of sharp focus either to render a subject entirely sharp, or to intentionally create unsharpness in parts of the subject, and

3. The control of cropping without changing the camera position or angle.

Most press-type cameras have provisions for adjusting the position of the lens, and on some the back can be adjusted also, but none of the press cameras have the number of adjustments and the extent of control of a good view camera.

The need for perspective, sharpness, and cropping controls by photographers who want to use roll film has usually been met in the past by attaching a roll-film camera body or a roll-film adapter to the back of a view camera. Popularity of colour slides has created a demand for perspective control on 35mm cameras. A lens that can be moved off centre in several directions with respect to the film, providing some perspective and cropping control with a 35mm camera, was introduced in 1962.

Interchangeable lenses

The second view-camera feature, interchangeable lenses, provides the photographer with control over the size of the image and the area of the scene included on the negative with the camera in a fixed position. It also enables him to change the camera-to-subject distance while maintaining the same image size. It is not always possible to place a camera at the ideal distance from the subject. Photographs made indoors often force the photographer to place the camera closer to the subject than he would like, and outdoors he is often forced to select a viewpoint farther from the subject than he would like. Interchangeable lenses enable him to adapt to both of these situations. Where he is not limited in the placement of the camera, the photographer may select his viewpoint on the basis of perspective or other considerations, and then select the lens that will produce the desired image size.

Flexibility in the choice of lenses with non-view cameras is not so great. Only single-lens reflex cameras approach view cameras with respect to practicability of interchanging lenses and even they cannot always use lenses that were not made specifically for the camera. There are variations in mounts and mechanisms for stopping the lens down, and many short focal length lenses can interfere with the movement of the mirror. Since composing and focusing are done on the ground glass with view cameras, and the bellows can be extended a relatively large distance, any limitations on interchanging lenses are more likely to be due to unsuitable optical characteristics in specific lenses than to limitations in the camera.

Long bellows

A long bellows extension, the third characteristic feature of view cameras, increases the usefulness of a camera in two important ways. First, it makes it possible to focus on objects close to the camera, producing large images of small objects, and second, it permits the use of long focal length lenses to obtain large images of objects that are more distant from the camera. Most cameras, other than view cameras, have been designed for photographing objects at moderate

to large distances from the camera. A minimum object distance of three feet is considered good for some types of hand-held camera. Typical single-lens reflex cameras are able to focus as close as one and one-half feet and produce an image that is approximately 1/7 the size of the subject. Specially-designed macro lenses produce somewhat larger images (1 : 1 or life size, for example, on one such lens), as do extension tubes and bellows attachments with conventional lenses. A typical view camera is capable of producing an image that is from one to two times the size of the object with the normal focal length lens. Using a 2 inch focal length lens on a view camera with a 20 inch bellows extension will produce an image that is 9 times as large as the object.

Camera limitations seldom restrict the ability to focus on distant objects as they do on those close-up. Problems of obtaining sufficiently large images do frequently arise, however, not only with distant scenes but also with objects at moderate distances from the camera. Perspective requirements for many types of photograph, including formal portraits, dictate that the camera must not be placed close to the subject. The long bellows extensions on view cameras enable photographers to use the necessary longer focal length lenses to obtain suitable images.

Non-view cameras have attempted to overcome the handicap of their more limited "bellows extension" on the use of long focal length lenses in two different ways. The most direct method is to use bellows or tube attachments or to build a tube into each of the longer focal length lenses. Some "miniature" cameras equipped in this manner rival 8×10 inch view cameras in length. Telephoto optics are employed to minimize the lens-to-film distances with longer focal length lenses, and mirror or folded optics are used for some extremely long focal length lenses.

Large film

As technological improvements have been made in films, the trend has been toward smaller film sizes. The increase in popularity of the 35mm camera among the hand-held cameras has been paralleled with view cameras by an increase in popularity of 4×5 in. film over

the larger 8×10 in. film, which had been considered the standard professional size. The 8×10 in. view camera is far from being extinct, but even 4×5 in. film has very real advantages over smaller film sizes, especially with respect to image definition. Although it is possible to make large prints of excellent quality from small negatives, too few photographers have exercised the necessary discipline in craftsmanship to accomplish this consistently. Photographers who are concerned with obtaining the best possible definition use a film size large enough to permit them to make contact rather than projection prints, thereby avoiding the inevitable loss of definition resulting from the insertion of a second optical system between the subject and the print. Film size, of course, is only one of many factors that determine the final image definition. Other factors will be considered in following chapters.

Limitations of view cameras

View cameras can do a number of things that other cameras cannot do, or cannot do as well, but they also have their limitations and disadvantages in comparison with other cameras when used for certain purposes. Since the image formed on the ground glass is used for composing and focusing, the camera must be used on a tripod or other support, and there is a delay between focusing the image and exposing the film while the shutter is closed, the aperture is set, and the film is placed in position in the camera. These procedures make the view camera ill-suited to photographing moving objects except in situations where the position of the object can be anticipated. Although view cameras are intended for use on location as well as in the studio, they cannot compete with the smaller hand-held cameras in portability and convenience of use. The more progressive view-camera manufacturers are incorporating such features as pre-set diaphragms, lightweight metals, roll-film backs, and modular construction to extend the usefulness, versatility, and convenience of the view camera.

2

FOCUSING AND CAMERA MOVEMENTS

Much of the quality and precision built into a camera by the manufacturer may be wasted by carelessness in the way the camera is used or by a lack of knowledge of the principles involved. Because focusing a camera seems so simple and straightforward, it is not always given the attention it deserves. Most cameras are designed so that the distance between the lens and the film can be adjusted to keep the image in sharp focus as the distance from the camera to the subject changes. The major exceptions are the inexpensive "fixed-focus" type of camera which depends upon a lens that has a fairly large depth of field to produce an image that will have acceptable sharpness for the non-critical viewer, and the specialized cameras designed to photograph objects at fixed distances from the camera, such as fingerprint and data-recording cameras.

Focusing principles

Fig. 1 *(below)*. Limitations on lens to film distance with near and far objects

Fig. 2 *(right)*. Focusing on a two-dimensional subject that is parallel to the lens board and the film, points A, B and C of the subject can all be brought, into focus in the film plane.

To obtain sharp images of objects at large distances from the camera, the film must be positioned one focal length from the image nodal point of the lens. (With lenses of conventional design, the image nodal point is normally located between the centre and the back surface of the lens.) The film will never be moved closer to the lens than this for focusing purposes. As the camera is moved closer to the object being photographed, the distance between the film and the lens must increase to keep the image in sharp focus. The limit of

Bed Length

Focal Length

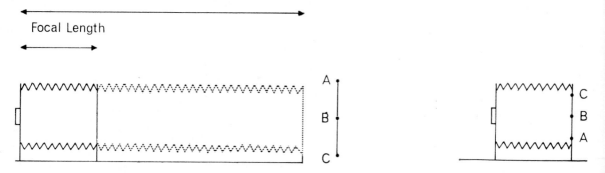

this adjustment is reached with a view camera when the lens and the camera back are at the extreme ends of the camera bed or the bellows is fully extended (Fig. 1)

Two-dimensional subjects provide the least complicated focusing situation. With the camera aligned so that the lens board and the ground glass are parallel with the subject, as when copying paintings, photographs, and documents, focusing on any part of the image should produce satisfactory focus for the entire image — assuming the lens is well corrected for aberrations (Fig. 2). Shortcomings in craftsmanship and equipment may prevent optimum focus from being realized in practice. If the camera has been properly aligned, the major craftsmanship problem facing the photographer is to place the ground glass (or the lens) in the *exact* position that will produce the sharpest focus. People have a tendency to overestimate their ability to do this. Experiments in which a person focuses repeatedly on the same subject have revealed that it is not uncommon for the focus to vary considerably. Photographers can check their own ability to focus consistently by focusing the camera, placing a fine pencil mark on the camera bed to indicate the position of the focusing adjustment, moving the adjustment and refocusing several times, each time marking the position on the bed. Consistency on one test situation does not guarantee accuracy of focus on all future photographs, especially where the light is dim and the subject has little detail, but a lack of consistency on the test should not be ignored (Fig. 3). If the variation is measurable, the procedure should be repeated with the photographer using a focusing magnifier to examine the image on the ground glass.

A too-strong magnifying glass, however, can cause the graininess of the ground glass to become so pronounced that it interferes with the ability of the photographer to focus on extremely fine detail. The graininess can be minimized by the application of petroleum jelly, oil, clear nail polish, transparent tape or similar material to the ground side of the ground glass. It is advisable to treat only a small spot in the centre, as treatment of the entire ground glass will cause the brightness of the image to decrease excessively toward the corners making it difficult to evaluate the overall effect. Ground glass with a finely ground surface produces a similar effect. Complete elimination of the ground surface would enable the photographer to focus more precisely on the aerial image, but this technique requires hair lines or other detail on the surface of the glass so the eye can focus on the proper plane.

Focusing with photoconductive probes and electronic equipment has been used successfully in lens testing and other applications. Tests, in which a number of people focused a lens repeatedly, visually and electronically, revealed there was less variation in the position of focus with the electronic method. The advantage of the electronic method applied to repeated focusing attemps by each individual in addition to focusing agreement among all of the participants.[1] A comparison of the results of two methods of focusing is shown in Fig. 4.

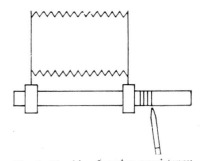

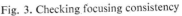

Fig. 3. Checking focusing consistency

Fig. 4. Histograms of electronic focusing *(top)* and visual focusing *(bottom)*

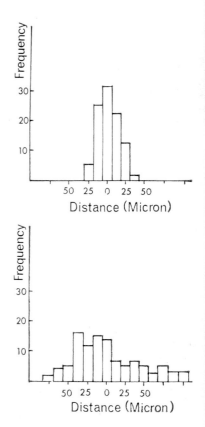

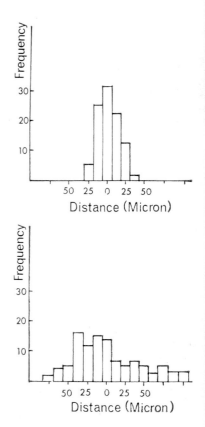

Distance (Micron)

Distance (Micron)

[1] P. Parga and R. Youso, *SPSE News*, Vol. 7, No. 3, May–June, 1964

V.C.T—B

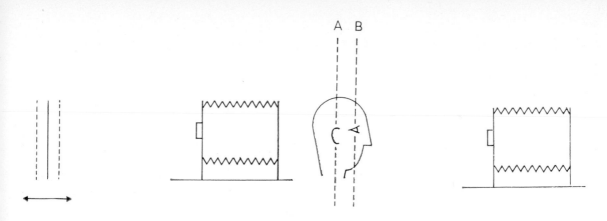

Fig. 5 *(above)*. Focusing on a near object by moving the object

Fig. 6 *(right)*. Plane of sharpest focus with soft-focus lens at the maximum aperture (B) and stopped down (A)

Sharp focus may be difficult to achieve, even with a focusing magnifier, when the camera is placed so close to the object being photographed that the image is approximately the same size as the object. Under these conditions, image sharpness changes so slowly with movement of the lens or ground glass that it is difficult to determine when optimum focus has been attained. It is somewhat easier to focus with the back of the camera than with the lens, but greater accuracy can be obtained by changing the distance from the object to the camera to obtain sharp focus than by using the focusing adjustments. If the image is not the desired size when sharp focus is achieved, the bellows extension should be increased to make the image larger or decreased to make it smaller, again focusing by moving the camera or the object (Fig. 5).

Impeccable craftsmanship alone does not assure satisfactory image sharpness. Even though the image is sharp on the ground glass, the film surface may not conform to the plane of the ground glass when the film is inserted. Film buckle is the most common cause of difficulty of this nature, especially with the larger film sizes and with the camera tilted down, so that the weight of the film causes it to sag. Sag can be eliminated by applying a tacky adhesive to the film holder before loading it with film. Roll film, which can be used with adapters on most view cameras, is especially prone to buckling due to the thinness of the base, although improvements in the design of some roll-film adapters to avoid any severe bending of the film before exposure have done much to minimize this difficulty. When even a slight amount of buckle cannot be tolerated, it is necessary to use rigid glass plates in place of film, or to use a special device, such as a vacuum back, to hold the film flat. Linhof produce a vacuum sheet-film holder with a separate portable vacuum pump, and a bulk rollfilm holder with an integrated vacuum pump.

Stopping the camera lens down tends to minimize unsharpness resulting from inaccurate focus, film buckle, and lens aberrations. Complications may be encountered with some lenses due to a shift in focus as the lens is stopped down. This is quite noticeable with most soft-focus portrait type lenses, where the plane of sharpest focus may shift from the eyes to the ears if the lens is focused at the largest aperture and then stopped down before exposing the film (Fig. 6). Lenses of this type should be focused at the aperture that will be used to expose the film.

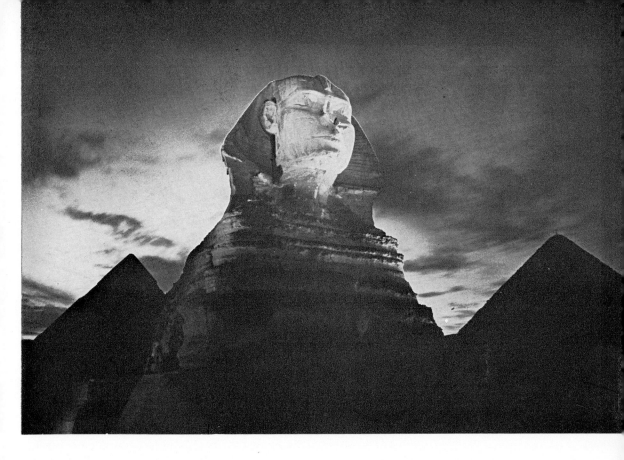

Choosing the plane of focus

With a three-dimensional subject, the photographer must decide on which part of the subject to focus. A shallow depth of field is more suitable to some subjects than overall sharpness. Portrait photographers, for example, normally focus on the subject's eyes and often allow the ears, side of the head, and far shoulder to be rendered unsharp. When overall sharpness is desired, the camera must be focused on the appropriate distance so that as the lens is

Fig. 7. Buckling of the film between the dusk exposure for the sky and the later exposure for the floodlights on the Sphinx caused an out-of-register fringe around the head. This difficulty can be minimized by applying a tacky adhesive to the centre of the holder and then pressing the film gently against the adhesive – *Norman Kerr*

Fig. 8. An enlarged view of a section of the Sphinx, revealing the change in film position

19

Fig. 9. Distribution of depth of field in front of and behind the plane focused on with a shallow depth of field *(top)* and with a moderat, depth of field *(bottom)*

stopped down the increasing depth of field will extend to the near and the far parts of the subject simultaneously.

It is often stated categorically that the photographer should focus on a point one-third of the distance from the nearest to the farthest points desired sharp. This is a dangerous generalization. The best point to focus upon varies with the same factors that determine depth of field — focal length, *f*-number, and object distance. When the depth of field is small, as it tends to be with a long focal length lens, large aperture, and small object distance, one should focus approximately half way into the subject. As the depth of field increases, the point focused upon must move toward the front of the subject or scene (Fig. 9). Accurately prepared depth of field tables may be useful in determining the best point to focus upon when the image on the ground glass is dim due to weak illumination on the subject, a small aperture, or a subject that has low detail contrast.

Even after the camera has been focused, care must be exercised to be sure that the lens-to-film distance does not change before the film is exposed. The mere act of locking the focusing adjustment on some view cameras presents a danger due to "play" in the mechanism that attaches the focusing adjustment to the track, or the possibility of accidentally turning the focusing knob while locking it. When the camera is tilted up or down at extreme angles, the force of gravity may cause the focusing adjustment to creep before the adjustment is locked. Even on a camera that seems relatively sturdy, the weight of a film holder or focusing cloth, or the pressure of a magnifying glass placed against the ground glass may cause the camera back to flex enough to affect the focus. A camera can be checked easily for sturdiness by pressing a finger against the top edge of the camera back, after it has been focused and locked, while examining the image through a focusing magnifier.

Swing and tilt movements

Movements that provide for alterations in the angle of the lens board and the ground glass in relation to the camera bed are identified as swings and tilts. The horizontal rotation (about a vertical axis) is referred to as a "swing" and the vertical rotation (about a

Fig. 10. A view camera, as seen from the side and from above, with lens and back in their normal positions (A), with lens tilted (B), and with lens swung (C)

A

B

C

SIDE VIEW TOP VIEW

horizontal axis) as a "tilt." Thus there are four swing and tilt adjustments:

1. Lens tilt.
2. Lens swing.
3. Back tilt.
4. Back swing.

When all adjustments are in their normal or "zero" positions, the lens board and the ground glass are parallel to each other and are perpendicular to the camera bed (Fig. 10). Normal positions are indicated by markers, scales, or click stops. It is important to set each adjustment to its normal position except when it is intentionally tilted or swung for a desired effect.

The reader should be warned that not all camera manufacturers and writers are in agreement on the use of the terms "swing" and "tilt" as defined above. "Swing" is sometimes used as an all-inclusive term in reference to both the vertical and horizontal rotations when there is no need to distinguish between them. One manufacturer, however, refers to the "horizontal swings" and the "vertical swings," while another uses the terms "horizontal and vertical swing back" and "horizontal and vertical tilting lens."

Two aspects of the image are altered by the use of these camera movements:

1. The shape of the image.
2. The angle at which the plane of sharp focus intersects the subject.

21

Fig. 11. There is no convergence of vertical or horizontal subject lines on the ground glass image when the lens board and camera back are both parallel with the subject

Fig. 12. Image sharpness is affected, but not image shape, when the lens is tilted

Fig. 13. Use of a small aperture to obtain a sharp image reveals that tilting the lens has not altered image shape

Shape control

To visualize better how the shape of the image can be controlled with the swing and tilt adjustments, consider a view camera in position to make a photograph of a subject containing vertical and horizontal lines. With the camera positioned so that the lens board and the camera back are both parallel to the subject, the image on the ground glass will have the same shape as the subject — that is, there will be no convergence of the vertical or the horizontal lines (Fig. 11). Tilting or swinging the lens board will not affect the shape of the image, although the sharpness of the image will be altered (Fig. 12). The variation in sharpness of the image may create an illusion that the lines are converging or perhaps are even curved, but stopping the lens down will minimize the unsharpness and reveal that the shape of the image has not been affected by tilting the lens (Fig. 13).

Tilting the top edge of the back of the camera toward the lens and the subject will cause the vertical lines to converge toward the top of the ground glass (Fig. 14). Notice that the parallelism of the *horizontal* lines has not been affected by *tilting* the back of the camera, only the vertical lines. Swinging the left side of the back toward the subject causes the horizontal lines to converge toward the left side (Fig. 15). Swinging the back in the other direction results in the horizontal lines converging toward the right side, without affecting the parallelism of the vertical lines. If the subject consisted of a single vertical line and a single horizontal line whose images crossed in the centre

Fig. 14. Tilting the top edge of the back forward causes the vertical lines to converge toward the top of the ground glass.

Fig. 15. Swinging the left side of the back forward causes the horizontal lines to converge toward the left side of the ground glass

Fig. 16. There is less convergence of the horizontal lines when a longer focal length lens is used, even though the angle of the back remains the same as in the preceding figure

of the ground glass, tilting and swinging the back of the camera would have no effect on the shape of the image. The closer image lines are to the edges of the ground glass, the greater will be the change in the angle of the lines as the back is tilted or swung.

Another factor that affects the angle of convergence of parallel subject lines is the distance from the lens to the centre of the ground glass. As this distance increases, either due to substituting a longer focal length lens or moving the camera closer to the subject, the less will be the convergence (Fig. 16). Tilting or swinging the back of a camera equipped with a short focal length lens produces more violent changes in the shape of the image than with a normal or long focal length lens.

In addition to altering the shape of the image, tilting and swinging the back affects the sharpness of the image. The unsharpness introduced by adjusting the back can be minimized by stopping the lens down or by altering the angle of the lens board.

So far, the convergence has been created by tilting or swinging the back of the camera. If the back is returned to the normal position, but the camera is angled up, down, or sideways at the subject, the image lines will again converge. The direction of convergence is due solely to the relationship that exists between the plane of the back of the camera and the plane of the subject. The only time parallel lines on the subject will be rendered parallel on the image, with lenses of conventional design, is when the plane of the back of the camera is parallel to the plane of the subject (Figs. 17-19). It follows that the

Fig. 17. Vertical subject lines converge toward the top of the print image when the camera is tilted upward with adjustments zeroed

Fig. 18. Tilting the back of the camera parallel with the subject eliminates convergence of vertical subject lines with most lenses

Fig. 19. With telephoto lens, tilting the back of the camera parallel with the subject produces the effect of overcorrection. A smaller tilt is required to minimize convergence of lines. (An explanation of this phenomenon is given in Chapter 3.)

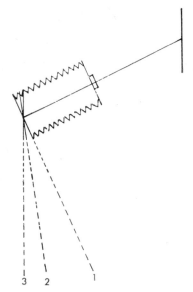

Fig. 20. Camera tilted upward at subject containing vertical lines. Normal position (1) results in convergence of vertical lines. Tilting the back parallel to the subject (3) eliminates convergence with most lenses. With a telephoto lens, however, a smaller tilt (2) is required

larger the angle between the back and the subject, the greater will be the convergence of the image lines – other factors remaining the same. This illustrates why it is impossible to eliminate convergence of horizontal lines on the front and the side of a building simultaneously. As the back is swung parallel to the front of the building to eliminate convergence of the horizontal lines, the angle between the back of the camera and the side of the building is increasing, causing the horizontal lines to converge more rapidly (Figs. 21–22a).

Fortunately, people are not as disturbed by converging horizontal lines as they are by converging vertical lines, although there are situations where it is desirable to either minimize or exaggerate the rate of convergence. These variations can be used by the photographer to alter the apparent length of an object. Slightly converging lines close to the edges of a photograph tend to be more disturbing than lines that converge more strongly, possibly because they create the impression in the mind of the viewer that the convergence is due to carelessness rather than intent. Thus, when photographing box-shaped objects, the results are generally more attractive if the back is swung parallel to the plane of the object that requires the least correction, even though this exaggerates the convergence of the horizontal lines on another plane.

It is possible to increase or decrease the convergence of horizontal lines simultaneously on two planes that are at right angles to each other, but this must be done by changing the distance from the camera to the subject, usually accompanied by a change in lens focal

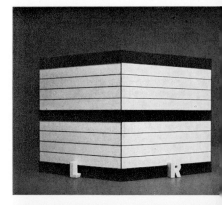

Fig. 22. Effect with the back swing parallel with the left plane

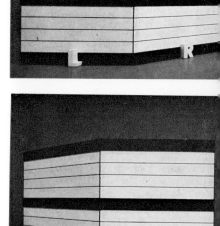

length, rather than by using the swing adjustments. This type of perspective control will be discussed in Chapter 5. The photographs in Figures 23 – 29 show the relationship between position of the camera back and resulting image shape.

Although we have been concerned only with subjects containing parallel lines, the images of irregularly shaped objects are similarly affected by the position of the camera back. Casual viewers of photographs rarely notice such changes in image shape when the subject does not contain straight lines unless the changes are extreme.

Plane of sharp focus

Photographic lenses are capable of focusing with maximum sharpness only on a two-dimensional object plane – a plane parallel to the lens board and the camera back when they are in their normal positions. Thus, when copying a document, for example, a sharp image can be obtained at a large aperture with the camera properly aligned, but changing the angle of the subject relative to the camera back causes the near and far parts to deviate from the plane of sharp focus. With a conventional camera, it would be necessary to stop the lens down to obtain an acceptably sharp image of the whole document. The swing and tilt adjustments on the view camera make it possible to alter the plane of sharp focus so that it coincides with the subject and produces a sharp image at a large aperture (Fig. 26).

Fig. 22a. Effect with the back swung parallel with the right plane

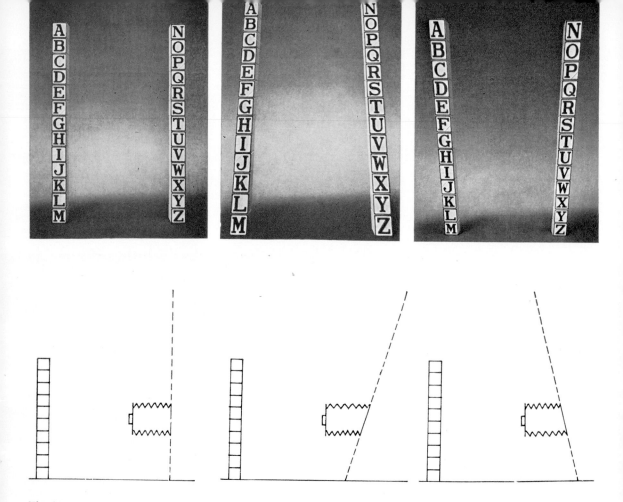

Fig. 23. Vertical subject lines are rendered parallel when the camera back is in the zero position, parallel with the subject

Fig. 24. Tilting the top of the back away from the subject causes vertical lines to converge toward the top of the print. This creates the illusion that the camera has been lowered

Fig. 25. Tilting the top of the back toward the subject reverses the direction of convergence. The camera lens is still level with the centre of the columns

There are three major advantages in using the swings and tilts in preference to stopping the lens down:

1. Shorter exposure times can be used.

2. Sharp images can be obtained for objects over a wider range of distances.

3. Distracting detail at the same distance from the camera as the subject can often be thrown out of focus.

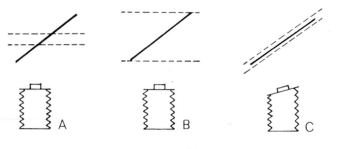

Fig. 26. Obtaining a sharp image of an object at an oblique angle (A) by stopping the lens down (B) and by swinging the lens (C)

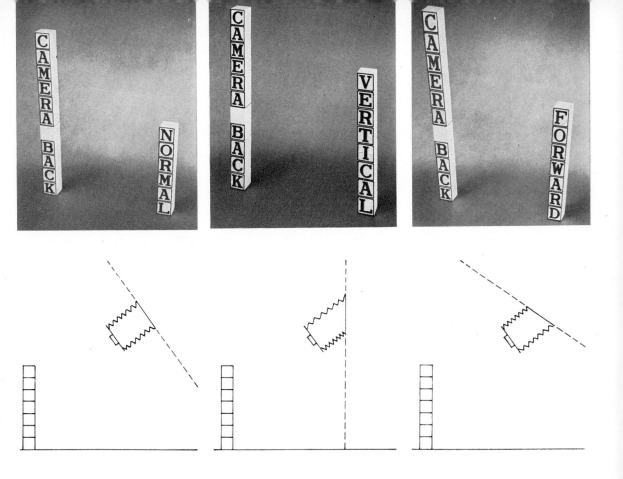

Fig. 27. Aiming the camera downward at the subject from a high viewpoint causes vertical subject lines to converge toward the bottom of the print

Fig. 28. Tilting the back of the camera to the vertical position eliminates convergence of the subject lines

Fig. 29. Tilting the back to the extreme forward position exaggerates convergence of the vertical subject lines

Either the lens or the back adjustments can be used to control the plane of sharp focus, whereas the shape of the image is controlled solely by the back. Both the lens and back can be adjusted when either one alone does not provide sufficient control. However, if it is necessary to control shape and the plane of sharp focus on the same photograph, the back must be used to control the shape and the lens to control the plane of sharp focus, and the back must be adjusted first. The general rules are:

To control shape only:

Swing or tilt the back.

To control sharpness only:

Swing or tilt the lens and/or the back.

To control shape and sharpness:

1. Swing or tilt the back for shape.

2. Swing or tilt the lens for sharpness.

It is often possible for the photographer to determine the correct angle of tilt or swing for sharpness control by examining the image on the ground glass as the adjustment is being made. This trial and

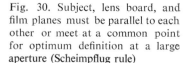

Fig. 30. Subject, lens board, and film planes must be parallel to each other or meet at a common point for optimum definition at a large aperture (Scheimpflug rule)

Opposite, top to bottom:

Fig. 31. A Only the near part of the subject appears sharp at a larger aperture with swing adjustments zeroed

Fig. 32. The lens board is swung toward the plane of the subject to obtain a sharp image of the entire subject

Fig. 33. With the lens board in the normal position, a sharp image is obtained by swinging the back of the camera away from the plane of the subject

Fig. 34. Combined use of lens and back swings is necessary when the subject is at an extreme angle. Dashed line indicates the maximum angle at which the subject could be rendered sharp using either the lens swing or the back swing

error method can be time-consuming, especially when the subject does not have bold detail or when the image is dim due to a low level of illumination. Adjustment of the lens or back can be made more accurately and more rapidly if the photographer notes that to obtain overall sharp focus, the plane of the subject, the plane of the lens board, and the plane of the back must either be parallel to each other or meet at a common point—the Scheimpflug rule (Fig. 30).

The drawings and photographs opposite illustrate how a sharp image can be obtained by swinging the lens only, the back only, or both the lens and the back. Both adjustments are used when the subject is at such an extreme angle that neither the lens or back used alone can be swung far enough to produce a sharp image. In many situations it is possible for the photographer to place his eye at the intersection of the subject, lens board, and back planes to determine if the adjustments are correct.

Inexperienced photographers sometimes become confused concerning the choice between using tilts or using swings to improve the image sharpness in a given situation. The photographs in Fig. 35 illustrate the ineffectiveness of swinging the lens when a camera is aimed downward at a horizontal subject plane, whereas overall sharpness results when the lens is tilted. The effects shown in the middle two photographs are occasionally desired, however, for the purpose of emphasizing certain parts of a scene.

Variations in the bellows extension affect the angle of the plane of sharp focus in addition to the angle of convergence of parallel lines,

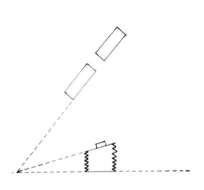

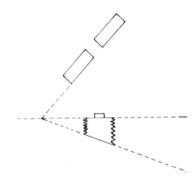

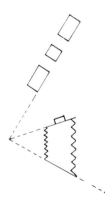

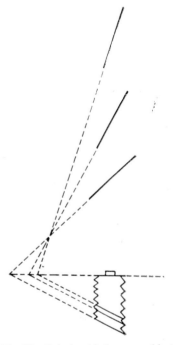

Fig. 35 *(Top)*. Only a narrow strip across the subject is sharp when the camera is aimed down at the blocks on the table top with tilt and swing adjustments zeroed

(Upper and lower middle). Swinging the lens controls the angle at which the plane of sharp focus crosses the subject, but does not help in achieving overall sharpness

(Bottom). Tilting the lens forward produces a sharp image of the entire subject

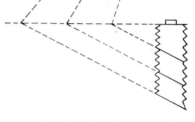

Fig. 36. Relationship between lens focal length and angle of the plane of sharp focus

Fig. 37. Relationship between object distance and the plane of sharp focus

Fig. 38. Shape of the depth of field area with the lens board and back in their normal positions (*left*) and with the back swung (*right*)

which was discussed previously. The angle at which the subject can be inclined with respect to the camera and yet be rendered sharp, becomes less as the bellows extension increases. Thus, long focal length lenses and close-up objects, both of which require increased bellows extensions, limit the control that can be exercised over the plane of sharp focus. Observe the differences in the angles of the planes of sharp focus in the drawings in Fig. 36 and 37, representing different focal length lenses, and three different object distances, with the angle of the back remaining constant.

Stopping a lens down increases the depth of field, but the shape of the depth of field area is drastically different when the tilts or swings are employed than when the lens and back are in their normal positions. Since the depth of field increases with object distance, the depth of field will be uniform over the entire width of a scene when the lens board and back are parallel to each other, but it will vary from side to side when the swings are used and from top to bottom when the tilts are used. In Fig. 38 the solid line represents the plane of sharp focus, and the dotted lines the near and far limitations on the depth of field. Actually, the camera is focused on various object distances simultaneously when the swings or tilts are used, and the depth of field varies accordingly.

This unusual depth of field pattern makes it possible to utilize the tilts and swings to obtain better overall image sharpness with certain types of three-dimensional subjects. Two adjacent walls of a room, for example, can be made sharp on the photograph by swing-

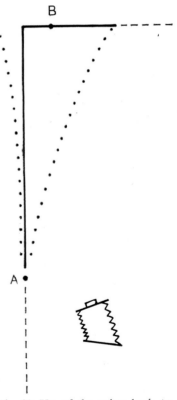

Fig. 39. Use of the swing back to bring both points A and B into sharp focus, obtaining a sharp image of two adjacent walls

31

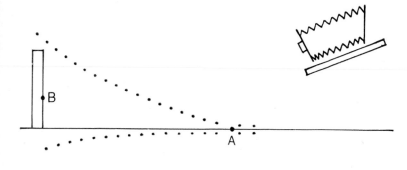

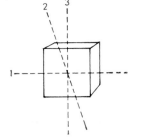

Fig. 41. Different positions of the plane of sharp focus with a subject having equal height and depth

ing the lens or back so that the plane of sharp focus includes points "A" and "B" (Fig. 39). A corresponding situation for the tilts is illustrated in Fig. 40. By tilting the lens or back so that plane of sharp focus includes point "A" (the nearest point on the ground that is to be included in the photograph) and point "B" (approximately halfway up the building), maximum use is made of the depth of field pattern in obtaining a sharp image of the building and the ground. With the lens and back in their normal positions the depth of field at the same aperture would be far from adequate.

Little is gained by using the tilts or swings to alter the plane of sharp focus with subjects that have equal height and depth. No adjustment will produce a sharp image of the cube in Fig. 41, for example, without stopping the lens down. Although the angle of the plane of sharp focus can be altered with the tilts, as indicated by positions "1", "2", and "3", the differences in the apertures required to obtain sharp images would be slight.

Knowing where on the subject to focus is often a problem when tilts or swings are used. In Fig. 42, the back has been tilted to make the vertical subject lines parallel. If the photographer decides to focus one-third of the way into the subject and selects a point on the top of the cube, he will in effect be focusing on the closest part of the subject regardless of whether the selected point is one-third, one-half, or two-thirds from the front to the back. As the camera is focused, the plane of sharp focus will move from the top of the sub-

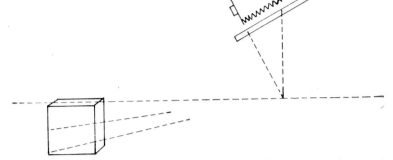

Fig. 42. Effect of focusing when the back
is not in the zero position

ject to the bottom, rather than from the front to the back as would
be normal for a camera without tilts or swings. A technique used by
some photographers when it is difficult to know where to focus on
the subject, is to rack the bellows in and out to determine the mini-
mum and maximum bellows extensions that will produce sharp
focus on any part of the subject, place a pencil mark on the camera
bed for each of the two positions of the focusing adjustment, and
then set it midway between the two marks.

Controlling shape and sharpness

Since alterations in the position of the back of the camera affect
both shape and sharpness, its use to control shape may either sim-
plify or complicate the subsequent task of controlling sharpness with
the lens. For example, tilting a camera downward to photograph
objects results in a convergence of the vertical lines, and the plane
of sharp focus cuts through the objects parallel to the lens board
and back (Fig. 43) so that the bottoms of the objects are unsharp.
To correct for the converging vertical lines, the back must be tilted
in the opposite direction from which it would be tilted to improve the
sharpness, thereby causing the top and bottom of the object to appear
less sharp than when the back was in the normal position (Fig. 44.).
The lens will now have to be tilted farther than it would with the
back in the normal position (Fig. 45.).

If the photographer wants to exaggerate the convergence of the
vertical lines to make the building appear taller, or for a dramatic
effect, he will tilt the back in the same direction he would tilt it to
improve the sharpness (Fig 46). There is no assurance, however, that
it will be tilted to the exact angle necessary for optimum sharpness.
Therefore, using the back to exaggerate perspective may result in
optimum, under, or over correction for sharpness requiring no ad-
justment, a forward tilt, or a backward tilt of the lens to obtain sharp
focus.

In practice, it is not uncommon for a photographer to encounter

v.c.i.—c

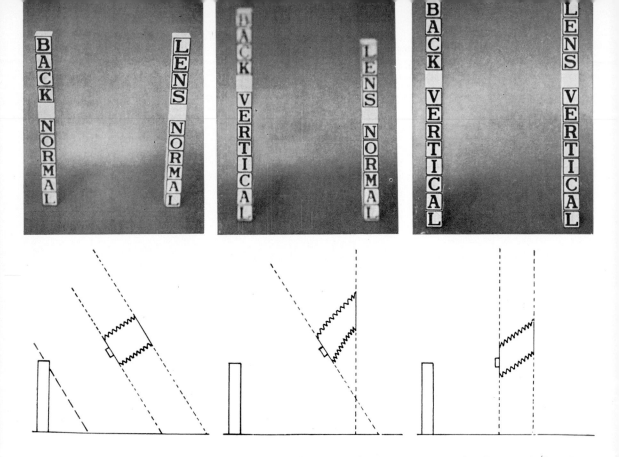

situations requiring the simultaneous use of swings and tilts. Consider the situation illustrated in Fig. 47. where the camera is tilted down and also sideways at the subject. In addition to the limited sharpness, there is convergence of vertical and horizontal lines. We will assume that the photographer wants to eliminate the convergence of the vertical lines but not the horizontal lines, and to obtain a sharp image of the entire subject. In Fig. 48 the back has been tilted to eliminate convergence of the vertical lines (also causing the bottom of the object to become less sharp) and the lens has been swung to improve the sharpness from side to side. In Fig. 49 the lens has been tilted to improve the sharpness from top to bottom.

Rising-falling and lateral movements

These movements alter the position of the image – up, down, or sideways with respect to the film (Fig. 50). Identical results can be achieved with the swings and tilts combined with a change in the angle of the camera bed. There are two reasons for using the rising-falling and lateral adjustments, however. First, this approach may be quicker and easier. If the top of a building is not included on the ground glass when the camera is level, one movement of the rising front will correct the situation. Otherwise three separate operations are required, as illustrated in Fig. 51. A frequently-cited situation calling for the use of vertical or lateral adjustments is one where the

Left to right:

Fig. 43. Appearance of the image with the camera aimed downward at the subject before using the tilt adjustment to eliminate convergence and unsharpness

Fig. 44. Tilting the back to eliminate convergence also reduces the area of sharpness on the subject

Fig. 45. With the back in the vertical position to eliminate convergence, the lens board must also be tilted to the vertical position to obtain a sharp image —a larger change than would have been required with the back in the zero position

Fig. 46. Tilting the back forward to exaggerate convergence may also produce a sharp image, providing the back is at the correct angle

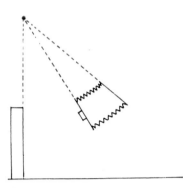

Left to right:

Fig. 47. Appearance of the image with the camera aimed downward and sideways at the subject before correcting convergence and unsharpness

Fig. 48. Back has been tilted to eliminate convergence of vertical lines and lens has been swung to improve sharpness from side to side

Fig. 49. Sharpness has been obtained from top to bottom by tilting the lens

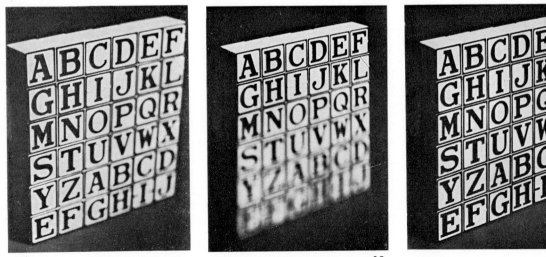

Fig. 50. The lateral shift moves the image from side to side and the rising-falling front moves the image up and down

Fig. 51. Using the rising front, only a single adjustment is required to include the top of the building (*below*) whereas three adjustments are required when the camera tilts are used (*right*)

camera cannot be placed directly in front of the subject due to an obstruction or reflection (Fig. 52). It is then placed above, below, or to one side of the obstruction and the image is positioned with the appropriate vertical or lateral adjustment. There is no difference between the image formed in this way and one obtained by using the appropriate tilts and swings, but the latter method may be less convenient.

The second reason for using the rising-falling and lateral adjustments is that they extend control over the plane of sharp focus and perspective when the tilts and swings are inadequate. If the building in Fig 51 is so tall that it is impossible to obtain full correction of the vertical lines and the plane of sharp focus by using the rising front alone or by using the tilts alone, a combination of both methods will be required as illustrated in Fig. 53.

Some non-view cameras, lacking tilts and swings, make use of the principle of the rising front to enable the user to achieve a limited control over converging lines The camera is first positioned so the film plane is parallel to the subject plane. The lens is then raised (or shifted sideways or lowered, with some cameras) to obtain the desired image placement. Since the back of the camera is not tilted with respect to the subject, there is no convergence of the subject lines. Latitude of movement of the lens tends to be small on cameras of this type in comparison with view cameras.

Raising the lens a fixed distance, two inches for example, produces an equal displacement of the image on the film with distant

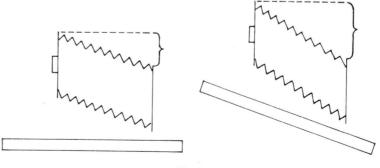

Fig. 53. Use of rising front and tilted bed for increased lens displacement

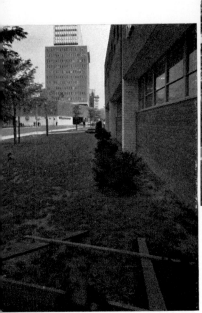

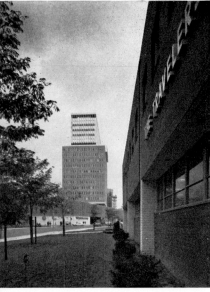

Fig. 54. Raising the lens or lowering the back a distance of 2 inches will move the image of a distant object 2 inches on the film, regardless of the lens focal length, as illustrated with 90 mm *(left)* and 254 mm *(left below)* lenses

Fig. 55. Rising front and image movement with different focal length lenses and a distant subject *(below)*

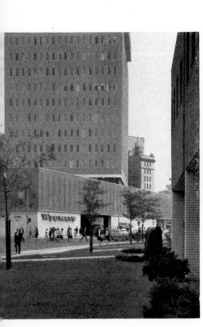

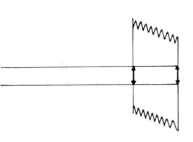

Fig. 57. Use of the rising front to increase control over the plane of sharp focus

Fig. 56. Rising front and image movement with a near object

subjects. Lens focal length has no effect on the amount of displacement, as illustrated in Fig. 54. With close-up objects, the displacement of the image on the film will be larger than the movement of the lens, and there will be some variation with focal length (Fig. 56).

A less obvious use of the rising front is to increase control over the plane of sharp focus as illustrated in Fig. 57 ·With the camera in position "A", the lens and back cannot be tilted far enough to obtain sharp focus on the subject — as indicated by the dotted lines extending from the lens board and the back, which meet below the plane of the subject rather than at it. The three planes can be made to intersect at a common point by tilting the camera down to position "B". Raising the lens will return the image to its original position on the film and the image will be sharp even though the lens and back tilt adjustments have not been altered.

Essentially there is no difference between the use of the rising-falling and tilt adjustments with vertical subject lines and planes, and the use of the lateral and swing adjustments with horizontal lines and planes. The reader may find it worthwhile to check his understanding of the use of the camera adjustments by indicating the changes he would make in the swing and lateral adjustments for each of the following situations:

1. Swing the back to prevent convergence of horizontal lines (Fig. 58).

2. Swing the back to exaggerate convergence of horizontal lines (Fig. 59).

3. Swing the back to make the plane of sharp focus conform to the front of the subject (Fig. 60).

Fig. 58. Swing the back to prevent convergence of horizontal lines

Fig. 59. Swing the back to exaggerate convergence of horizontal lines

Fig. 60. Swing the back to make the plane of sharp focus conform to the front of the subject

Fig. 61. Swing the lens to make the plane of sharp focus conform to the front of the subject

Fig. 62. Swing the back and the lens to prevent convergence of horizontal lines and to make the plane of sharp focus conform to the front of the subject

Fig. 63. Shift the lens and back to include the entire object while retaining parallel horizontal lines and sharp focus

Fig. 64. The back has been swung to the limit of the adjustment but is not parallel to the subject. Change the angle of the camera and shift the lens and back to prevent convergence of horizontal lines while including the entire object

Fig. 65. The lens and back have been swung to the limit of their adjustments but the plane of sharp focus does not conform to the subject. Change the angle of the camera and shift the lens and back to achieve this

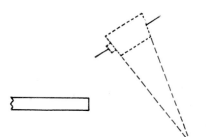

40

4. Swing the lens to make the plane of sharp focus conform to the front of the subject (Fig. 61.).

5. Swing the back and the lens to prevent convergence of horizontal lines and to make the plane of sharp focus conform the front of the subject (Fig. 62.).

6. Shift the lens and back to include the entire object while retaining parallel horizontal lines and sharp focus (Fig. 63.).

7. The back has been swung to the limit of the adjustment but is not parallel to the subject. Change the angle of the camera and shift the lens and back to prevent convergence of horizontal lines while including the entire object (Fig. 64.).

8. The lens and back have been swung to the limit of their adjustments but the plane of sharp focus does not conform to the subject. Change the angle of the camera and shift the lens and back to achieve this (Fig. 65.).

Reversible and revolving backs

Since rectangular negative formats are normally used on view cameras, provisions must be incorporated into the camera for making both horizontal and vertical photographs. With most non-view cameras, it is necessary to rotate the entire camera ninety degrees to change between horizontal and vertical formats. This is a simple matter when the camera is hand held, but when it is mounted on a tripod either two tripod sockets are required (one on the bottom and one on a side) or a tilting device must be used on the tripod.

View cameras are normally equipped with revolving or reversible backs. Revolving backs are designed so the ground glass and film can be rotated to produce vertical, horizontal, or intermediate positions without removing the back from the camera. Reversible backs can be placed only in horizontal or vertical format positions, and they must be detached from the camera.

Effect of back movements on perspective

Alterations in perspective with changes in the angle of the film plane are essentially nothing more than changes in scale—from

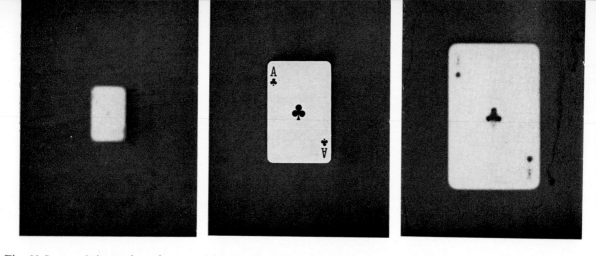

Fig. 66. Increase in image size as lens to film distance increases

side to side when the back is swung, from top to bottom when the back is tilted, or diagonally when the back is both swung and tilted. Image size, for a given subject, depends upon the relative distances from the subject to the lens (object distance) and from the lens to the film (image distance). A change in either of these distances results in a change in image size. Image size *decreases* as object distance *increases*, an inverse relationship. We are accustomed to seeing distant objects appear smaller than near objects, but we are more aware of the change in size when the near and far parts are connected with parallel lines – like rail tracks and the edges of tall buildings.

Image size *increases* as image distance *increases*, a direct relationship. This relationship may not be obvious because the photographer is normally concentrating on obtaining sharp focus when he adjusts the lens to film distance rather than observing the change in image size. However, it is easy to observe this change in image size even though the image goes considerably out of focus (Fig. 66.). The same change in image size with image distance can be observed with sharp images by using different focal length lenses.

Adjusting the back to compensate for differences in object distances of opposite ends of the subject requires an increase in image distance for the part of the image that appears too small with the back in the normal position. Since the light rays cross at the lens, the *right* side of the camera back is moved away from the lens when the *left* side of the subject is farther from the camera (Fig. 67). The camera back and subject planes must be parallel to produce images of equal scale. With the back in this position, the ratio of image to object distances will be the same for all parts of the subject and the corresponding images. This relationship can be expressed as –

$$\text{Scale of reproduction} = \frac{\text{Image distance}}{\text{Object distance}}$$

Mathematical applications of this relationship are presented in Chapter 3.

The advantage of pivoting the back about axes that run through the centre of the back, for the tilt and swing adjustments, is that this position minimizes any overall increase or overall decrease in image size as the back is tilted or swung, which would require repositioning

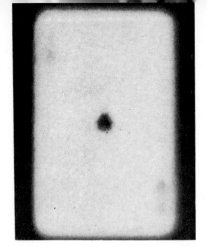

the camera to obtain the desired image size. With the centrally lo-
cated pivot, the image size increases for the part of the back that
moves away from the lens, remains unchanged at the point of pivot,
and decreases for the part that moves toward the lens. This position
of the pivot also minimizes the movement of the back or lens nec-
essary for refocusing after adjustments have been made in the angle
of the back or lens.

Fig. 67. Back swung to compensate for
differences in object distances of op-
posite ends of a subject

Effect of back movements on sharpness

Since the movements of the tilt and swing back are made in oppo-
site directions to minimize convergence and to improve sharpness,
the back cannot be used to control the plane of sharp focus except
when there is no need to be concerned about perspective, or in the
less frequent situations requiring exaggeration rather than elimi-
nation of convergence.

An explanation of how the tilt and swing adjustments control the
plane of sharp focus is simpler for the back than for the lens. Focus-
ing on objects at varying distances from the camera reveals the funda-
mental relationship that as the distance between the subject and the
lens becomes smaller, the distance between the lens and the film
must be increased to obtain a sharp image. This relationship can be
formulated as—

$$\frac{1}{\text{Focal Length}} = \frac{1}{\text{Object Distance}} + \frac{1}{\text{Image Distance}}$$

43

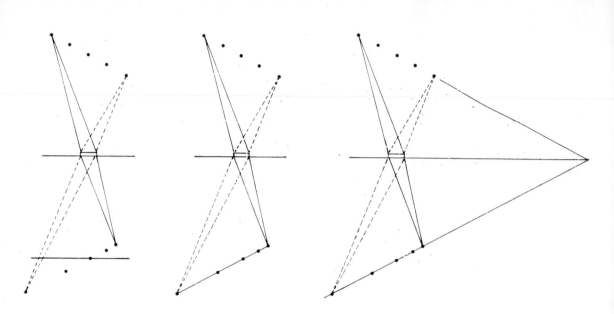

Left to right:

Fig. 68. Near objects come to a focus farther behind the lens than distant objects

Fig. 69. The back positioned to conform to the plane of sharp focus of the images

Fig. 70. Subject, lens board, and image planes meet at a common point

Although specific mathematical applications of this formula will be deferred to Chapter 3, we can observe that with the focal length remaining constant, any change in object distance requires an inverse change in image distance. Fig. 68 illustrates that with a subject that is inclined with respect to the camera, the part of the subject that is closest to the camera comes to a focus farthest behind the lens, and Fig. 69 shows that to obtain a sharp image the angle of the back is changed so that the points of sharpest focus all fall on the film. Because of the nature of the relationship, swinging or tilting the back to obtain optimum focus always places it in a position where the subject, lens, and back planes all meet at a common point (Fig. 70).

Effect of lens movements on sharpness

The same inverse relationship between image and object distances

$$\frac{1}{\text{Focal Length}} = \frac{1}{\text{Object Distance}} + \frac{1}{\text{Image Distance}}$$

can be used to explain control of the plane of sharp focus with the lens adjustment. At first glance it appears that swinging or tilting the lens (about a point at the centre of the lens) does not change the distances. Object and image distances are measured perpendicularly to a plane that is parallel to the lens board, however, rather than to

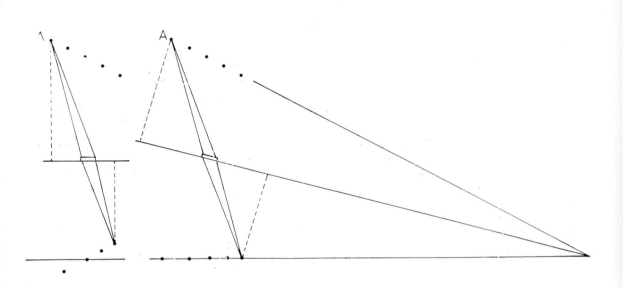

Fig. 71. Effect of swinging the lens on object and image distances

the centre of the lens. For now, we will assume that the measurements are made to the lens board (Fig. 71). Swinging the lens reduces the object distance for the most distant part of the subject — part "A". A decrease in object distance results in an increase in image distance. The image of object point "A" now comes to a focus farther behind the lens, and when the lens is swung to the correct position the sharp image falls on the film plane rather than in front of it. The converse occurs with the near part of the subject, and the ratio of image and object distances remains unchanged for objects on the lens axis.

Movement limitations

There are three types of limitation imposed upon the acceptable amount of movement that can be made in the various camera adjustments — mechanical, optical and aesthetic. Mechanical limitations of the maximum bellows extension, the extent of rise, shift, tilt, and swing movements are determined primarily by the design and construction of the camera. The mechanical limitations of some of the adjustments will not necessarily be the same for all lenses used on the camera, and it is not unusual for the mechanical movements of at least some of the adjustments to exceed the capabilities of the lens to form a satisfactory image. The optical limitations are then revealed as a loss of definition of a part or all of the image, or as a

Fig. 72. Increase in distance between front and back standards with recessed lens board

variation in the illumination at the ground glass and film. Even though the photographer is not limited by mechanical or optical factors, he may decide that he does not want to fully correct converging lines or to render an inclined subject entirely sharp for aesthetic reasons.

Focusing limitations

Focusing limitations are mostly mechanical in nature. As the distance between the subject and the camera is decreased, a limitation is reached where the distance between the lens and the film can no longer be increased to keep the image in sharp focus. The maximum bellows extension varies considerably among the various brands of view camera. It should be noted that the maximum advertised extension can be obtained on some cameras only when all other adjustments are zeroed. One view camera that has a 17-in. bellows extension when all adjustments are in their normal positions is limited to 16 in. when the front is raised and 13 in. when the front is raised and the lens and back are tilted to their extreme positions. Some cameras have provisions for adding bed and bellows units, tandem style, to increase the maximum bellows extension.

Minimum bellows extension is not normally a problem with view cameras, but situations are encountered where the lens and film cannot be brought close enough together to obtain a sharp image. This tends to occur when the camera is equipped with a short focal length lens and it is necessary to use the rising front, lateral shift, tilt, or swing adjustments, as the bellows may bind due to the limited space between the lens and back standards. Recessed lens boards minimize the difficulty by allowing the distance between the lens and back standards to be increased while keeping the lens at the same distance from the film (Fig. 72). Some view cameras have provisions for substituting special flexible non-accordion type bellows to minimize the binding (Fig. 73). An optical limitation on the focusing may occur when photographing small objects from a close position with a large bellows extension. Under these conditions some lenses that have been designed for the purpose of photographing objects at larger distances are not capable of producing images with satisfactory definition.

Lens movement limitations

All movements of the lens (rising-falling, lateral shift, tilt, and swing) change the relative position of the lens with respect to the film in such a way that the film is no longer centred in the part of the image field that is capable of producing the best definition. The extent to which the position of the lens may be altered before the definition or illumination of the image is seriously affected, depends upon the covering power of the lens. Some press type cameras have been supplied with lenses of such limited covering power that the corners of the negative reveal noticeable loss of definition even with the lens in the normal position, and any use of the rising front results in obvious unsharpness. At the other extreme, top quality wide-angle lenses, especially in the longer focal lengths, have such excellent covering power that good definition is obtained over the entire negative even with the extensive adjustments of the lens possible on a view camera.

Mechanical limitations on lens movements vary considerably among the numerous makes of view camera. The more flexible cameras appear as though they could almost photograph themselves when the adjustments are in the extreme positions. Limitations with such cameras are invariably due to optical and aesthetic factors rather than mechanical. Cameras with only modest movements of the lens can prove to be surprisingly versatile in the hands of a photographer who has a good understanding of view camera adjustments. For example, a limitation of $\frac{1}{2}$ in. on the lateral shift may be expanded to an effective shift of 7 in. or more by shifting the back an equal distance in the opposite direction, swinging the lens and back, and changing the angle of the bed as illustrated in Fig. 74.

Aesthetic limitations on the lens adjustments seem to be somewhat more rigid in relation to perspective effects than the plane of sharp focus. Tilting or swinging the lens has no effect on perspective, but with extreme vertical or horizontal displacement of the lens, the viewer may be disturbed by the fact that parallel subject lines are rendered parallel while it is obvious that the camera is viewing the subject from an extreme high, low, or side viewpoint. Since the control of shape is primarily a function of the tilt and swing movements of the camera back, this aspect of aesthetic limitations will be considered in the next section, on back adjustments.

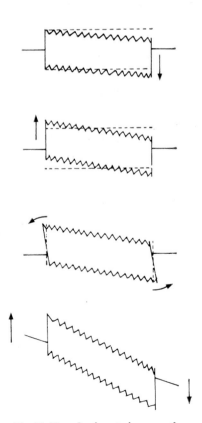

Fig. 74. Use of swings to increase the lateral displacement of lens and back

47

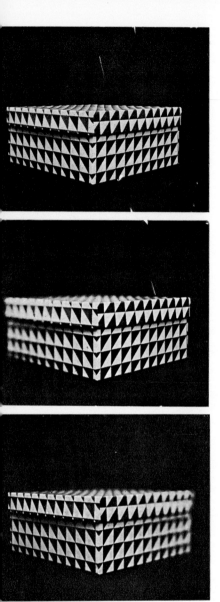

Fig 75. Adjusting the plane of sharp focus to conform to one plane of a box-shaped object while sacrificing the sharpness on the other plane tends to produce a disconcerting effect when the two planes are equal in importance

Viewers are quite tolerant about the treatment of image sharpness in photographs. They will accept photographs that are sharp overall, photographs that have a shallow depth of field, sometimes even photographs that have no sharp areas, and they will also accept photographs where the plane of sharp focus is at an extreme angle, providing each effect is appropriate for the subject. There is usually no problem where the subject consists of a single plane that can be rendered sharp by tilting or swinging the lens, but discretion must be used where adjusting the lens to improve the sharpness in one plane will decrease the sharpness in another plane or another part of the subject. For example, in photographing box shaped objects, if two planes of equal size and importance are visible from the camera position, adjusting the plane of sharp focus to conform to one plane while sacrificing the sharpness in the other, may produce a disconcerting effect (Fig. 75). Similarly, adjusting the plane of sharp focus to conform to the plane of the shoulders for a portrait may result in one sharp eye and one unsharp eye, a less attractive result than if the swing adjustment had not been used.

Back movement limitations

Mechanical limitations on the back movements are usually identical or similar to those on the lens. Not all view cameras have the same adjustments on the lens and the back, however. The rising-falling adjustment, which is used on both the lens and the back on a number of cameras, is omitted from the back on others. Tilt and swing adjustments were used on the back and not on the lens on some earlier view cameras, with the reverse situation of adjustments on the lens but not on the back now existing on some press type cameras.

Rising-falling and lateral shift movements of the back produce essentially the same results obtained with the same movements of the lens, but in the opposite direction. That is, shifting the back one-half inch to the right is comparable to shifting the lens one-half inch to the left, and the optical limitations concerning the covering power of the lens are identical. Tilting and swinging the back, however, do not involve the same risk of having part of the film lie outside the

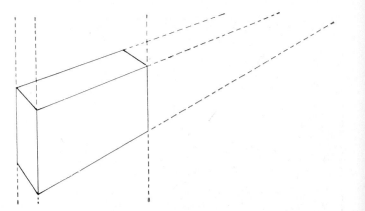

Fig. 76. Conventional treatment of vertical and horizontal subject lines

covering power of the lens that is involved when the lens is tilted or swung. For this reason, it is safer to adjust the plane of sharp focus with the back than with the lens when using a lens having limited covering power, although the back adjustments must be reserved for perspective control when this is a prime consideration.

Aesthetic limitations are imposed more on the swing and tilt adjustments of the back than on any of the other view camera movements. Although viewers apparently prefer to see parallel subject lines — especially vertical lines — rendered parallel on the print when the inclination of the camera is slight or moderate, the same treatment often produces an unnatural effect when the inclination of the camera is large. It is impossible to establish an absolute set of rules as to when parallel subject lines should be rendered parallel, when they should be allowed to converge, and the most acceptable angle of convergence. These things are concerned with the psychology of vision, and the interpretation of the image by the viewer is dependent upon such factors as the shape and nature of the subject, the lighting, previous experience and training of the viewer, and other factors. It is easy to deceive the eye into believing that two-dimensional objects are three-dimensional. Excellent examples of these and other effects appear in Ralph M. Evans' book *Eye, Film, and Camera in Color Photography*.[1] It is important that the photographer does not create optical illusions, due to either carelessness or ignorance, when he is striving for realistic effects, although he should be alert to the possibilities of utilizing optical illusions, exaggerated realism, and other special effects when their use is appropriate. The interpretation of converging lines on a print as normal perspective or as distorted perspective varies from person to person, although there are generally accepted conventions in certain professional fields of photography. Where realistic effects are required, vertical subject lines are almost always made parallel on the photograph, and parallel horizontal lines on receding planes are allowed to converge at a moderate rate. This treatment is illustrated by the drawing in Fig. 76. The nine photographs in Fig. 77 show the results of placing the tilt back in three different positions, and the swing back in three different positions.

[1] Ralph M. Evans, *Eye, Film, and Camera in Color Photography*, New York: John Wiley and Sons, Inc.; London: Chapman and Hall, Limited, 1959

49

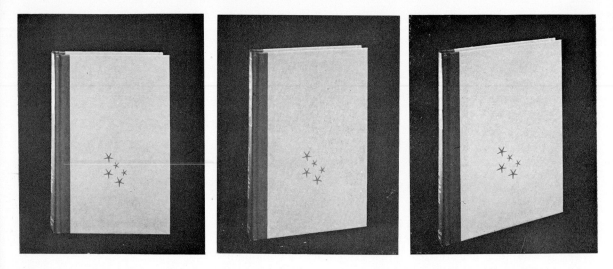

Fig. 77. The photographs above and opposite show the various effects obtained with the three different positions of tilt and swing back.

Tilt: Parallel to vertical subject lines
Swing: Parallel to horizontal subject lines

Tilt: Parallel to vertical subject lines
Swing: Zero position

Tilt: Parallel to vertical subject lines
Swing: Away from horizontal subject lines

Tilting and swinging the back also affect the shape of images of objects that do not have parallel lines. Irregularly shaped objects reveal the least obvious changes in shape, but the changes may be apparent when extreme adjustments are made with the camera back. Modifications in the position of the camera back produce significant changes in the shape of images of circular, spherical, and other regularly shaped objects (Fig. 78).

It should not be assumed that it is unnecessary to use tilts and swings with objects that are less geometrical in shape (Figs. 79–80). Photographs of a person, full length, from high, normal, and low viewpoints will reveal changes in the relative sizes of the head and feet. If it is necessary to photograph a person from a high or a low viewpoint and the size relationship is objectionable, it can be altered by tilting the back of the camera parallel to the subject. Other factors that affect perspective will be considered in the next chapter.

Anamorphic effects

Even though the tilt and swing movements of the back of the view camera provide extensive control over the way parallel subject lines are recorded on the photograph, they may not always give the exact change of shape that the photographer requires. He may

50

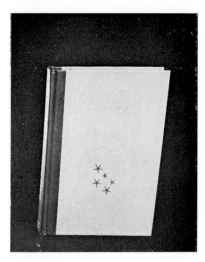

Tilt: Zero position
Swing: Parallel to horizontal subject lines

Tilt: Zero position
Swing: Zero position

Tilt: Zero position
Swing: Away from horizontal subject lines

Tilt: Forward
Swing: Parallel to horizontal subject lines

Tilt: Forward
Swing: Zero position

Tilt: Forward
Swing: Away from horizontal subject lines

51

Fig. 78. Effect of tilting the back of the camera on images of circular objects. *(Top)* Back in zero position. *(Middle)* Back tilted parallel with subject plane. *(Bottom)* Back tilted away from subject plane

want to make an object appear taller, longer, or shorter than it does in a straightforward photograph made without the use of special controls. A building, of course, can be made to *appear* taller by tilting the back of the camera away from the plane of the building to make the vertical lines converge more rapidly. If, however, the objective is to stretch the image and also keep the vertical subject lines parallel, the problem becomes more complex, and the solution requires the use of printing controls.

Tilting the easel is often used as a means of controlling the convergence of parallel subject lines at the printing stage, but it is less satisfactory and more awkward than tilting or swinging the back of the camera. Moreover, many enlargers do not have a tilting lens adjustment to control the plane of sharp focus, and unexpected cropping difficulties may be encountered unless considerable space is provided around the desired area on the negative.

True shape is obtained in the image when photographing a two-dimensional object by keeping the back of the camera parallel to the object. Thus, tilting a camera upward to photograph a building produces an image with the same height to width proportions as on the building providing the back is positioned perpendicular to the ground to prevent convergence of the vertical lines. With the back in this position, there can be no stretching or compressing of the image. If, however, a negative is made under identical conditions except that the camera back is in the normal (zero) tilt position, and the resulting converging vertical lines are made parallel by tilting the easel when the print is made, the height to width proportions of the image may be larger than, smaller than, or the same as on the subject.

52

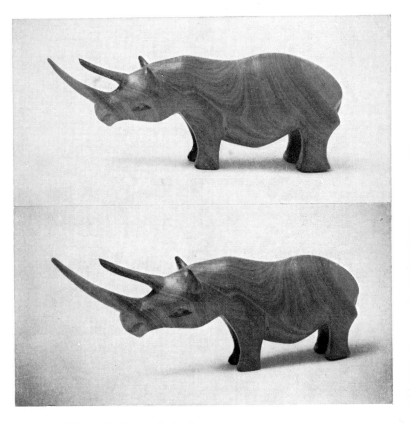

Fig. 79. Effect of swinging the back with an irregularly shaped object

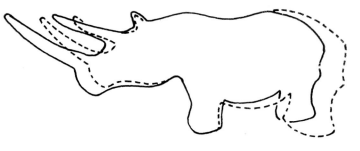

Fig. 80. Superimposed outlines resulting from swinging the back in opposite directions

Fig. 81 illustrates the effects obtained by photographing a square two-dimensional subject from a low viewpoint. Whether true rectification is obtained or the image is stretched or compressed, depends upon the relationship between the bellows extension on the camera when the negative is exposed and the bellows extension on the enlarger when the print is exposed. When the two distances are equal, true rectification results. Stretching results when the enlarger bellows extension is larger, and compression results when it is smaller. Bellows extension on the camera is determined by the camera lens focal length and the distance from the subject to the camera,

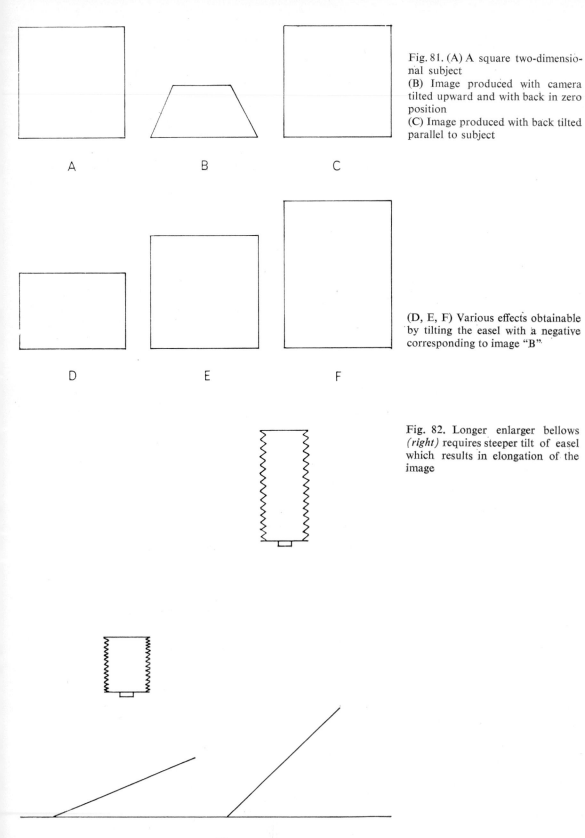

Fig. 81. (A) A square two-dimensional subject
(B) Image produced with camera tilted upward and with back in zero position
(C) Image produced with back tilted parallel to subject

A B C

(D, E, F) Various effects obtainable by tilting the easel with a negative corresponding to image "B"

D E F

Fig. 82. Longer enlarger bellows *(right)* requires steeper tilt of easel which results in elongation of the image

Fig. 83. Negative with image contain-
ing converging lines (*left*)

Projected image on a tilted easel
(*right*). Converging lines on the neg-
ative are parallel on the easel, but
edges of negative diverge and are
included in the picture area

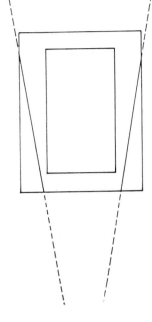

and the enlarger bellows extension is determined by the focal length
of the enlarger lens and the distance from the enlarger lens to the
easel.

The reason a change in either bellows extension affects the pro-
portions of the image is that the angle to which the easel must be
tilted to correct the converging lines depends upon the ratio of the
two bellows extensions. As the enlarger bellows extension increases,
the required tilt of the easel and the stretching of the image will both
increase (Fig. 82). Thus, maximum stretching of the image will be
obtained with a short focal length lens on the camera and a long
focal length lens on the enlarger. (Also, more stretching will be
obtained on a small print than on a large print.) A long focal length
camera lens and a short focal length enlarger lens should be used to
obtain maximum compression of the image. Difficulty may be en-
countered with poor definition at the edges of the print with enlarger
lenses having a focal length shorter than the diagonal of the negative,
due to their limited covering power.

When allowing lines to converge on the negative with the inten-
tion of correcting them by tilting the easel, precautions must be
'taken to avoid obtaining an image that cannot be cropped as desired
on the final print. As the easel is tilted to make the converging lines
on the negative parallel on the projected image, the edges of the
negative (or the edges of the opening in the negative carrier) which
are actually parallel will diverge on the projected image. Unless
there is sufficient space around the image on the negative, it may be
impossible to include all of the image on the print without also
showing the edges of the negative at one end of the print as illustrated
in Fig. 83.

3

LENSES AND SHUTTERS

Much of the versatility of view cameras and the potential high quality of the resulting photographs depends upon the lens. First, view cameras permit the photographer to use almost any lens that can be attached to a lens board. He can select a lens having the characteristics necessary to produce the desired results for each of a wide variety of photographic situations. Second, after the lens has been selected, the view camera provides the photographer with freedom in varying the relative positions of lens and film to obtain maximum utilization of the features of the lens.

Considering the many ways that lenses can vary one from another, photographers often have little specific information concerning the lenses they purchase. Not infrequently, the focal length and the maximum f-number are the only tangible data provided. Since few photographers are prepared to conduct comprehensive lens tests, they tend to be influenced by the recommendations of others and by the manufacturer's claims. Although some lens manufacturers are providing more information about their lenses, many of the characteristics of the images formed by photographic lenses are difficult to measure and to document in terms that are meaningful to the photographer. Some of the more significant ways in which the images formed by two different lenses may vary are — image size, illumination at the maximum aperture, variation in illumination from the centre to the edges of the film, definition from the centre to the edges of the film at all marked f-numbers and when focused on far to near distances, accuracy of the image with respect to shape, colour and contrast, and the distance the image is formed behind the lens board in relation to the focal length. Although lens problems encountered in routine picture making situations can be solved by following rules, an understanding of the basic principles of optics is helpful for the most effective selection and use of lenses in the diversified situations encountered by professional photographers.

Pinhole photography

Images formed by pinholes are not good enough to compete with those formed by photographic lenses, although one may have a moment's pause in identifying comparison photographs made with

Fig. 84. Photographs made with a pinhole aperture (*left*) and a soft-focus portrait lens (*right*)

a pinhole and a soft-focus portrait lens (Fig. 84). The value of the pinhole, however, is its simplicity of image formation which makes it easier to understand the more complex process of image formation with lenses. Five comparisons are made between a pinhole and a lens in the drawings in Fig. 85.

A. An image of a point object is formed by a pinhole by allowing only a small bundle of rays of light to reach the film. Since the lens accepts light over a larger area, it must change the direction of all except the central rays to bring the image to a focus.

B. With two-dimensional objects, only two points at the extremities are needed to establish the size of the image.

C. An attempt to increase the illumination by enlarging the size of the pinhole results in a loss of image definition, but the lens suffers from a similar difficulty for objects at distances other than the one focused upon.

D. An attempt to improve the definition of the pinhole image by reducing the size of the opening reveals that there is an optimum pinhole size for a given pinhole to film distance, and diffraction causes a loss of definition when the pinhole is made too small. Diffraction also affects the image formed with a lens, although lens manufacturers do not normally equip their lenses with diaphragms that can be stopped down so far that diffraction produces an obvious degradation of the image.

E. Changing the distance from the pinhole to the film changes the size of the image and the resulting images are about equal in defini-

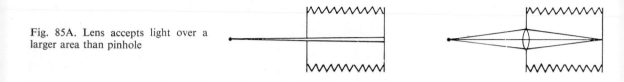

Fig. 85A. Lens accepts light over a larger area than pinhole

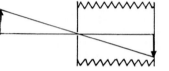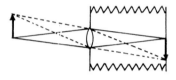

Fig. 85B. Size of image established with light rays from extremities of object

Fig. 85C. Increased aperture size results in loss of image definition

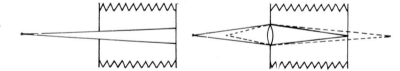

Fig. 85D. Decreased aperture size results in loss of image definition

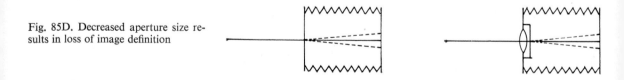

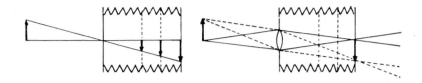

tion unless the distance is changed drastically. Similar changes in distance between the lens and film will also change the size of the image, but it will be in focus at only one distance behind the lens. Different focal length lenses must be substituted to obtain sharp images at different distances.

Lens terminology

The following fourteen terms refer to important physical and optical features of photographic lenses.

Spherical Surfaces. The surfaces of most photographic lenses are either flat or spherical (Fig. 86). Cross-section drawings of lenses show the curved surfaces as parts of circles, but on the actual lenses they are parts of spheres. Aspherical surfaces (curved surfaces that are not spherical) are being used on some photographic lenses. The difficulty of mass producing aspherical lenses economically has restricted their use.

Centre and Radius of Curvature. If the lens surface is extended to form a complete sphere, the centre of the sphere and the radius of the sphere are referred to as the centre of curvature and the radius of curvature respectively (Fig. 87).

Positive Lenses. Positive lenses are thicker in the centre than at the edges. One surface of all positive lenses must be convex. The other surface can be convex, plane, or concave. If the second surface is concave, it must have a larger radius of curvature than the convex side. The three basic types of positive lens are shown in Fig. 88.

Negative Lenses. Negative lenses are thinner in the centre than at the edges. They are incapable of forming real images, that is, images that can be focused on a ground glass or film, but negative lenses are used in combination with positive lenses. The three basic types of negative lens are illustrated in Fig. 89.

Lens Axis. The lens axis is a straight line through the centres of curvature of the lens surfaces (Fig. 90). Two of the six basic types of lens have only one centre of curvature. With lenses having one plane surface, the lens axis is a line through the centre of curvature perpendicular to the plane surface. When two or more elements are

59

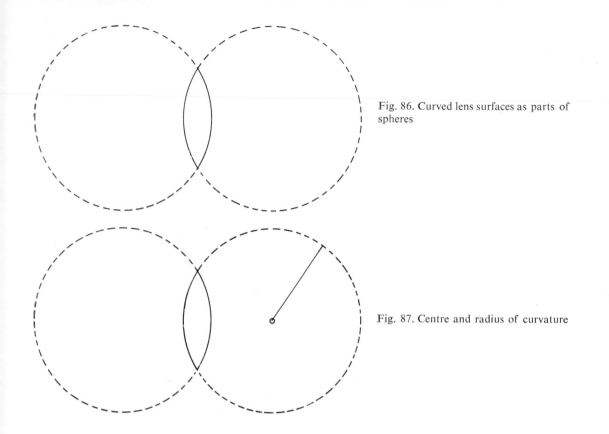

Fig. 86. Curved lens surfaces as parts of spheres

Fig. 87. Centre and radius of curvature

Fig. 88. Positive lenses

Fig. 89. Negative lenses

combined to form a compound photographic lens, the lens axes of the individual elements must coincide. Dropping a photographic lens may destroy this alignment, which in turn will affect image definition even though there is no outward evidence of damage to the lens.

Optical Centre. The optical centre of a single element of a compound lens is a point on the lens axis through which every ray of light that passes is undeviated (Fig. 91). That is, all rays of light that pass through the optical centre leave the lens traveling in the same direction they entered, although they may be displaced laterally. The surfaces where undeviated rays enter and leave the lens are parallel to each other, so that for these particular rays the lens is acting like a piece of window glass with parallel sides.

Nodal Points. Nodal points are two points on the lens axis, so located that every ray of light that passes through the optical centre will enter the lens in the direction of one (the object nodal point) and leave the lens as if it came from the other (the image nodal point) (Fig. 92).

Nodal Planes. Nodal planes are planes through the nodal points, perpendicular to the lens axis (Fig. 93). A knowledge of the location of nodal points and planes is useful in three ways. First, accurate measurement of distances, such as object and image distances and focal length, must be made to the appropriate nodal plane (Fig. 94). Measuring to the physical centre of the lens may introduce considerable error with some lenses. Secondly, it is desirable to have lenses

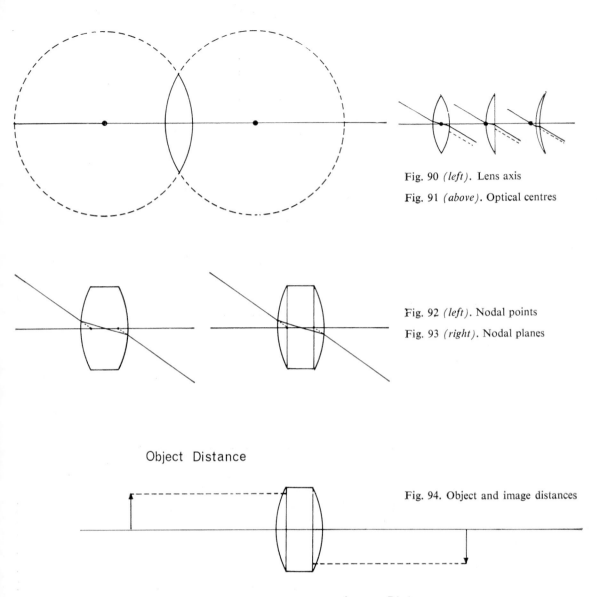

Fig. 90 *(left)*. Lens axis

Fig. 91 *(above)*. Optical centres

Fig. 92 *(left)*. Nodal points

Fig. 93 *(right)*. Nodal planes

Object Distance

Fig. 94. Object and image distances

Image Distance

tilt and swing about the rear nodal point to minimize the amount of refocusing and recomposing necessary after adjusting the lens. A practical method for locating the image nodal point is to focus the lens on a distant object and locate the point along the lens axis where pivoting the lens will not result in a movement of the image (Fig. 95). Reverse the lens and repeat the process to locate the object nodal point. Thirdly, the concept of image formation is simplified with compound lenses by utilizing the nodal planes. Once the location of the two nodal planes has been established, all glass surfaces can be disregarded even if the lens contains many elements.

Principal Focal Point. The principal focal point is the position of best axial focus for an infinitely distant object. Actually, there are two principal focal points. The first is in the front space (normally

Fig. 95. Determining the position of nodal points

the object side of the lens) and the second is in the back space. Where the term is used without modifiers, it refers to the back principal focal point (Fig. 96).

Focal Length. The focal length is the distance from the emergent nodal point to the principal focal point. Every lens has two focal lengths, the front and the back, corresponding to the two principal focal points. The two focal lengths are equal. Lenses of different focal lengths produce different size images and different angles of view when used with the same film format. The recommendation for general purpose photography is that the focal length of the lens should be approximately equal to the diagonal of the film but extreme deviations from this rule are frequently required for various types of photographs.

Angle of View. The angle of view is the angle formed by lines from the image nodal point to two opposite corners of the film with the film located one focal length from the image nodal point (Fig. 97). An angle of 53 degrees is formed when the lens focal length is equal to the film diagonal. Some lens manufacturers publish two values for the angle of view, $27° \times 40°$ for example, one based on the short dimension of the film and the other on the long dimension. Angle of view is determined solely by focal length and film size, and should not be confused with terms applied to the covering power of lenses.

Circle of Good Definition. The circle of good definition is a circular area in the image plane within which the lens is capable of forming an image having acceptable definition. The diameter of the circle of

Fig. 96 Principal focal point, and focal length

Principal Focal Point

Focal Length

Principal Focal Point

Focal Length

good definition of a lens must be at least as large as the diagonal of the film if the camera has no movements but appreciably larger when adjustments are to be used (Fig. 98). Shifting the lens or back vertically or horizontally, or tilting or swinging the lens, will throw the circle of good definition off centre relative to the film, and image definition will not be satisfactory on any parts of the film that are outside the boundaries of the circle. Tilting and swinging the back do not appreciably alter the relative positions of the circle of good definition and the film. The only conditions under which the circle of good definition is actually circular in shape in the film plane is when the lens board and film plane are parallel to each other. When they are not parallel, the "circle" of good definition becomes elliptical in shape.

Four factors affect the size of the circle of good definition (Fig. 99). First, with lenses of conventional design, the diameter of the circle of good definition is approximately equal to the focal length. Secondly, stopping a lens down increases the size of the circle of good definition with most lenses. With an eight-inch focal length lens, the diameter of the circle may increase from eight inches at the largest aperture to nine or nine and one-half inches at the smallest aperture. Thirdly, lens design affects the ratio of the circle of good definition to the focal length. The diameter of the circle of good definition is larger than the focal length with wide angle lenses and smaller than the focal length with telephoto lenses. Fourthly, since the usable light transmitted by a lens is projected toward the film in the shape

63

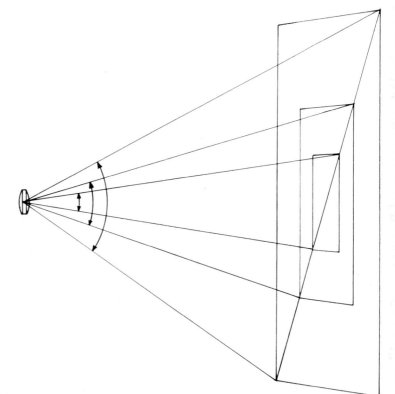

Fig. 97 A. Angle of view with different focal length lenses and constant film size

Fig. 97 B. Angle of view with different film sizes and constant lens focal length

of a cone, the farther the image is formed behind the lens, the larger the circle of good definition will be. Thus, an eight-inch lens that has an eight-inch diameter circle of good definition when photographing distant scenes will have twice as large a circle when photographing a closer object that requires double the bellows extension.

Angle of Coverage. The angle of coverage is the angle formed by lines connecting the image nodal point to opposite sides of the circle of good definition, or the angle of the cone of *usable* light transmitted by the lens (Fig. 102). Thus, angle of coverage and circle of good definition both measure the covering power of lenses. Observe,

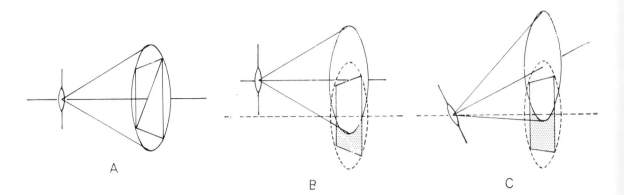

A

B

C

Fig. 98. Position of the circle of good definition in relation to the film with the lens zeroed (A), with the lens raised (B), and with the lens tilted (C)

however, that the angle of coverage is altered by only two of the four factors that determine the size of the circle of good definition. Changes in lens to film distance, either due to a change in focal length or a change in subject to lens distance, do not affect the angle of coverage.

Since the standard angle of view (when the focal length is equal to the film diagonal) is 53 degrees, the angle of coverage of a lens intended for general purpose photography must be at least 53 degrees, and larger if camera adjustments that alter the position of the lens axis in relation to the film are to be used. Information concerning the angle of coverage and the circle of good definition is available from some lens manufacturers for specific lenses, but since the values of these lens properties vary with the aperture, a person who is considering purchasing a lens should determine if the data apply to the lens wide open or stopped down.

Fig. 99. Factors affecting the size of the circle of good definition—stopping down (1 & 2), focusing on a closer object (1 & 4), substituting a wide-angle lens with the same focal length (1 & 3), and substituting a longer focal length lens of conventional design (1 & 4)

V.C.T.—E

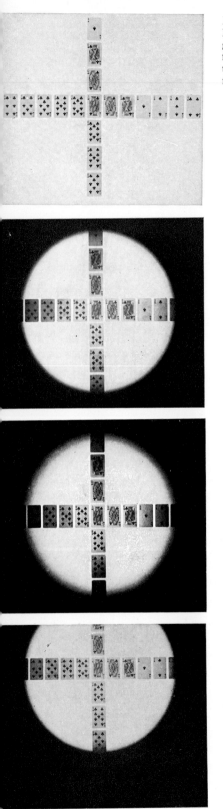

Fig. 100. Photographs made with a lens having a large enough circle of good definition to cover the entire film area (*left*) and a lens having too small a circle of good definition for the film (*below*)

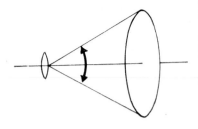

Fig. 102 (*top*). Angle of coverage

Fig. 101. Positions of the circle of good definition in relation to the film with the lens adjustments zeroed *(left)* and after lowering the lens with the rising-falling adjustment *(below)*

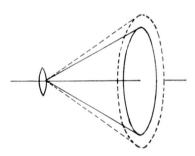

Fig. 103 *(bottom)*. Circle of illumination and circle of good definition

Circle of Illumination. The circle of illumination is the circular area in the image plane formed by the entire cone of light transmitted by the lens. Although the circle of illumination is always larger than the circle of good definition, the difference in size of the two circles varies with lenses, and as a given lens is stopped down (Fig. 103). Poor image definition in the zone outside the circle of good definition but inside the circle of illumination normally makes that area unusable, but if parts of the subject that are devoid of detail, such as blue sky or a plain background, are represented in this zone there is less danger of an objectionable result.

Fig. 104. Three photograhs made with the same lens, with the camera progressively moved closer to the subject. The circle of good definition increases in size as the lens to film distance is increased to keep the image in sharp focus. At the intermediate position, the circle of good definition of the conventional 2 inch focal length lens is large enough to cover 4×5 inch film. At the closest position, the circle is large enough to permit moderate use of the tilt, swing, lateral shift, and rising-falling adjustments on the camera

Practical problems of image formation

Photographers are frequently faced with the need to anticipate such problems as—How large an image can I obtain of a small object with a certain camera and lens?—What focal length lens will I need to include all of a subject where the distance the camera can be placed from the subject is limited?—How large a studio will I need to make full-length portraits with a certain camera and lens? — What is the longest focal length lens I can use on a certain camera for photographing distant scenes? There are several methods by which photographers can determine the answers to such problems.

The most obvious and direct method is to set up a camera in the actual situation or as close an approximation of the actual situation as possible and vary the appropriate factors to obtain the desired information. This experimental procedure is occasionally the most satisfactory method, but it is often difficult and time consuming, or the variety of equipment needed is not available. Two other methods will be presented—graphic drawings and lens formulae. Graphic drawings have the advantage of helping the photographer to visualize the situation and the variables involved, whereas the lens formulae become more useful as he forms clearer concepts of the process of image formation.

Graphic drawings

Up to now schematic drawings of image formation by lenses have been satisfactory to illustrate the basic concepts involved. We are now concerned with making drawings that are correct with respect to size and position of the image for a specified set of conditions. If all of the distances are small, we can make a full size drawing, but as the distances increase it is necessary to make the drawings to scale.

67

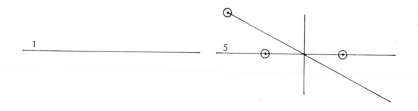

Fig. 105. Procedure for making a graphic drawing

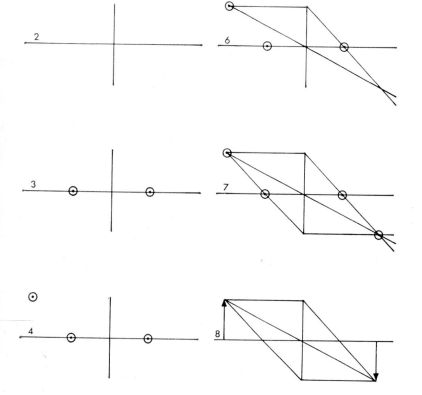

The following distances are involved in graphic drawings:

Focal Length (f) Object Size (O) Image Size (I) Object Distance (u) Image Distance (v)

For the following example, let—

Focal Length = 4 inches; Object Distance = 8 inches; Object Size = 4 inches.

A scale of 1 : 4 will be used, reducing the actual dimensions on the drawing to $f=1$, $u=2$, and O$=1$. There are eight steps in making the graphic drawing, as shown in Fig. 105, after which we can

68

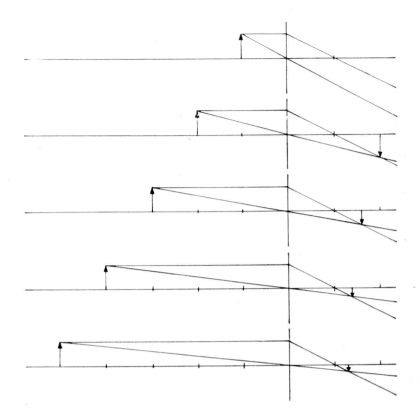

Fig. 106. Graphic drawings with the object at one, two, three, four, and five focal lengths from the lens

determine the values for the two unknown factors—image distance and image size.

1. Draw a straight horizontal line to represent the lens axis.

2. Draw a line perpendicular to the lens axis to represent the nodal planes. (The two nodal planes are combined for thin lenses, but separate nodal planes are drawn for thick lenses.)

3. Place a mark on the lens axis 1 in. on either side of the nodal planes to represent the principal focal points.

4. Place a mark 2 in. to the left of the nodal planes and 1 in. above the lens axis to represent a point on the object.

5. Draw a ray from the object point straight through the optical centre of the lens.

6. Draw a second ray from the object point parallel to the lens axis to the nodal planes, then through the back principal focal point. The image comes to a focus where the two rays intersect.

7. Draw a third ray from the object point through the front principal focal point to the nodal planes, then parallel to the lens axis. This ray is not essential, but serves as a check on the accuracy of the position of the image.

8. Draw a line from the object point perpendicular to the lens axis to represent the entire object and a line from the image point perpendicular to the lens axis to represent the corresponding image.

9. Measure the distance from the nodal planes to the image (2 in.) and the image height (1 in.) and multiply each by 4 to compensate for the scale. The image distance is thus found to be 8 inches and the

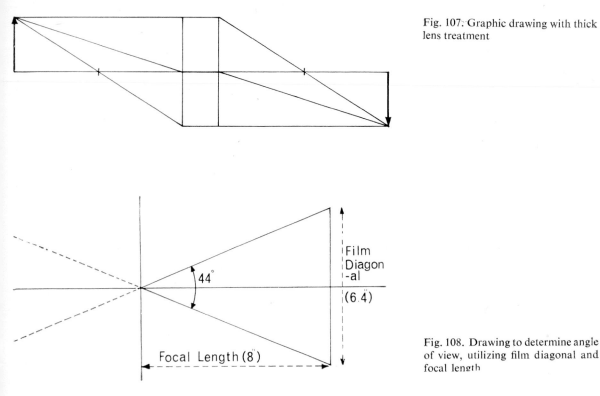

Fig. 107. Graphic drawing with thick lens treatment

44°

Film
Diagon
-al
(6.4)

Focal Length (8)

Fig. 108. Drawing to determine angle of view, utilizing film diagonal and focal length

image size 4 inches. This, of course, is the situation where the object and image distances are equal and the image is the same size as the subject.

Repeating the above procedure for objects at different distances will produce images that are correct in size and position. An attempt to place the object at one focal length from the lens or closer will result in the rays leaving the lens travelling parallel or diverging, since it is impossible to obtain real images at these distances. The results of placing an object at 1, 2, 3, 4, and 5 focal lengths from the lens are illustrated in Fig. 106. With the thick lens treatment, all rays from the object are drawn to the object nodal plane and all rays to the image are drawn from the image nodal plane. Between the two nodal planes, all rays are drawn parallel to the lens axis (Fig. 107).

Graphic drawings are not limited to determining image distance and image size. If the image distance and image size are known but the object distance and object size are unknown, the same procedure can be used to make a drawing. The principal focal points can also be located to determine the focal length providing the sizes and distances for both object and image are known.

Angle of view can be determined by drawing a line of the appropriate length for the film diagonal through the back principal focal point perpendicular to the lens axis. Lines drawn from the ends of the film diagonal to the nodal points, as illustrated in Fig. 108 will produce an accurate angle of view that can be measured with a protractor. (No scale compensation is necessary with angles.) Angle

Fig. 109. Angle of view (A) with film located one focal length behind the lens, and effective angle of view (B) with camera focused on near object

of view is defined for a distant object where the film is located one focal length behind the image nodal point. The *effective* angle of view that results when the camera is focused on close objects can be found by substituting the lens to film distance for the focal length on the drawing. The two angles can be drastically different, as shown in Fig. 109.

Lens formulae

Four lens formulae can be used to solve problems involving the five distances listed in the preceding section on graphic drawings. A sixth term, Scale of Reproduction (R) will now be added. Scale of reproduction is not a distance, but a ratio of image size to object size (I/O). Although a total of only four terms appear in the formulae, Focal Length (f), Object Distance (u), Image Distance (v) and Scale of Reproduction (R), problems involving image size or object size can be solved by substituting I/O for R in the appropriate formula. The four formulae are listed below with a chart of the terms contained in each. There are three terms in each formula, but no two formulae contain the same terms. Thus, to solve a poblem in which the object distance and the focal length are known and the scale of reproduction is to be found, for example, the formula containing these three terms — u, f, and R — is selected. The values are substituted for the two known terms and the formula is solved for the unknown term.

	R	f	u	v
1. $\dfrac{1}{f} = \dfrac{1}{u} + \dfrac{1}{v}$		*	*	*
2. $R = \dfrac{v}{u}$	*		*	*
3. $R = \dfrac{v-f}{f}$	*	*		*
4. $R = \dfrac{f}{u-f}$	*	*	*	

Formula No. 1 mathematically confirms two important relation-

U = 12" V = 8"

U = 8" V = 12"

Fig. 110. Two lens positions result in sharp images with a fixed distance between subject and film

ships that exist between object distance and image distance, which are referred to as *conjugate* distances. The first relationship is that as the object distance increases the image distance decreases, as was shown graphically in the preceding section. With a 4-in. focal length lens, it is possible to have an infinite number of combinations of values for u and v, but once a value is selected for either there is only one value for the other. If u is 8, then v must be 8 also $\left[\frac{1}{4} = \frac{1}{8} + \frac{1}{8}\right]$. If u is increased to 12, then v decreases to 6 $\left[\frac{1}{4} = \frac{1}{12} + \frac{1}{6}\right]$

The second relationship is that the object distance and the image distance are interchangeable. Changing the object distance in the preceding equation from 12 to 6 changes the image distance from 6 to 12. The significance of this is that images can be obtained with a lens in two different positions, keeping the subject and the film stationary, as shown in Fig. 110. This situation is encountered most frequently in close-up work with the view camera (and in enlarging), as the bellows must be capable of being extended as far as the larger of the two distances. If the object and image distances are equal, however, there is only one position where the lens will produce a sharp image.

Sample problem using the formula $\frac{1}{f} = \frac{1}{u} + \frac{1}{v}$:

A camera has a maximum bellows extension of 30 in. and is equipped with a 20 in. focal length lens. What is the minimum object distance the camera can be focused on?

$$\frac{1}{20} = \frac{1}{u} + \frac{1}{30}$$

$$u = 60 \text{ in., or 5 ft.}$$

Formulae No. 2, 3, and 4 each contain the scale of reproduction and different combinations of two of the three terms—object distance, image distance, and focal length.

Sample problem involving the scale of reproduction:
A camera has a maximum bellows extension of 20 in. and is

72

equipped with an 8 in. focal length lens. What is the maximum scale of reproduction that can be obtained with this camera and lens? Since the three terms involved in the problem are image distance, focal length, and scale of reproduction, formula No. 3 is selected.

$$R = \frac{v-f}{f}$$

$$R = \frac{20-8}{8}$$

$$R = 1.5$$

Lens shortcomings

Even though it was convenient to ignore lens shortcomings in the preceding section on image formation, no lens is capable of forming a perfect image. It could be argued that if a lens is capable of making a photographic copy that, when viewed at the normal viewing distance, cannot be distinguished from the original, it has for all practical purposes made a perfect image. Although this can be done, and although most of the photographic images being produced in a wide variety of situations by professional photographers are satisfactory, photographers have not been freed from the problems of lens shortcomings.

Five types of lens shortcoming involving image definition, image shape, image colour, uniformity of illumination, and image contrast will be considered.

Image Definition. Ability to produce images having good definition seems to be the quality in lenses that photographers are most concerned with. There are many factors that affect the definition of the images formed by lenses. Most of the well-documented lens aberrations affect definition. Spherical and chromatic aberrations affect all parts of the image field, while coma, lateral colour, astigmatism and curvature of field do not affect the image in the centre of the field but become progressively worse toward the edges. Lens designers have considerable control over aberrations, but they are hampered by the necessity of compromising. Aberrations can be

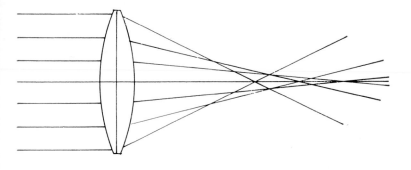

Fig. 111. Spherical aberration

minimized quite effectively for a specific object distance — large for aerial camera lenses, smaller for process camera lenses, and very small for macro type lenses — but definition suffers when the lens is used at other object distances. Definition may suffer also when the lens designer is required to increase the angle of coverage considerably beyond the 53° necessary for a "normal" focal length to film diagonal ratio, or when he is required to increase the speed of the lens, or when he is required to minimize the cost of production, or when various other special conditions are stipulated.

Readers who are interested in studying each of the various aberrations in detail are referred to any of the numerous optics books available. Only one aberration will be examined briefly here as being representative of the problem of aberrations and image definition. Spherical aberration is characterized by the difference in focus for light rays that are transmitted through the central portion of the lens compared to rays passing through the outer zones. As illustrated in Fig. 111, the marginal rays come to a focus closer to the lens than do the axial rays. Lens designers can control the spherical aberration of a lens in several ways — by altering the radii of curvature of the spherical surfaces, by restricting the diameter of the lens, by combining two or more elements having the proper shapes and characteristics, and by using aspherical (non-spherical) surfaces. It may be apparent to the reader that if an appreciable amount of spherical aberration remains in a photographic lens, the photographer can still minimize it by reducing the size of the aperture, thus eliminating the marginal rays. Soft-focus portrait lenses normally obtain their soft-focus effect with spherical aberration. Since the spherical aberration is reduced as the lens is stopped down, the photographer can control the effect (Fig. 112). Some soft-focus lenses produce images with excellent definition at the smaller openings, but it is necessary to focus at the aperture that will be used to expose the film since the position of best focus will change as the marginal rays are eliminated.

Not all of the aberrations that affect image definition are minimized as effectively by stopping the lens down as spherical aberration is, but the overall loss of definition of the image attributable to lens aberrations is reduced over the entire field at smaller apertures. This does not mean that image definition is always better at small lens

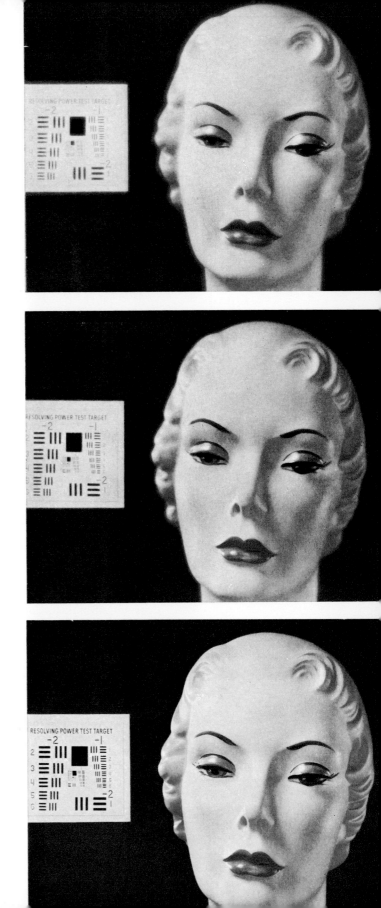

Fig. 112. Photographs made with a soft-focus portrait lens at relative apertures of f/6 *(top)*, f/8 *(middle)*, and f/32 *(bottom)*

Fig. 113. Barrel distortion *(top)*
and pincushion distortion *(bottom)*

openings. Diffraction, which causes a loss of definition with the pinhole aperture when it is made too small, also affects the image produced by a lens when the opening is small. Two opposing actions occur as a lens is stopped down — the smaller opening tends to improve the definition by minimizing the aberrations and at the same time tends to worsen the definition by increasing the diffraction. Many lenses can be expected to produce the best compromise at some intermediate opening, with the best definition obtained with poorly corrected lenses by using small openings and with well corrected lenses by using larger openings. The situation is somewhat more complex than indicated, since the best compromise is not reached simultaneously over the entire field, and other factors that affect definition of the image, such as accuracy of focusing and depth of field have not been considered.

Image Shape. Distortion is a lens aberration that affects the shape of the image without affecting the definition. It is most apparent when the subject contains straight lines that are imaged close to the edges of the film, as distortion will cause them to bow either toward or away from the centre of the field. With a single-element lens, the lines bow in if the diaphragm is placed in front of the lens and bow out if it is placed between the lens and the film (Fig. 113). The distorted shape of images results from a variation in the scale of reproduction from the centre to the edges of the field. Stopping the lens down does not affect distortion. Photographers have little control over this lens shortcoming except in their choice of lenses, although lenses with some distortion may be entirely satisfactory for photographing subjects devoid of long straight lines, such as portraits and landscapes. Extremely high distortion correction is required for certain types of photography such as mapping, copying, and some industrial, technical, and scientific applications. Placing the diaphragm between elements that are approximately symmetrical in shape and spacing, rather than in front of or behind the lens, is the lens designers best control over distortion. It should not be assumed that all expensive lenses are distortion free. Some zoom type lenses for 35mm cameras have more distortion at certain focal length settings than inexpensive box camera lenses, and distortion correction must be sacrificed on extreme wide-angle lenses.

Image Colour. Longitudinal chromatic aberration is characterized

Fig. 114. Distortion-free photograph *(right)* made with an $8\frac{1}{2}$ inch focal length commercial type lens and 4×5 inch film

Pincushion distortion *(below)* produced with a 10 inch focal length telephoto lens on 8×10 inch film

Use of a 4×5 inch film area, *(below right)* the size recommended for the 10 inch focal length telephoto lens, eliminates much of the distorted image on the 8×10 inch photograph but curved image lines can still be detected near the edges of the smaller format

by a difference in focal length for light of various colours. White light is dispersed by lenses having longitudinal chromatic aberration, and the component colours are brought to a focus at varying distances behind the lens. Of the visible colours blue light comes to a focus closest and red light farthest. Ultraviolet radiation, to which most films are highly sensitive, and infrared radiation, to which films can be specially sensitized, create special problems when the focal points for these wavelengths are at different distances behind the lens than the focal point for visible radiation. Under these circumstances the photographer must adjust the lens to film distance after focusing visually. Longitudinal chromatic aberration produces colour haloes around image points on colour photographs and causes a loss of definition on both colour and black-and-white photographs.

Lateral chromatic aberration is evidenced by images that vary in size according to colour, producing colour fringing that becomes progressively worse near the edges of the field. Lens designers cannot completely eliminate the two colour aberrations, but they can reduce them to very acceptable levels. Stopping down will minimize the effects of longitudinal but not lateral chromatic aberration.

Lenses can also influence image colour by selectively absorbing and reflecting different wavelengths. The effect the lens has on the colour balance of the transmitted light depends upon the absorption characteristics of the glasses used, whether the lens is coated or not, and if coated, upon the nature and thickness of the coating. There are enough variations in these factors among lenses so that two colour transparencies exposed through two different lenses may appear considerably different in colour, even though all other factors were identical. Such differences in colour are inconsequential in black and white photography, but they can be troublesome on colour transparencies — especially when the transparencies are to be viewed simultaneously or in sequence. Even with colour negatives, where there is considerable control over the colour balance in the printing process, large variations of this type complicate the problem of producing prints of consistent quality.

Less variation in the influence of lenses on the colour balance of transmitted light can be expected in the future, as a result of the publication of standards by The American National Standards Institute on a method for measuring lens colour and on variability

Fig. 115. Vignetting by lens barrel

limits.[1] Most lens manufacturers have made changes to minimize colour differences in their lenses. When a lens is found to have an objectionable colour, the effect can be minimized on the photograph by using an appropriate filter over the camera lens. A study made of a number of photographic lenses has revealed that the largest variation is in absorption of ultraviolet energy, which affects the photographic image even though invisible.[2] Using an ultraviolet absorbing filter over all lenses minimizes this effect on colour photographs.

Uniformity of Illumination. Illumination of the film plane normally decreases from the centre toward the edges. This occurs even with a pinhole. Lenses are subject to all of the factors that cause the variation of illumination with the pinhole plus vignetting due to obstruction of oblique rays by the lens barrel (Fig. 115). In the absence of vignetting, the illumination at the corners of the film is approximately 50% of the illumination at the centre when the lens focal length is equal to the film diagonal — producing an angle of view of 53 degrees. As the angle of view increases, the fall-off in illumination becomes more pronounced. With a 120 degree angle of view, the corners receive approximately 6% of the illumination at the centre, a variation equivalent to 4 stops. A moderate fall-off is of little consequence in conventional photography. Prints are often burned in around the edges because the effect of slightly darker edges is considered attractive with many subjects, an effect that is obtained automatically with normal focal length lenses unless it is cancelled out by a similar action on the part of the enlarger lens and the enlarger illumination (Fig. 116). A minimum variation in illumination is required for certain types of photographs, such as those made with aerial cameras for mapping purposes, and with process cameras for use in photomechanical reproduction. The severe fall-off in illumination encountered with some wide-angle lenses is quite objectionable. Lens designers attempt to reduce it to an acceptable level by minimizing vignetting, and in some lenses by incorporating light equalizing devices. Photographers can exercise some control at the printing stage, providing the exposure differential was not so large as to result in a loss of detail or an obvious change in contrast.

[1] PH3.37–1969 Test Method for the Selective Transmissian of a Photographic Lens. PH3.44–1970 Recommended Values for Color Contribution of Photographic Lenses.
[2] F. Williams and F. Grum, *Photographic Science and Engineering,* Vol. 4, No. 2, March-April, 1960

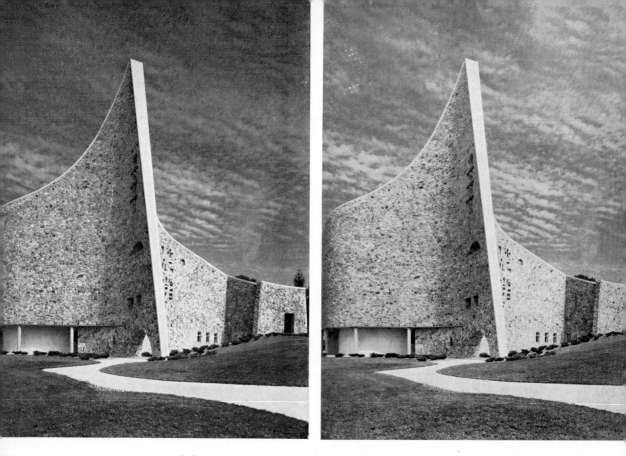

Fig. 116. Illumination fall-off is evident at the top of a photograph *(left)* made with a wide-angle lens, using the rising-front adjustment on the camera. Comparison print *(right)* made from the same negative was dodged to minimize the effect

Any use of the lens or back adjustments will cause a further change in the uniformity of illumination on the film plane. In the same way that adjustment of the lens changes the position of the circle of good definition with respect to the film, the brightest area of illumination is centered around the lens axis and moves as it moves. Tilting and swinging the back also changes the distribution of light since these movements affect the lens-to-film distances and the angles at which the light strikes the film.

Lens shades, although desirable from the viewpoint of controlling non-image forming light, may increase the vignetting effect by cutting off some of the rays of light included within the angle of view. In extreme situations lens shades may prevent all the light from the corners of the field of view from reaching the film, resulting in clear areas in the corners of the negative similar in appearance to the effect produced by a lens with a circle of illumination that is too small for the film size. Interference by the lens shade can be checked by sighting through the lens from the corners of the ground glass. This should be checked after all adjustments have been made in the positions of the lens and the back, and at the aperture that will be used to expose the film since vignetting by the lens barrel or the lens shade is reduced as the lens is stopped down.

Non-image Forming Light. Considerable light reaches the film in a camera in addition to the light that forms the desired image. This is non-image forming light, and it originates primarily from reflections. Light that is reflected from lens surfaces may either escape to

a b c

d e f

a Fig. 117 (*left to right*). Lens opening appears circular when viewed from the centre of the film

b Vignetting by the lens barrel is evident when the lens opening is viewed from a corner of the film

c Increased vignetting results from swinging the lens

d Vignetting in the preceding photograph has been eliminated by stopping the diaphragm down two stops

e Appearance of lens opeining at full aperture with moderate swing and moderate tilt of the lens board

f Lens has been tilted to a more extreme position, but short of the mechanical limitation of the camera

Vignetting effect of a lens shade. The lens opening without the lens shade is indicated by the dotted line

81

Fig. 117. Localized flare and a circular ghost image as a result of including the sun in the picture area

the front of the lens or it may reach the film after multiple reflections. Light also may be reflected from internal parts of the lens mount or from the bellows or other internal surfaces of the camera. The non-image forming light that reaches the film may be in the form of generally uniform flare over the entire film area, localized areas of flare or identifiable shapes called ghost images (Fig. 117). Uniform flare is the least obvious of the three, but it can be damaging to the quality of the photographic image. Overall contrast is reduced, but most of the loss of contrast occurs in the thinner areas of the negative (Fig. 118). Increasing development of the negative or printing the negative on a higher contrast grade of paper does not cancel out the effect of the non-image forming light, although such changes generally result in an improvement in the appearance of the print.

Controlled "coating" of the glass-air surfaces of lenses with magnesium fluoride or other suitable material greatly reduces the amount of non-image forming light that reaches the film. By blackening the internal parts of the lens barrel and introducing baffles, lens designers have reduced the danger of reflections from these areas, and using an efficient lens shade will reduce the amount of light that is allowed to enter the camera from outside the field of view. Even if all other sources of non-image forming light could be controlled, some of the image forming light that falls on the film will itself be reflected about inside the camera, a small portion of which will again reach the film as non-image forming light. Thus, the choice between a white background and a black background for a subject will influence the flare factor. The flare factor is the ratio of the luminance range of the subject to the illuminance range of the image. (The complete absence of flare would result in a flare factor of 1.0,) A significant amount of non-image forming light reaching the film can, in addition to degrading the image, complicate the problem of exposing the film correctly with materials that have little exposure latitude.

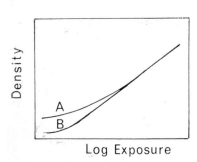

Fig. 118. Flare curve (A) reveals how flare light has the largest effect on the thinner areas of the negative

Fig. 119. The *f*-number is determined by dividing the focal length by the effective aperture

Effective Aperture

Focal Length

Apertures

Exposure of film in a camera is normally controlled by varying the time of exposure with the shutter and the intensity of the illumination with the diaphragm opening. The conventional method of calibrating the diaphragm opening is in terms of *f*-numbers, which are calculated by dividing the focal length of the lens by the effective aperture. (Fig. 119). The effective aperture, in turn, is the diameter of the beam of light entering the lens that will just fill the opening in the diaphragm. If the diaphragm is located in front of the lens, the effective aperture and the diaphragm opening will be the same, but since the diaphragm is normally located between the elements of the lens, entering light is refracted before passing through the diaphragm opening (Fig. 120). On new lenses the area of the opening in the diaphragm (and therefore the relative amount of light passing through the opening) can be assumed to be accurate to within plus or minus 10 per cent. Since image definition and depth of field are also affected by the size of the diaphragm opening, it is usually necessary to take these factors into account before selecting the combination of shutter speed and *f*-number that will be used to expose the film.

The following numbers represent "whole stops" in the standard series of *f*-numbers: *f*0.7, 1.0, 1.4, 2.0, 2.8, 4, 5.6, 8, 11, 16, 22, 32, 45, 64, 90, 128. A typical professional quality lens will have considerably fewer than the 16 stops listed above—usually in the proximity

Fig. 120. The effective aperture is the diameter of the entering beam of light that just fills the diaphragm opening. The effective aperture and the diaphragm opening are the same only when the diaphragm is situated in front of the lens

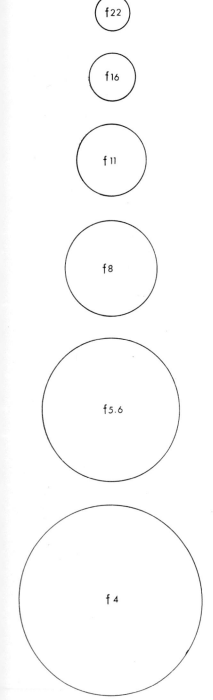

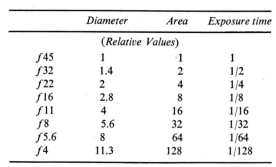

APERTURES AND EXPOSURE TIMES

	Diameter	Area	Exposure time
	(Relative Values)		
ƒ45	1	1	1
ƒ32	1.4	2	1/2
ƒ22	2	4	1/4
ƒ16	2.8	8	1/8
ƒ11	4	16	1/16
ƒ8	5.6	32	1/32
ƒ5.6	8	64	1/64
ƒ4	11.3	128	1/128

of 7 stops. The area of the diaphragm opening and, therefore, the amount of light transmitted both change by a factor of 2 with each whole stop, decreasing as the *f*-number increases. The interrelationship of effective aperture size, *f*-number, area of the effective aperture and corresponding exposure time are shown in Fig. 121.

More precise control of exposure is occasionally needed than is permitted with whole stops. Exposure meter scales and dials are normally subdivided into one-third stops. Intermediate *f*-numbers are not marked on the *f*-number scales on lenses, but one-third or one-half stops may be indicated by dots or lines. In the absence of intermediate markings on the scale, the photographer must estimate the settings. Most shutters, however, are not designed to be used at intermediate settings, so that small changes in exposure must be made by changing the *f*-number setting.

Exposure times corresponding to two different *f*-numbers can be determined by multiplying or dividing (depending upon the direction of change) the exposure time by a factor of 2 for each whole stop, or by referring to the calculator dial on an exposure meter for either whole stops or the standard subdivisions. When it is necessary to make use of mathematical calculations, the following formula establishes the relation between *f*-number (*f*N) and exposure time (T).

$$\frac{T_1}{T_2} = \frac{(fN_1)^2}{(fN_2)^2}$$

Maximum diaphragm openings occasionally do not correspond

to a whole stop $-f7.7$ for example. We can apply the above formula to find the ratio of exposure times that correspond to $f7.7$ and the next whole stop, $f8$.

$$\frac{T_1}{T_2} = \frac{(7.7)^2}{(8)^2} = \frac{59.29}{64} = \frac{1}{1.08}$$

Thus, $f8$ transmits 8% less light than $f7.7$, which is smaller than the allowable plus or minus 10% manufacturing tolerance.

Other calibrations of diaphragm openings than the conventional f-number series listed above will be found on some lenses. Older lenses may be encountered that have been calibrated according to systems that are now obsolete, such as the Uniform Standard System which uses 1, 2, 4, 8, 16, etc. as numbers representing whole stops. The Continental series is similar in progression to the conventional f-number series, but the numbers that represent whole stops are $-$ $f1.1$, 1.6, 2.2, 3.2, 4.5, 6.3, 9, 12.5, 18, 25, 36, etc. No change in procedure is necessary when using a lens marked with the Continental series.

Some lenses have been calibrated in Aperture Values in accordance with the Additive System of Photographic Exposure (APEX), which it was once thought would replace other systems. The following table relates Aperture Values (A_V) and f-numbers. Lenses calibrated with Aperture Values are normally calibrated with the conventional f-numbers also.

A_v	$-$	0	1	2	3	4	5	6	7	8	9	10	11
fN	$-$	1	1.4	2	2.8	4	5.6	8	11	16	22	32	45

T-stops

Two lenses set at the same f-number and used under identical conditions may produce images that differ considerably in illumination due to loss of light through reflection and absorption in one of the lenses. Since f-numbers do not take this factor into account, underexposure of the film will result when the shutter speed is selected on the basis of the marked f-number and a significant amount of light is lost in passing through the lens. Lenses calibrated in accordance with the T-stop system are free of this source of exposure error,

since the T-numbers are based on the actual transmittance of the lens. Thus, any two lenses calibrated in T-numbers will produce the same image illuminance when used under identical conditions. Very simply, a lens with a maximum diaphragm opening marked $f5.6$ with the relative aperture system would be calibrated T-8 with the T-stop system if 50% of the incident light is lost in transmission. The exposure *time* is then selected for $f8$ for the T-8 calibration, which will be twice as long as the time indicated for $f5.6$ with the relative aperture calibration. The longer exposure time used at the T-8 setting will exactly compensate for the amount of light lost.

Variations in transmittance of lenses at the same f-number are seldom large enough to be of concern in the production of most black and white, and even colour, photographs, but such variations can cause difficulty in situations where exposure tolerances are small. With the introduction of coated lenses in 1938, loss of light due to reflection from lens surfaces was reduced, but some modern, coated lenses, containing a large number of elements, may still transmit less than 50% of the incident light.

Effective f-numbers

A second inherent shortcoming of the f-number system is that it is based on an image distance equal to the focal length of the lens. Changing the lens-to-film distance, either as a result of altering the subject to camera distance or of adding a supplementary lens, makes the marked f-number on the lens an inaccurate control over the film exposure. The *effective* f-number can be thought of as a corrected f-number that takes into account changes in lens to film distance as the T-number compensates for loss of light in being transmitted through the lens. Lens manufacturers cannot simply substitute effective f-numbers for the conventional f-numbers on the lens mount because the relationship varies with every change in lens-to-film distance.

Cameras are available that automatically open the diaphragm to compensate for increases in image distance resulting from focusing on close subjects, but with conventional lenses the photographer must make the adjustment. The effective f-number can be determined by multiplying the marked f-number (fN) at which the aperture

pointer is set by the ratio $\dfrac{\text{Image Distance}}{\text{Focal Length}}$ That is

$$\text{Effective } f\text{N} = f\text{N} \times \frac{v}{f}$$

To illustrate, if the aperture on an 8-in. focal length lens is set at $f11$ and the bellows extension is 16 in. the effective $f\text{N} = 11 \times 16/8 = 22$. Thus, the increase in the bellows extension has resulted in the lens acting as though it is set at $f22$ even though it is actually set at $f11$, and the exposure time should be based on $f22$ rather than $f11$. Observe that when the camera is focused on infinity, the image dis-

Fig. 122. Addition of a positive supplementary lens does not appreciably affect image illumination if lens to film distance remains unchanged

tance is equal to the focal length, reducing the ratio $\dfrac{v}{f}$ to 1, and the effective f-number becomes equal to the (marked) f-number.

Supplementary lenses and effective f-numbers

Adding a supplementary lens to a camera lens affects the image illumination at the film only if it is accompanied by a change in the lens to film distance. Thus, if a camera is focused on infinity, a positive supplementary lens is added, and the subject is placed at the front principal focal point of the supplementary lens (as illustrated in Fig. 122) the image will be in focus and the marked f-number will be accurate. With *positive* supplementary lenses, the new lens-to-film distance can be larger, the same as, or smaller than the camera lens focal length. As a result, the effective f-number can be larger, the same as, or smaller than the marked f-number, If the lens-to-film distance is changed, the effective f-number can be computed with the same formula used above for close objects —

$$\text{Effective } f\text{N} = f\text{N} \times \frac{v}{f}$$

Note that f still refers to the focal length of the camera lens, not the combination.

Negative supplementary lenses produce an increase in the focal length. As a result, the image distance with the combined lenses is

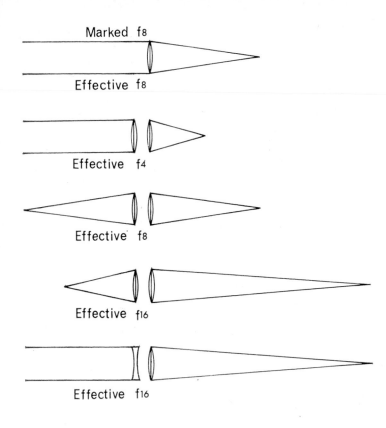

Marked f8

Effective f8

Effective f4

Effective f8

Effective f16

Effective f16

Fig. 123. Comparison of the marked f-number and the effective f-numbers with a positive supplementary lens (with the subject at three different distances) and with a negative supplementary lens

always greater than the focal length of the camera lens alone, and the effective f-number is always larger than the marked f-number. Figure 123 shows how the addition of a positive supplementary lens (with the subject at three different distances) and the addition of a negative supplementary lens alter the effective f-number.

Shutters

Shutters are called upon to perform three important functions in exposing film in a camera. In conjunction with apertures, they control the total amount of light received by the film. In controlling the time of exposure, they determine the motion stopping characteristics of the image. Additionally, shutters can be constructed to close an electrical circuit at the appropriate time to synchronize flash with the shutter opening.

The conventional series of shutter exposure time markings used on between-the-lens shutters in the past has been—1, 1/2, 1/5, 1/10, 1/25, 1/50, 1/100, 1/200 (or 1/250), and 1/500 second. There are many variations in the number of exposure time selections and in the shortest time on different shutters. On earlier cameras, only focal plane shutters had exposure times shorter than 1/400 or 1/500 second but between-the lens shutters are now available with times as short as 1/1000 second.

Another series of exposure time markings is now being used that

Fig. 124 *(top to bottom)*. The amount of light transmitted through a lens increases as the shutter blades open, until the diaphragm or lens barrel is completely uncovered

has the advantage over the above series of consistently changing the exposure time by a factor of 2 between adjacent settings. This series makes it possible to change the shutter and aperture settings simultaneously without changing the exposure of the film. Time values for use with the Additive System of Photographic Exposure are marked on some lenses in addition to the conventional exposure time markings. The equivalent numbers used in the two systems are listed below

T_v — 0 1 2 3 4 5 6 7 8 9 10
Time — .1–1/2–1/4–1/8–1/15–1/30–1/60–1/125–1/250–1/500–1/1000

Effective exposure times

There are differences between the *effective* exposure times and the exposure times marked on the lens mounts of between-the-lens shutters under some circumstances, just as there are differences between *effective* f-numbers and marked f-numbers. Because of the intricate mechanism in a typical shutter, it is subject to a certain amount of mechanical error. Such errors can be detected with appropriate testing equipment and adjustments can be made or the photographer can compensate for any significant errors.

Apart from such mechanical errors, the effective exposure time also varies at a given shutter setting as the diaphragm is stopped down. This change occurs because the shutter blades are incapable of completely uncovering and completely covering the diaphragm opening instantaneously (Fig. 124). Shutters are normally calibrated so that the marked exposure time is equal to the effective exposure time at the maximum diaphragm opening. To achieve this equality, the marked exposure time must correspond to the time elapsing between the half open and the half closed positions of the shutter blades (Fig. 125). Thus, at a marked exposure time of 1/100 second, it requires longer than 1/100 second for the shutter to go from the completely closed position, open, and back to the completely closed position. This time in excess of 1/100 second allows enough extra light to be transmitted to exactly compensate for the fact that the diaphragm opening is completely uncovered for something less than 1/100 second (Fig. 126).

If lenses were always used at their maximum diaphragm openings

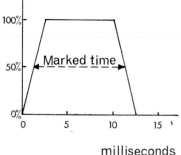

milliseconds

Fig. 125. Shutter curve for a typical between-the-lens shutter

there would be no problem, but as a lens is stopped down the smaller opening is uncovered sooner and stays uncovered longer. Thus, a point is reached, for example, where the diaphragm opening is completely uncovered when the shutter blades reach their half open position (Fig. 127). The diaphragm opening is now transmitting its full quota of light for 1/100 second, and in addition, light is being transmitted during the time in excess of 1/100 second that the shutter blades are partially open. The additional light is unwanted and causes the film to be overexposed unless compensated for. In extreme situations it can result in the film receiving almost twice as much light as it was intended to receive on the basis of the marked exposure time on the lens mount.

A simple practical test will reveal the extent of the discrepancy between the marked and the effective exposure times. Make a negative of a subject in sunlight on an ASA 400 film at settings of 1/400 or 1/500 second and $f16$ (or 1/200 or 1/250 second and $f22$ if the shutter does not have a higher speed). Open the diaphragm to the largest whole stop and add one or more neutral density filters having a total density of 0.3 for each stop opened up—e.g., ND 0.9 for opening up three stops from $f16$ to $f5.6$. Expose a second film at the same shutter setting. Even though the neutral density filter will exactly compensate for the greater transmittance at the larger diaphragm opening, the negative exposed at the smaller opening without the filter will be denser due to the longer effective exposure time at the smaller diaphragm opening.

Flash synchronization

Flash-synchronized shutters are designed to close the electrical circuit to the flash at the appropriate time so that the shutter will be fully open when the flash reaches its peak light output.

Synchronizing devices vary in complexity with the amount of versatility required. A shutter that is to be synchronized only with electronic flash (X-synchronization) can produce positive synchronization at any shutter speed with a simple electrical contact that is closed when the shutter blades reach their fully open position because there is no significant delay between closing the circuit and the peak output of light (Fig. 128). This type of synchronization can also be used with the various classes of expendable flashlamps that

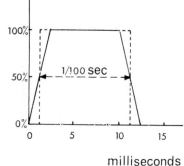

milliseconds

Fig. 126. Comparison of a theoretically perfect shutter (dashed line) and a typical between-the-lens shutter

90

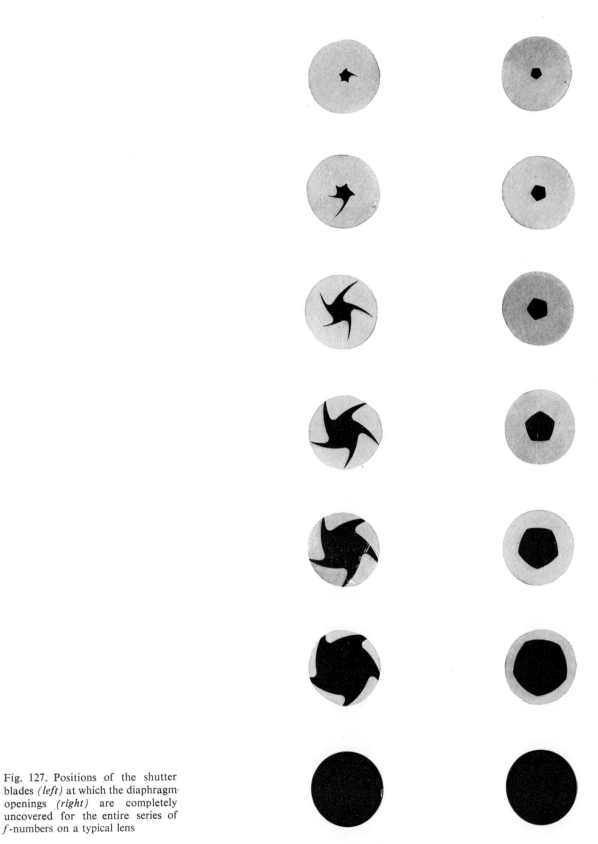

Fig. 127. Positions of the shutter blades *(left)* at which the diaphragm-openings *(right)* are completely uncovered for the entire series of f-numbers on a typical lens

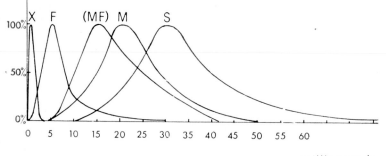

Fig. 129. Curves for electronic flash and four classes of flashlamps

milliseconds

have delays between closing the circuit and peak light output of 5 milliseconds (class F), 14–20 milliseconds (class M), and 30 milliseconds (class S), by using a slow shutter speed, which allows the shutter to remain open long enough to catch most of the light (Fig. 129). This requires an exposure time as long as 1/10 second with the longer-delay flashlamps, and is approaching the open flash technique used with non-synchronized shutters with which the shutter is held open on the "bulb" or "time" setting while the flashlamp circuit is closed manually with a separate switch.

Since flash is frequently used in situations where there is considerable existing light, use of long exposure times to catch the flash is unsatisfactory. Shorter exposure times are also needed for action-stopping purposes. To synchronize the shutter with flashlamps at short exposure times, a mechanism must be incorporated to delay the opening of the shutter by an appropriate length of time to catch the peak of the flash (Fig. 130).

The most common types of synchronized shutters on view camera lenses are X and XM. Shutters have been made with the following types of synchronization: (one point) X, F, and M, (two point) XF, XM, and FM, (three point) XMF, and *full* synchronization with variable delay up to 25 or 30 milliseconds. Some shutter manufacturers, however, use the term "full synchronization" as a designation for XM-type synchronization. X-type synchronized shutters with colour-coded exposure time markings to indicate the settings that can be used with flashlamps are designated as type XS.[1]

It is sometimes assumed that because of the short duration of the light from electronic flash tubes, none of the light can be cut off by the shutter, and the guide number will remain constant at all exposure time settings. Although duration times of 1/2,000 second and shorter were typical of early electronic flash units, longer duration times have been designed into some of the newer units in an effort to minimize reciprocity effects. The longer flash duration, the shorter exposure times that are possible with some shutters, and synchronization that closes the circuit when the shutter is in the fully open position, make it possible for the shutter blades to close soon enough to prevent some of the light from reaching the film. A test made with

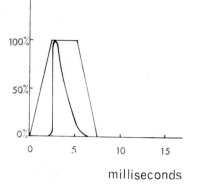

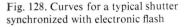

Fig. 128. Curves for a typical shutter synchronized with electronic flash

[1] *Criteria for Classifying and Testing the Internal Synchronization of Front Shutters*, PH3.18–1957, American National Standards Institute.

92

Fig. 130. Delay required in opening shutter to catch peak light output of flashlamp

SHUTTER DELAY

Fig. 131. Resolving power test target mounted on a motor to test motion stopping characteristics of shutter and electronic flash. (Motor stopped)

(Right). 1/500 second shutter setting (1/330 actual) with tungsten illumination

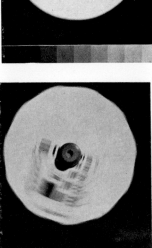

Professional type electronic flash illumination with shutter set at 1/25 second *(left)* and 1/500 (1/330) second *(right)*. Decreased blur and darker print image on photograph on the right indicates cutoff of illumination at the higher shutter speed setting

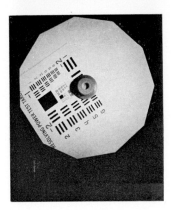

The low power setting on the electronic flash power pack produces a shorter flash duration with a corresponding decrease in image blur *(left)*

Three microsecond duration of electronic flash unit designed for scientific and technical applications makes spinning target appear stopped *(right)*

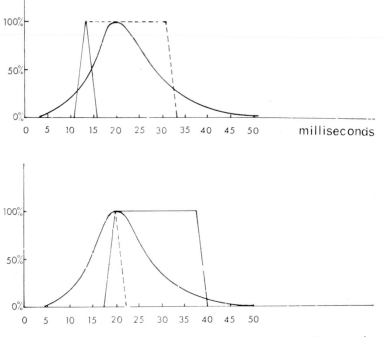

Shutter that is correctly synchronized at a high shutter speed will not be effectively synchronized at a slow shutter speed

one professional type electronic flash unit revealed that only 59 % of the light was transmitted at 1/500 second, compared to 1/100 second and slower speeds — at the maximum aperture. The cut off of light by the shutter blades decreases, however, as the lens is stopped down (Fig. 127).

Class M flash lamps have a duration at half peak of approximately 1/75 second — long enough to allow changes in exposure time settings to affect the amount of light transmitted except at settings of 1/25 second and longer. The change in transmitted light is not proportional to the change in exposure time, since the light from the flash lamp varies in intensity with time, as shown on time-light curves. Changing the exposure time setting from 1/30 second to 1/500 second reduces the light from a continuous source to approximately 1/17, but it reduces the light from flash lamps to approximately 1/4. Thus, to obtain maximum action-stopping ability with a flash lamp, the shutter must be set for a short exposure time; to obtain the maximum amount of light, it must be set for a long exposure time. Most shutters will not provide optimum synchronization at both 1/30 and 1/500 second because the shutter opens at the same time at both settings and the closing time is altered. As a result, synchronizing the shutter at either 1/30 or 1/500 second results in a loss of light at the other setting as illustrated in Fig. 132. Synchronizing the shutter for an intermediate exposure time prevents an excessive loss of light at either the short or the long settings. Shutters with a fully adjustable delay can be synchronized correctly at all exposure time settings.

10" (Stopped down)

10"

8"

6½"

4"

6½"

5"

4

TYPES OF LENSES

Lenses for view cameras are often classified under three headings — normal, telephoto, and wide-angle. Normal lenses are designed for general purpose photography. In some respects they are compromises, in that they are intended to perform adequately in a variety of situations rather than ideally in limited situations. Different connotations are attached to the word "normal" in relation to various photographic fields such as architecture, press, and portraiture.

Focal length is one of the more important factors considered by photographers in selecting lenses. A standard focal length lens for general purpose photography is often expressed as a lens whose focal length is equal to the film diagonal. This relationship is satisfactory for non-view cameras, but since the diameter of the circle of good definition is generally about equal to the focal length, such a lens will just adequately cover the film on a view camera when the adjustments are zeroed. The circle of good definition may increase sufficiently when the lens is stopped down to permit moderate use of the lens and back adjustments, but a longer focal length lens is more satisfactory. To illustrate, the diagonal of 4×5-in. film is approximately $6\frac{1}{2}$ in., but 8 to 10-in. focal length lenses are considered standard for view cameras using this size film. Standard lenses for 4×5-in. press cameras range from $5\frac{1}{4}$ to $6\frac{1}{2}$ in. (Fig. 133.). Maximum apertures on normal type view camera and press camera lenses generally range from *f*4.5 to *f*6.8. Image definition is adequate at large openings, but improves as the lens is stopped down, especially toward the corners of the film. Two or three lines of normal lenses, with variations in

Fig. 133. Circle of good definition and focal length for typical lenses of normal design

95

Image Nodal Plane

Fig. 135. Location of image nodal
plane with telephoto lens

Fig. 134. Basic telephoto lens design

degree of correction of aberrations, maximum aperture, and price are produced by some lens manufacturers. A choice is often given between barrel mounting (without shutter) and with shutter.

Telephoto lenses

Telephoto lenses are characterized by having a shorter lens to film distance than a normal lens of the same focal length. This is the only advantage telephoto lenses have over normal lenses. If two negatives are made under identical conditions, one with a 10-in. focal length *normal* type lens and the other with a 10-in. *telephoto* type lens, the two negatives can be superimposed and the images will coincide in all parts in the absence of aberrations.

Long focal length lenses of normal construction are sometimes incorrectly referred to as telephoto lenses. Long focal length lenses are used when a larger image is desired than is produced with a normal focal length lens from a given camera position. It is not necessary to change to a telephoto type construction when substituting a longer focal length lens unless the increased lens to film distance required with the conventional lens cannot be accommodated (because of limitation of the bellows extension on the camera) or because of objection to the increased bulkiness of the camera with the bellows extended.

Telephoto lenses have a classic basic structure (Fig. 134) that results in the placement of the image nodal plane in front of the lens (Fig. 135) rather than within the body of the lens. A positive element is always located in front of a negative element separated by a space. Additional elements are used to minimize aberrations. Both the front and back components may contain a positive and a negative element, as illustrated in Fig. 136, but the front component must have a converging effect and the back component a diverging effect. Image definition with early telephoto lenses was inferior to that of conventional lenses, but the gap has been narrowed with telephoto lenses of modern design.

The lens formulae and terms presented previously apply to all lenses, regardless of their design. Care must be used, however, to measure image distance to the *image nodal plane* with telephoto lenses. This also applies when calculating the effective *f*-number or

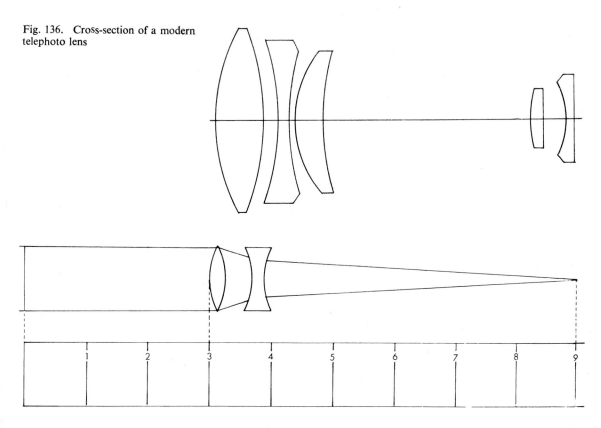

Fig. 136. Cross-section of a modern telephoto lens

the bellows factor when photographing objects that are close to the lens. The image nodal point for a telephoto lens can be located by the technique described — focusing the lens on a distant object and pivoting the lens at various points along the lens axis until the image does not move. (It will be difficult to pivot the lens about a point in front of the lens unless it is placed in a "nodal slide", which is a long lens-supporting device that can be pivoted at various points along its length.) Assuming the marked focal length on the lens mount is accurate, however, the image nodal point can be located by focusing the lens on a distant object and then measuring one focal length from the image, forward along the lens axis (Fig. 137). If the image nodal point is found to be 3 in. in front of the front surface of the lens, for example, all image distances can be determined by measuring to the front surface of the lens and adding 3 in.

Fig. 137. Method for determining the position of the image nodal plane with a telephoto lens

A knowledge of the lens board to film distance with telephoto lenses is often useful since the actual bellows extension is the limiting factor that determines the maximum focal length lens that can be used and the minimum object distance the camera can be focused on with a given lens. The distance from the image of a distant object to the lens flange is referred to as the *flange focal distance*. A 10-in. focal length telephoto lens may have a flange focal distance of 7 inches, for example.

Reference is made occasionally to the "power" of a telephoto lens. Power refers to the ratio of the focal length to the *back focal distance*, which is the distance from the image of a distant object to

97

Fig. 139. Equivalent focal length,
flange focal distance, and back focal
distance of a telephoto lens compared
with a normal lens having the same
focal length

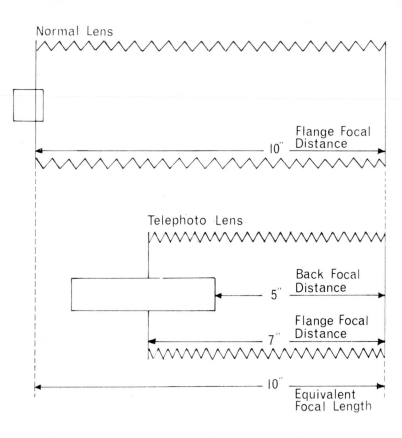

Fig. 138. Back surface of telephoto
lens *(bottom)* extends farther behind
the lens board than the normal lens
(top)

the back surface of the lens. This information is of little value to the photographer since the back surface of telephoto lenses usually extend farther behind the lens board than normal lenses (Fig. 138). A more meaningful indication of the telephoto effect of a lens is the ratio of the focal length to the flange focal distance. Thus, with telephoto lenses, image size and angle of view are related to the equivalent focal length (as with all lenses), the bellows extension is related to the flange focal distance, and the telephoto effect is found by dividing the equivalent focal length by the flange focal distance (Fig. 139).

Wide-angle lenses

Wide-angle lenses are characterized by having greater covering power than normal lenses of equal focal length. Since covering power is measured in terms of the diameter of the circle of good definition and the angle of coverage, both of these factors will be large with wide-angle lenses. The diameter of the circle of good definition will be considerably larger than the focal length and the angle of coverage will be considerably larger than 53°, the angle produced when the diameter of the circle of good definition is equal to the focal length. The establishment of a limiting value to separate wide-angle lenses from normal lenses would be arbitrary. Some lens manufacturers classify lenses with an angle of coverage of 65°, only 12° higher than the 53° that can be expected with normal lenses, as wide-angle

98

lenses. Angles of 80° to 100° are more representative of this type of lens, and lenses with an angle of coverage up to 180° are now mass produced.

Excessive fall-off in illumination, as well as definition, toward the corners of the film must be avoided in designing wide-angle lenses. There is no classic basic structure for wide-angle lenses as with telephoto lenses, but the problem of vignetting is minimized by limiting the thickness of the lens and by increasing the size of the elements with their distance from the diaphragm (Fig. 141). The conventional controls of lens designers, choice of glass, shape, arrangement, and spacing of elements, are employed to obtain acceptable definition over a larger image area. Image definition in the centre of

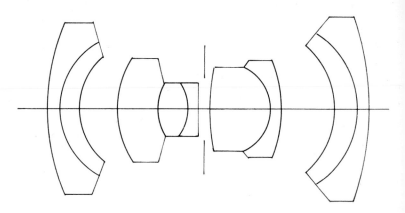

Fig. 141. Cross-section of a modern wide-angle lens

Fig. 142. More severe vignetting occurs with a telephoto lens *(bottom)* than with a wide-angle lens *(top)* when viewed at the same angle

the field may be compromised and the aperture may be restricted to obtain the increased angle of coverage. Older wide-angle lenses usually do not produce images with acceptable definition at larger apertures than $f11$ or $f16$, although larger apertures were often provided to assist the photographer in focusing and composing the image on the ground glass. Some wide-angle lenses of recent design are capable of producing excellent images at their maximum apertures, and there is as little as one stop difference in the maximum aperture of these lenses and comparable normal type lenses.

Wide-angle lenses are used in preference to normal type lenses for one of two reasons. Either the normal lens does not have sufficient covering power to produce an acceptable image to the edges of the film when the camera lens and back adjustments are used, or a smaller image and wider angle of view are desired from a certain camera position than is produced with the normal lens, and a shorter focal length normal type lens will not cover the entire film. Only in the second situation is it necessary to switch to a shorter focal length lens. Thus it is incorrect to apply the term "wide-angle" to all short focal length lenses, or to restrict use of the term to lenses with shorter focal lengths than the corresponding film diagonals.

It is possible to predict with sufficient accuracy whether a specific wide-angle lens will have sufficient covering power to use the full adjustments on a specific view camera. If a 4×5-in. view camera has a 3-in. rising front adjustment, the diameter of the circle of good definition must be 6 in. larger than the film diagonal. This will allow the lens to be raised, lowered, or shifted laterally any distance up to 3 in., or slightly more if the revolving back is not used (Fig. 143). In other words, the lens must have a $12\frac{1}{2}$-in. circle of good definition. If, by tilting the bed of the camera up and using a combination of front and back tilt adjustments and rising front, the lens can in effect be raised 8 in. above the centre of the film, a circle of good definition 16 in. larger than the film diagonal (or $22\frac{1}{2}$ in.) will be required.

The covering power requirements of a lens for full use of the tilt and swing adjustments can be determined more readily in terms of angle of coverage than circle of good definition. If the tilting lens adjustment on the view camera allows the lens board to be tilted 25° in each direction, the angle of coverage of the lens must be $2 \times 25°$,

Fig. 143. Use of a 3 inch rising front adjustment *(left)* requires an increase of 6 inches in the diameter of the circle of good definition

(Above) Effect of raising 6½ inch and 12½ inch focal length lenses 3 inches with 4 × 5 inch film

or 50° larger than required with the lens in the zero position. With a lens having a focal length equal to the film diagonal, the required angle of coverage is 50°+53° = 103° (Fig. 144).

Complications may be encountered with the shorter focal length wide-angle lenses due to the closeness of the lens to the film. Some view cameras are constructed in such a way that the lens board cannot be brought closer than 3 in. or so to the film. It may be impossible to focus on distant subjects with very short lenses on such cameras, and use of the camera adjustments may be seriously interfered with when even moderately short focal length lenses are used. There are several methods of overcoming these difficulties.

1. Recessed lens boards place the lens closer to the film than the lens board frame, and thus relieve pressure on the bellows which restricts use of the adjustments.

2. Lens boards with off-centre holes for the lenses duplicate the effects of rising-falling front and lateral shift without using these adjustments on the camera. Displacement of the lens from the normal position is fixed, but the lens board can be placed on the camera in four different positions to vary the direction of displacement of the lens.

3. A modification of the off-centre hole is a lens board with an elongated hole that allows adjustment in the displacement of the lens.

4. An optical solution to the short lens-to-film distance problem is the *reversed-telephoto wide-angle* lens which is designed so that the

101

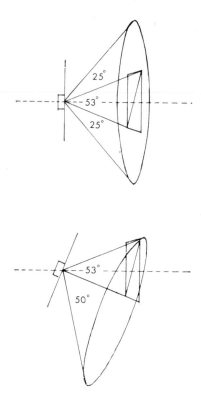

Fig. 144. Use of a 25 degree tilting lens adjustment requires an increase of 50 degrees in the angle of coverage of the lens

image nodal plane is behind the lens, resulting in a large lens-to-film distance in comparison with the focal length. This is achieved by reversing the principle of telephoto lenses and placing a diverging group of elements in front of, and separated from, a converging group, as illustrated in Fig. 145. This type of lens has been used mostly for motion picture and small reflex cameras where shutter mechanisms and movable mirrors prevent the use of conventional short focal length lenses.

Specialized lenses

In addition to the three basic types of lens — normal, telephoto, and wide-angle — lenses are sometimes classified under various other headings on the basis of their design or intended use.

Since good photographic lenses are expensive, many attempts have been made over the years to introduce economies by making one lens do the work of two or more. The most successful efforts in this direction have been supplementary lenses, convertible lenses, and variable focal length lenses. Increasing the versatility of lenses often requires compromises that result in a loss, such as a decrease in image definition, but it should not be assumed that this always happens. The use of a supplementary lens can, in certain circumstances, even bring about an improvement in image definition and speed of a camera lens.

Supplementary lenses

The addition of a supplementary lens to the front of a camera lens has the effect of changing the focal length. Converging supplementary lenses decrease, and diverging supplementary lenses increase the focal length. An 8-in. focal length camera lens can be converted into the equivalent of a 5-in. or a 21-in. focal length lens, for example, by the addition of converging or diverging 13-in. focal length supplementary lenses respectively. The focal length of the combined

Fig. 145. Basic design of reversed-telephoto wide-angle lenses *(upper)*

Location of image nodal plane with reversed-telephoto wide-angle lens *(lower)*

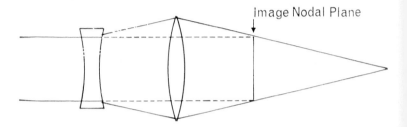

Image Nodal Plane

camera and supplementary lenses can be determined with reasonable accuracy with the following formula:

$$\frac{1}{f_c} = \frac{1}{f} + \frac{1}{f_s}$$

where f_c is the focal length of the combined lenses.

f is the focal length of the camera lens.

f_s is the focal length of the supplementary lens.

In the preceding example, converging (+) and diverging (−) 13-in. focal length supplementary lenses were used with an 8-in. focal length camera lens. Substituting these values:

$$\frac{1}{f_c} = \frac{1}{8} + \frac{1}{13} \qquad \text{and} \qquad \frac{1}{f_c} = \frac{1}{8} + \frac{1}{-13}$$

$$\frac{1}{f_c} = \frac{21}{104} \qquad\qquad\qquad \frac{1}{f_c} = \frac{5}{104}$$

$$f_c = 5 \text{ in. (approx.)} \qquad\qquad f_c = 21 \text{ in. (approx.)}$$

The power of supplementary lenses is often expressed in diopters (D), as 3+ and 3−, for example. Focal length in meters equals $\frac{1}{D}$. For a 3-diopter supplementary lens, $f_s = \frac{1}{3}$ meter = 333mm = 13 inches (approx.).

Inexpensive supplementary lenses can be expected to introduce aberrations to the system, and thus to have an adverse effect on

image definition. Stopping the lens down minimizes the aberrations and may improve the definition to a very acceptable level. As the quality of supplementary lenses is improved by increasing the number of elements, the price tends to increase, nullifying the major advantage of a supplementary lens over purchasing another focal length camera lens. (Highly corrected supplementary lenses are made for some cameras that cannot accommodate interchangeable lenses.) A second camera lens can sometimes be used as a supplementary lens with good results. For close-up photographs, a supplementary lens may produce more satisfactory results than the alternatives of substituting a short focal length lens, or extending the bellows with the standard focal length camera lens.

Camera lenses that are capable of producing excellent images at large to moderate distances often perform poorly when the subject is close to the camera. Lens designers assume that normal type lenses will be used at relatively great object distances and therefore minimize the aberrations for such conditions. Placing a converging supplementary lens in front of a camera lens with close-up objects causes the light rays to enter the camera lens as though they were coming from a more distant object. If the subject is placed at the front principal focal plane of the supplementary lens, the rays of light will leave the supplementary lens and enter the camera lens parallel, as though they came from an object at infinity (Fig. 122). Since the camera lens is in effect focused on infinity, the aberrations are minimized with respect to the camera lens. Attention must also be given to minimizing aberrations from the supplementary lens. This will be done quite effectively by turning a second camera lens around and using it as a supplementary lens. The light rays are then travelling through this lens at the same angles (but in the reverse direction) as when it is used alone in the normal way and focused on infinity. Thus the corrections built into the lenses are not sacrificed.

We have already noted under the heading "Supplementary lenses and effective f-numbers" that an additional advantage of using supplementary lenses in this way is that the marked f-number on the camera lens remains accurate because the bellows are not extended. A slight exposure change may be necessary to compensate for light lost due to reflection and absorption in passing through the supple-

mentary lens. This loss is seldom more than the equivalent of one-quarter to one-third stop.

Supplementary lenses are used for three major reasons —

1. To obtain larger images of small objects, with converging supplementary lenses. The largest images of small objects are obtained by extending the bellows fully, using a short focal length lens, and adding a short focal length (large diopter number) supplementary lens.

2. To increase the angle of view with converging supplementary lenses. Converging supplementary lenses reduce the focal length of the camera lens and increase the angle of view, but difficulty may be encountered with limited covering power when the lens to film distance is decreased as is necessary to focus on subjects farther from the camera than the principal plane of the supplementary lens. Compensation must be made in the exposure for any increase or decrease in the bellows extension.

3. To obtain larger images from a given camera position with diverging supplementary lenses. Camera lens focal length and bellows extension are always increased with the addition of diverging supplementary lenses, thus requiring a corresponding increase in the exposure. The maximum camera bellows extension determines how much the focal length can be increased. Focal length of the combined lenses, of course, cannot exceed the maximum bellows extension of the camera even for distant subjects.

Convertible lenses

Convertible lenses are constructed so that parts of the lens can be removed to produce a change in focal length. If the front and back components are not symmetrical, it may be possible to have three different focal lengths by using each of the components separately in addition to their combined use in the complete lens. Longer focal lengths are obtained with the individual components, but the definition is not as good as with the complete lens. Definition is improved as the aperture is decreased, although the soft-focus effect obtained at large apertures is not displeasing with appropriate subjects. Few convertible lenses are now being made for view cameras, although

they have been popular in the past. (A modification of the convertible lens is the interchangeable front component. With this type of lens the focal length can be changed without a serious loss of definition, while retaining much of the economy of the convertible lens by using the same diaphragm, shutter, and back component. This type of lens is used on some 35mm cameras.)

Variable focal length lenses

Variable focal length or zoom-type lenses are designed to produce a continuous change in focal length between the limits. The basic principle involved in such lenses consists of changing the spacing between elements of a telephoto lens. Due to the difficulties involved in minimizing aberrations, changes in image illumination, and changes in focus — at all focal length settings — zoom-type lenses found their first wide acceptance in the motion picture and television fields where the moving image is not subjected to the same critical examination as still photographs. They were made available later for 35mm still cameras but are not really suitable for view camera photography where the emphasis is on quality of the image.

Close-up lenses

There are several types of lens that have been designed to produce optimum image definition at relatively small object distances. Process and macro camera lenses and enlarging lenses all perform best at close range. Process lenses are available in a wide variety of focal lengths. One lens manufacturer provides process lenses in focal lengths ranging from 4 inches to 70 inches. Maximum relative aperture is often around $f9$.

These lenses are widely used on process cameras in the field of photomechanical reproduction where good definition and uniformity of illumination are more important than lens speed. Relatively long focal length lenses have the advantages of producing more uniform image illumination and of being able to cover the larger sizes of film when necessary. Since the bellows is seldom a limiting factor on process cameras, lenses with focal lengths of two or more times the

film diagonal are normally used. Process lenses are used on view cameras when the maximum image definition is required.

Macro lenses are made primarily for use with 35mm cameras, but they can be easily adapted to view cameras for large-scale photo-macrographs. The standard focal length for this type of lens is approximately 2 in. Some macro lenses have provisions for automatically compensating for changes in the effective f-number as the image distance increases, and for reversing the lens when the object distance becomes so small that image definition is threatened with the lens in the normal position. A larger scale of reproduction can be obtained with a view camera equipped with a 2-in. focal length macro lens than with a longer focal length process lens, but difficulty will be encountered with limited covering power if an attempt is made to use it for anything except very close objects.

Soft-focus lenses

Photographers do not always require overall sharpness in their photographs. Various methods have been employed to limit definition of the image, such as placing diffusing attachments over the camera or enlarger lens, exposing at a large aperture to obtain a shallow depth of field, exposing at a slow shutter speed to obtain a blurred image due to subject or camera movement, etc. Soft-focus lenses have been used extensively for portraits and occasionally for other types of photographs. Since the soft-focus effect with this type of lens results from spherical aberration, the degree of diffusion can be controlled by adjusting the aperture. The attractiveness of images produced with soft-focus lenses is attributed to two characteristics. The image actually consists of an unsharp image superimposed over a sharp image, and the light areas of the subject are surrounded with light haloes on the photograph. Diffusing a sharp negative during printing results in dark haloes around the dark areas.

Lens testing

Many attempts have been made to devise a meaningful, objective method for testing lenses. Image definition is the characteristic of

107

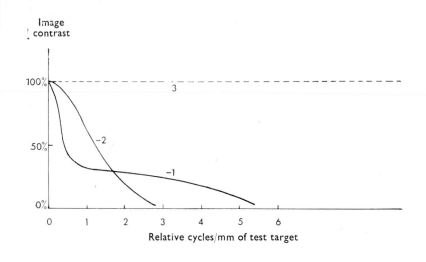

Fig. 146. Modulation transfer function curves for the photographs opposite (1 and 2) and for the ideal image (3). The contrastier type of picture *(far right)* frequently appears sharper, although the less contrasty picture shows greater resolution (*Carl Zeiss, Inc.*)

Image contrast

100%

50%

0%

3

-2

-1

0 1 2 3 4 5 6

Relative cycles/mm of test target

lenses that photographers seem to be most concerned about, although there are other factors that influence the usefulness of lenses that should not be ignored, such as uniformity of illumination across the image plane, distortion, accuracy of the marked focal length and the *f*-numbers, lens transmittance, the effect the lens has on the colour of the transmitted light, changes in position of sharpest focus as the lens is stopped down, and image contrast.

Even though the testing is limited to lens image definition, the situation is not so simple that the definition can be expressed by a single number. Definition varies considerably over the image plane from the lens axis to the edge of the circle of good definition. It also varies as the lens is stopped down, as the object distance changes, and with other miscellaneous factors.

Lens manufacturers have made use of test targets, visual examination of the aerial image of a point light source with a microscope, and more recently, electronic testing methods such as the modulation transfer function to evaluate image definition. Although experienced workers can gain considerable information about a lens with the first two methods and can use them as a basis for quality control to detect defective lenses, the introduction of electronic testing methods has provided quantitative methods of evaluating lens images that are essentially free from the influence of individual judgement (Fig. 146). The equipment necessary for electronic testing is complex and expensive. The value of modulation transfer curves (and other objective lens tests) to camera users is questionable except on a

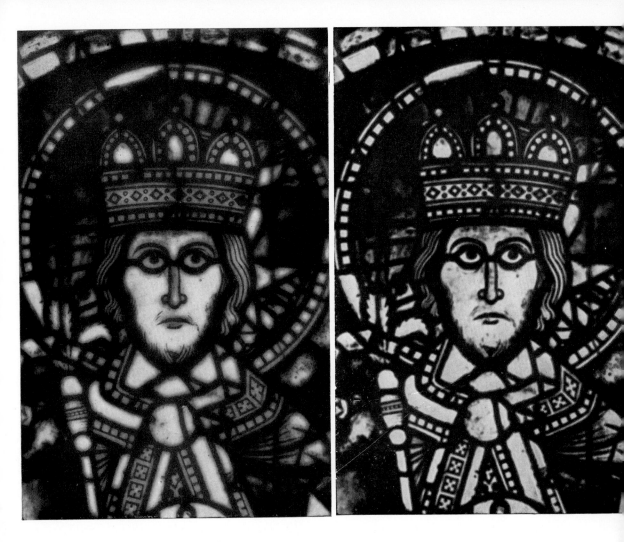

comparative basis since it is difficult to relate such curves to visual impressions of image definition.

Practical photographic tests of lens image definition by the photographer can be either valuable or meaningless, depending upon the conditions of the test. It is necessary to select a subject that is capable of revealing the desired information, and the other conditions of the test must be carefully controlled so that the results are not invalidated. Examining the image on the ground glass with a magnifier rules out the influence of other factors than the lens that affect image definition, such as film, exposure, processing, and printing. However, it is difficult to determine whether loss of definition seen through a magnifier on the ground glass is serious enough to be noticeable when the print or transparency is viewed under normal conditions. Since a print or transparency is the normal end product that is judged, the most meaningful test of a lens that can be administered by the photographer is one that includes the entire system and involves conditions as rigorous as are likely to be encountered in future use of the lens.

5

USING THE BELLOWS

Long bellows on cameras increase their versatility in two ways. First, they permit the use of lenses that vary in focal length over a wide range, and second, they allow the camera to be focused on objects over a wide range of distances. In terms of the photographic image, this flexibility provides the photographer with extensive control over image size, perspective, and depth of field.

Image size with distant objects

When photographing distant scenes, image size varies in direct proportion to lens focal length. A 12-in. focal length lens, for example, will produce twice as large an image as a 6-in. focal length lens. Using lenses of normal construction, limitations will be encountered with very long and with very short focal length lenses. A camera with a maximum bellows extension of 17 in. can focus a 17-in. focal length lens only on infinity, and longer lenses cannot be focused at all. The maximum bellows extension varies considerably among cameras. With cameras that have provisions for adding tandem supplementary bellows, a maximum extension of 40 in. and more can be obtained. A camera of this type can accommodate most available photographic lenses except for the longer (70-in., for example) process lenses.

Telephoto construction makes it possible to use longer focal length lenses than the maximum bellows extension on the camera. The flange focal distance must be known to determine if a telephoto lens can be used on a specific camera. Unfortunately this information is seldom published with the advertising literature for telephoto lenses, but it can be obtained by writing to the lens manufacturer, or it can be measured if the lens is available. The ratio of equivalent focal length to flange focal distance is often quite modest. One 15 in. focal length telephoto lens has a flange focal distance of 9.5 inches, for example, for a ratio of approximately 1.6 to 1. The *power* of telephoto lenses, which is often publicized, is based on the ratio of the equivalent focal length to the back focal distance rather than the flange focal distance. This results in a larger but meaningless number. The power of the 15-in. telephoto lens cited above is approximately 2.0 to 1.

110

Camera movement

There is more danger of obtaining a blurred image due to camera movement with the longer focal length lenses. Wind can cause a serious vibration of the camera unless it is securely anchored on a sturdy tripod. Even tripping the shutter with a cable release may cause the camera to move enough to affect the appearance of the image. With hand held 35 mm cameras, there is a rule of thumb that it is not safe to use an exposure time setting longer than the reciprocal of the focal length of the lens in millimeters. Thus a 16-in. (approximately 400mm) focal length lens would require use of an exposure time of 1/400 second. Since the depth of field is small with long focal length lenses, there is a tendency to use smaller apertures and corresponding longer exposure times. Photographers who have a need to use very long focal length lenses usually find it necessary to devise an especially sturdy support for the camera.

Range of image sizes

Unlike long focal length lenses, where bellows extension is the limiting factor, short focal length lenses are limited by covering power when focused on distant scenes. The shortest focal length lens of normal construction generally recommended for 4×5-in. cameras is approximately 6 inches, if lens and back adjustments are not needed. Three-inch focal length wide-angle lenses are capable of covering 4×5-in. film. If the camera will also accommodate a 30-in. focal length lens, the image size can be varied over a range of 1 to 10 from a fixed camera position (Fig. 147). Since 4×5-in. film is large enough to permit cropping and enlarging, the effective range is even larger — approximately 1 to 40 if an area on the negative equal to that of a 35mm negative can be enlarged.

Focal length limitations at close range

As the camera is moved toward the subject, the bellows extension limitation on *long* focal length lenses becomes more restrictive. At a 1 to 1 scale of reproduction, the image distance is double the focal

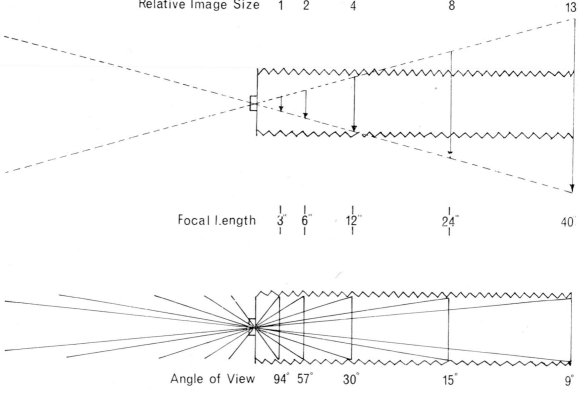

Relative Image Size 1 2 4 8 13

Focal Length 3" 6" 12" 24" 40"

Angle of View 94° 57° 30° 15° 9°

Fig. 147. Image size and angle of view ranges with various focal length lenses

length of the lens. Consequently, a camera that can accommodate a 30-in. focal length lens with distant scenes is limited to a 15-in. focal length lens of similar design for a 1 to 1 scale of reproduction. Conversely, the limitation on *short* focal length lenses becomes more liberal as the camera to subject distance decreases. If a 6 inch focal length lens will just cover 4×5 inch film when the camera is focused on a distant scene, a lens of half the focal length (3 in.) will have corresponding coverage when the camera is moved in for a 1 to 1 scale of reproduction where the object distance and the image distance are 6 in. As long as the bellows extension does not become smaller than 6 inches, any focal length lens of normal construction can be used, as illustrated in Fig. 148. This means, however, that the camera must be moved closer to the subject as the focal length becomes smaller to obtain adequate coverage.

Maximum scale of reproduction

Since the maximum scale of reproduction that can be obtained depends upon the bellows extension and the focal length, the limitations imposed by these two variables will be examined more closely.

The lens formula $R = \dfrac{v-f}{f}$ can be used to determine the maximum

112

Fig. 148. Short focal length lenses of normal construction have adequate covering power providing the lens to film distance remains at least as large as the film diagonal

Focal Length

Focused on Infinity

∞

scale of reproduction obtainable with given values for the lens focal length and bellows extension.

Scale of Reproduction and Bellows Extension. The following table shows the bellows extensions that are required to obtain various scales of reproduction with a $6\frac{1}{2}$-in. focal length lens, which is equal to the film diagonal of 4×5-in. film. Although it is theoretically possible to obtain as large an image as desired with this focal length lens by moving the camera closer to the subject and increasing the lens to film distance, it is obvious that the bellows extension becomes too large to be practicable as the scale of reproduction increases beyond 4 or 8 except with special cameras, such as the process type, that have unusually long bellows.

Object at 6"

SCALE OF REPRODUCTION AND BELLOWS EXTENSION FOR $6\frac{1}{2}$-IN FOCAL LENGTH LENS

Scale	Extension (in.)
1/16	7
1/8	$7\frac{1}{2}$
1/4	8
1/2	10
1	13
2	20
4	33
8	59
16	111

Object at 3"

Scale of Reproduction and Focal Length. It becomes necessary to substitute a shorter focal length lens when the bellows imposes a limitation on the use of the standard focal length lens for photo-macrography. The following table shows the relationship between focal length and the maximum scale of reproduction for a representative view camera that has a 20-in. bellows.

Object at 1.2"

V.C.T.—H.

MAXIMUM SCALE OF REPRODUCTION AND FOCAL LENGTH
(WITH 20-IN. BELLOWS)

Focal Length	Maximum Scale	Focal Length	Maximum Scale
19 in.	1/20	9	1.2
18	1/9	8	1.5
17	1/6	7	1.9
16	1/4	6	2.3
15	1/3	5	3.0
14	1/2.3	4	4.0
13	1/2	3	5.7
12	1/1.5	2	9.0
11	1/1.2	1	19.0
10	1	1/2	39.0

The following table shows the bellows extensions required for different scales of reproduction with the more popular view camera formats and corresponding standard focal length lenses.

SCALE OF REPRODUCTION AND BELLOWS EXTENSION
(WITH STANDARD LENSES)

Scale	Bellows Extension (in.) for film Size (in.) and *focal length* (in.)					
	11×14	8×10	5×7	4×5	$2\frac{1}{4} \times 3\frac{1}{4}$	$1 \times 1\frac{1}{2}$
	18	*13*	*$8\frac{1}{2}$*	*$6\frac{1}{2}$*	*4*	*2*
1/16	19	14	9	7	$4\frac{1}{4}$	$2\frac{1}{8}$
1/8	20	15	10	$7\frac{1}{2}$	$4\frac{1}{2}$	$2\frac{1}{4}$
1/4	23	16	11	8	5	$2\frac{1}{2}$
1/2	27	20	13	10	6	3
1	36	26	17	13	8	4
2	54	39	26	20	12	6
4	90	65	43	33	20	10
8	162	117	77	59	36	18
16	306	221	145	111	68	34

Focal Length and Object Distance. Shorter focal length lenses, as illustrated in the table above, have the advantage of being capable

of producing larger images with a limited bellows extension. There are, however, three disadvantages involved in using lenses that are considerably shorter than necessary to obtain the desired scale of reproduction. First, the circle of good definition may not be large enough to cover the film, especially if the camera adjustments are used. Secondly, the camera may have to be placed so close to the subject that it will interfere with lighting the subject, taking an exposure meter reading, and setting the shutter and diaphragm. Thirdly the perspective is often less attractive with three-dimensional subjects when the camera-to-subject distance is very small.

The following table shows the relationship between focal length and object distance for five different scales of reproduction ranging from 1 to 16. The advantage of the longer focal length lenses in providing more distance between the subject and the camera when making large scale photographs is evident.

SCALE OF REPRODUCTION AND FOCAL LENGTH
(OBJECT DISTANCE)

Focal Length (in.)	Object Distance (in.) for Scale of Reproduction				
	1	2	4	8	16
19	38	28	24	21	20
18	36	27	$22\frac{1}{2}$	20	19
17	34	25	21	19	18
16	32	24	20	18	17
15	30	$22\frac{1}{2}$	19	17	16
14	28	21	$17\frac{1}{2}$	$15\frac{1}{2}$	15
13	26	$19\frac{1}{2}$	16	$14\frac{1}{2}$	14
12	24	18	15	$13\frac{1}{2}$	13
11	22	$16\frac{1}{2}$	14	$12\frac{1}{2}$	12
10	20	15	$12\frac{1}{2}$	11	$10\frac{1}{2}$
9	18	$13\frac{1}{2}$	11	10	$9\frac{1}{4}$
8	16	12	10	9	$8\frac{1}{4}$
7	14	$10\frac{1}{2}$	9	8	$7\frac{1}{2}$
6	12	9	$7\frac{1}{2}$	7	$6\frac{1}{4}$
5	10	$7\frac{1}{2}$	6	$5\frac{1}{2}$	$5\frac{1}{4}$
4	8	6	5	$4\frac{1}{2}$	$4\frac{1}{4}$
3	6	$4\frac{1}{2}$	4	$3\frac{1}{4}$	$3\frac{1}{8}$
2	4	3	$2\frac{1}{2}$	$2\frac{1}{4}$	$2\frac{1}{8}$
1	2	$1\frac{1}{2}$	$1\frac{1}{4}$	$1\frac{1}{8}$	$1\frac{1}{16}$
1/2	1	3/4	5/8	9/16	17/32

Close-up photography

The terms *close-up*, *photomacrograph*, and *photomicrograph* have become established as categories of photographs representing different scales of reproduction, with the scale increasing in the order listed. Establishing a dividing line between *normal* and *close-up* photographs is an arbitrary matter. As the camera is moved toward the subject, a point is reached where the film will be noticeably underexposed unless compensation is made for the increased bellows extension. A general rule for critical work (when reversal colour film is used, for example) is that compensation should be made in the exposure when the camera is within 10 focal lengths of the subject — 200 in., for example, with a 20-in. focal length lens and 30 in. with a 3-in. lens. This is an appropriate place to begin the *close-up* category. An object distance of 10 focal lengths corresponds to a scale of reproduction of approximately 1 : 10 (actually 1 : 9).

A logical dividing line between a *close-up* photograph and a *photomacrograph* is where the image becomes equal in size to the object. The object distance for a scale of reproduction of 1 is always 2 focal lengths. *Photomicrograph* is a term applied to photographs made through a microscope. Thus, any image representing a scale of reproduction larger than 1 made directly with a camera is a *photomacrograph*. When a scale larger than 25 or 50 is required, it is usually more practical to make the photograph through a microscope.

Image definition on photomacrographs

Other than obtaining a sufficiently large image, the major optical problem in photomacrography is concerned with image definition. The following methods for obtaining an improved image should be considered when the definition on a photomacrograph is not satisfactory.

Vary the aperture. Even with a two-dimensional subject, where depth of field is not a factor, the definition is not the same at all apertures. Stopping the lens down minimizes loss of definition due to lens aberrations but increases the loss of definition attributable to diffraction, and the aperture that produces optimum definition

116

changes with the scale of reproduction. The harmful effects of diffraction are less likely to be a problem with photographs made with a view camera than with cameras using smaller film sizes, but the effects become more pronounced as the bellows is extended to obtain larger images of close objects. When the bellows extension is two times the focal length of the lens, the adverse effect of diffraction on image definition will be twice as large as when the lens is focused on infinity at the same f-number. If a lens is set at f45 for a photomacrograph with a bellows extension two times the focal length, the effective f-number is f90. The diffraction effect on the photomacrograph at f45, therefore, will correspond to that on a photograph of a distant scene at f90.

An additional reason for stopping the lens down is introduced with three-dimensional subjects. Depth of field decreases rapidly as the lens to subject distance decreases, so that obtaining as little as one-half inch depth of field may become impossible even at the smallest aperture with large scale photographs. It may be necessary to compromise by accepting some overall loss of definition due to diffraction when it is necessary to stop the lens down to obtain the maximum depth of field. Critical focusing becomes especially important in photomacrography because of the limited depth of field. It is easier to focus precisely by moving the subject or by moving the entire camera than by using the focusing adjustments.

Reverse the lens. Lenses that have been designed for use with subjects at large to moderate distances from the camera produce the best images when the front of the lens faces the larger of the conjugate distances. When the scale of reproduction is larger than 1, the lens to film distance is larger than the lens to subject distance.

Use a positive supplementary lens. By keeping the film plane approximately one focal length from the lens, the corrections designed into the camera lens for larger object distances are not disrupted. Aberrations in the supplementary lens can be minimized by using a small aperture, or preferably, by using a corrected lens as a supplementary lens, reversing it so that the front of the supplementary lens faces the camera lens.

Substitute a lens designed for use with shorter object distances. Process type lenses produce excellent images, but are not available in

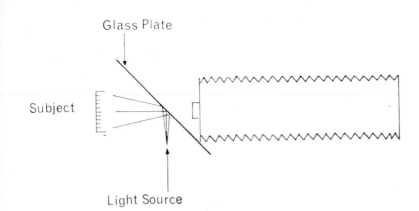

Glass Plate

Subject

Light Source

Fig. 150. Glass plate reflector in front of lens

the shortest focal lengths. Macro type lenses, designed for miniature cameras, and some shorter focal length enlarging lenses produce excellent results on view cameras at the larger scales of reproduction, but they may introduce complications in some situations due to the absence of built-in shutters.

Lighting for photomacrographs

Complications are often encountered in lighting small objects for photomacrographs due to the limited space between the subject and the camera. When detail is required in all parts of the subject, light must approach the subject from the direction of the lens. Since the lens is often only a few inches from the subject, conventional lights cannot be placed in the desired position. Three methods of overcoming this difficulty are to use a ring light that encircles the lens, to use reflectors that can be placed close to or even in front of the lens, and to surround the lens and subject with a translucent cone. Ring lights are available in electronic flash and fluorescent tubes (Fig. 149). Although most ring lights are compact, others have been made larger purposely with several revolutions of tubing to increase the intensity and the diffusion of the light. The larger units may, however, interfere with the tilt and swing adjustments on some view cameras.

The lighting technique that is most successful in lighting cavities in the subject is to place a piece of flat glass at an angle in front of the camera lens. Light from a source at the side will be reflected to the subject as though it had originated from the direction of the lens (Fig. 150). Mirrors, foil, or white paper can be placed near or around the lens when it is not necessary for the light to come precisely from the direction of the lens (Fig. 151). Care must be used to shield the lens from the direct light. When a more vigorous lighting effect is desired, these techniques can be used to provide the fill light, in combination with one or more stronger direct lights.

Perspective

Perspective may be defined as the appearance of objects with respect to their distance and position. Perspective is the quality that creates the illusion of three dimensions on two-dimensional photo-

Fig. 149 Electronic flash ring light

118

Fig. 151. Reflector with hole for lens *(top)*
Translucent cone illuminated from the outside *(bottom)*

Fig. 152 *(top to bottom)*. Photograph made with a ring light to show an unpainted lens flange in a view camera as a potential flare factor. Recessed areas of this type are difficult to illuminate with conventional lights

Use of direct light for photomacrography usually results in long shadows since a camera close to the subject interferes with placement of the lights. Shadows may conceal important detail with some subjects

Ring light does not produce shadowless lighting when used close to the subject

Glass plate at a 45 degree angle in front of the lens reflects light onto the subject as though it originated from the lens

Fig. 153. Image sizes are inversely
proportional to object distances

Fig. 154. Perspective with a single ob-
ject at an oblique angle is evident in
convergence of lines in addition to
difference in size of the two ends

graphs. There are several factors that contribute to this illusion of
depth in photographs, but the most obvious one is linear perspec-
tive, which is identified as a change in image size in relation to the
object distance. The freedom of choice of lens focal length and cam-
era position afforded by the long bellows provides view camera
users with extensive control over linear perspective.

Object distance and perspective. With two objects that are equal in
size located at different distances from the camera, the image sizes
will vary inversely with the distances, so that a 1 : 2 ratio of object
distances produces a 2 : 1 ratio of image sizes (Fig. 153). (A single
object at an angle will reveal perspective not only by the difference
in size of the near and far parts of the object, as they appear on the
photograph, but also by the convergence of parallel lines that con-
nect the near and far parts. (See Fig. 154.) Moving the camera away
from the two objects will cause both images to decrease in size, but
not at the same rate. Since the ratio of the distances of the two
objects decreases as the camera is moved away, the ratio of the image
sizes will also decrease. With objects at a 1 : 3 ratio of distances,
doubling the distance from the camera to the near object increases
the distance from the camera to the far object by only one third of
the original distance (Fig. 155). The ratio of the object distances is
now 1 : 2 and the ratio of the image sizes is 2 : 1. The relative image
sizes, and therefore the linear perspective, in this illustration are
determined solely by the position of the camera. With movable

Fig. 155. The near object decreases in size more rapidly than the far object as the camera distance is increased

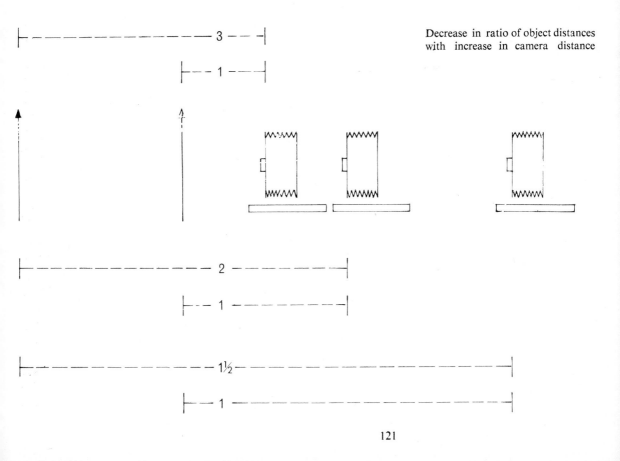

Decrease in ratio of object distances with increase in camera distance

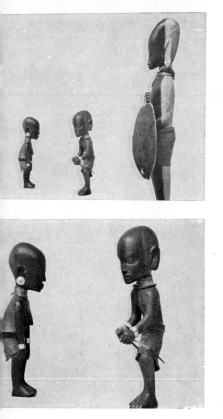

Fig. 156. Viewer's impression of depth changes with lens focal length, due to differences in the angles of view, even though the relative sizes of objects remain identical

objects, the linear perspective can also be altered by changing the distance between the objects.

Inexperienced photographers usually select the camera position on the basis of factors other than perspective. The tendency is to adjust the distance between the camera and the subject to obtain the desired image size and angle of view, or to select the most convenient location for the camera without giving consideration to the perspective. This casual approach will occasionally result in an obviously unfortunate perspective effect, such as the too-large nose on a portrait or the compressed appearance of a subject photographed from a distance. Professional photographers learn to control perspective to obtain the desired effect. To do this, it is first necessary for the photographer to be aware of the subtle as well as the obvious perspective effects. The camera position is then selected on the basis of the perspective desired, and finally the focal length lens is used that will produce the appropriate image size.

The perspective that results when a camera is moved relatively close to the subject is referred to as a *strong* perspective, and a *weak* perspective results when the camera is at a larger than normal distance from the subject. Objects appear to decrease rapidly in size with distance from the camera when the perspective is strong. This effect is sometimes referred to as "distortion" or "distorted perspective." (The noun *distortion* is more properly reserved for the aberration previously described.) When the perspective is weak, objects appear to decrease slowly in size with their distance from the camera, being represented more nearly by their true size relationship.

Focal length and perspective. Substituting lenses with different focal lengths, with the camera remaining in the same position, changes the size of the images of near and far objects at the same rate and there is no change in linear perspective. The result is the same as when a negative is placed in an enlarger and prints are made at different scales of reproduction. It is not correct, however, to say that focal length has no effect on perspective. Even though the relative sizes of near and far objects remain identical with different focal length lenses, the angles of view and overall image sizes will be different and can create different impressions of depth in the photographs (Fig. 156). The effect of focal length on perspective should

not be overlooked since viewers are generally more concerned with the total perspective effect than with the actual ratio of image sizes, and the perspective effect does depend upon such subtle factors as the cropping of the print and the distance at which the print is viewed. Focal length is related to the effect that viewing distance has on perspective, which is discussed below, but in general increasing the focal length tends to decrease the perspective, even though the camera position remains unchanged.

Simultaneous changes in object distance and focal length. Changes in linear perspective are most obvious when comparison photographs are made in which the object distance and the focal length are changed simultaneously in such a way that part of the subject remains constant in size. Figure 157 illustrates the control the photographer can exercise over linear perspective in photographing a subject by varying the distance between the camera and the subject, increasing the focal length as the camera is moved away to maintain a constant image size for the far part of the subject. Factors other than suitability of the perspective often dictate or limit the camera position. Architectural interiors, for example, seldom allow the photographer much freedom in respect to the distance at which he places the camera from the subject. Natural-appearing perspective is not always desirable. Unusually strong and unusually weak perspective can often be used effectively for dramatic impact (Fig. 158). Certain perspective customs have evolved over the years in some fields of photography. Rather weak linear perspective is the rule for studio portraits and catalogue photographs, for example. Stronger perspective is generally found on interior architectural photographs, not only because of the necessity of placing the camera close to the subject, but because strong perspective increases the feeling of spaciousness. The complete destruction of linear perspective is desirable on certain types of industrial photographs of three-dimensional subjects that are used for the preparation of non-perspective engineering drawings. Photographic copying requires the complete elimination of linear perspective, which would be evident as a change in shape of the image resulting from inaccurate alignment of the camera.

The treatment of vertical subject lines represents the most obvious discrepancy between the way the eye sees perspective and the way

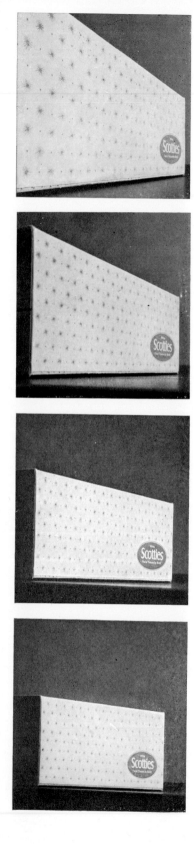

Fig. 157. Simultaneous increases in object distance and lens focal length result in weakening of linear perspective. Right side of object remains constant in size

(Right) Camera positions to obtain constant image size with four different focal length lenses

Fig. 158. Effective use of strong perspective – *Neil Montanus*

we have become accustomed to recording it photographically. Although vertical subject lines do appear to converge when examined from a high or a low viewpoint, complete elimination of the convergence is expected on the photograph in some fields of photography.

Use of camera movements versus changing object distance. Two techniques for modifying the convergence of parallel subject lines have been presented — tilting or swinging the back of the camera, and increasing or decreasing the subject to camera distance. Although similar effects may be obtained with the two techniques with some subjects, they are not generally interchangeable. Each of the two techniques has a limitation that may make it unsuitable for a specific situation. The tilt and swing adjustments are each capable of completely eliminating the convergence in only one set of parallel subject lines at a time. When photographing a box-shaped object so that two sides are visible, swinging the back to eliminate the convergence on one side exaggerates the convergence on the other side. Moving the camera farther from the subject, in the same situation, will decrease the convergence on both sides of the object simultaneously, but on the other hand, the convergence can never be eliminated completely with this method. Figure 159 illustrates how the converging vertical lines of the subject can be eliminated by tilting the back of the camera, whereas photographing the subject from a larger distance with a longer focal length lens reduces but does not eliminate convergence.

Fig. 159 *(top)*. Aiming a camera downward with a short focal length lens causes strong convergence of vertical subject lines (Back tilt zeroed.)

(Upper middle). Tilting the back of the camera to the vertical position eliminates convergence of vertical lines. Circular objects appear more unnatural in shape

(Lower middle). Same downward tilt of the camera from a larger distance with a longer focal length lens produces only slight convergence of vertical subject lines (Back tilt zeroed.)

(Bottom). Back must be tilted to the vertical position to completely eliminate converging vertical lines on the preceding photograph. Change in shape of circular objects is less obvious than when the camera was closer with a shorter focal length lens *(upper middle)*

Apparent perspective effects

Viewing distance. Several factors influence the appearance of linear perspective on photographs in addition to the actual size relationship of the various parts of the image and the extent of convergence of parallel subject lines. The most important of these factors is the distance at which photographs are viewed. The major reason why some photographs appear to have strong perspective and others weak perspective is because they are not viewed at the so-called "correct" viewing distance. For contact prints, this distance is equal to the image distance on the camera at the time the film was exposed (Fig. 160). If the negative is enlarged, the viewing distance is the image distance on the camera multiplied by the magnification in printing. (Focal length is often specified in place of image distance in defining viewing distance. This is sufficiently accurate except when the subject is close to the camera. In this situation, the discrepancy between focal length and image distance can be considerable.) Thus, an 8×10-in. contact print from a negative of a distant scene exposed with a 12-in. focal length lens should be viewed at 12 inches, and an 8×10-in. enlargement from a 4×5-in. negative (magnification of 2.0) exposed with a 6-in. focal length lens should also be viewed at 12 in. At this distance, the images of objects on either of the two photographs will subtend the same angle to the eye as the original objects would have subtended to the eye placed in the position of the camera lens, and the linear perspective will appear normal. Now, if the print is viewed from a *closer* position, there is no change in the relative size of the images of the near and far objects. The perspective now appears too weak, because the mind expects the near objects, to increase in size at a faster rate than the far objects, since this is what happens when the eye moves closer to an actual scene. To summarize, viewing a print from closer than the correct distance causes the perspective to appear too weak. Strong perspective results from too large a viewing distance.

Small variations in viewing distance obviously will not produce dramatic changes in perspective. The perspective on photographs of essentially two-dimensional scenes changes little even with large changes in viewing distance, while a photograph that contains dominant objects in the foreground and background, converging lines, or other good perspective clues may change quite dramatically.

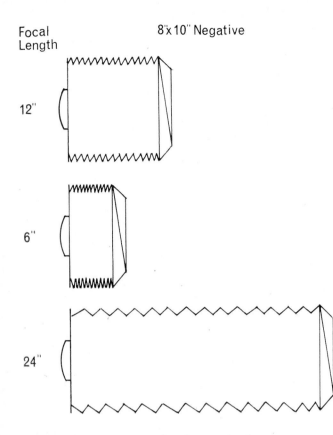

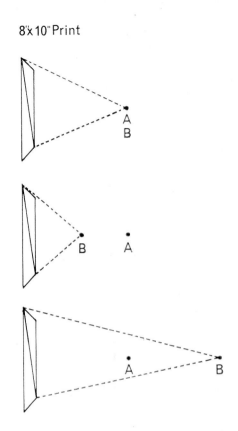

Focal Length

8"x 10" Negative

8"x 10"Print

12"

6"

24"

Fig. 160. Correct viewing distance (B) and conventional viewing distance (A) with different focal length lenses

How can the photographer force, or at least encourage, the viewer to look at his print from the correct distance when he wants to convey an impression of normal perspective, from a larger distance for strong perspective, and from a smaller distance for weak perspective? Except in unusual circumstances, the viewer can't be forced to accept a specified viewing distance, but observations have revealed that people tend to view prints from a distance approximately equal to the diagonal of the print. That is, print size is the most important factor that determines the distance which viewers voluntarily select to examine prints, although convenience often modifies the position. Therefore, the photographer can achieve his perspective objective by making the photograph in such a way that the correct viewing position will be in the appropriate place in relation to the position the viewer can be expected to assume.

Since the correct viewing position is determined by the image distance on the camera and the magnification in printing, the photographer can change either of these factors, but changing the magnification (without cropping) accomplishes little because the viewer tends to increase his viewing distance as the print size increases. Use of a shorter focal length lens on the camera, however, reduces the correct viewing distance without affecting the print size. The viewer will look at the print from the same distance he would if a normal lens had been used, and the perspective will therefore appear strong. Normal, strong, and weak perspective can result from using standard, short, and long focal length lenses respectively on the same

camera. This change in perspective occurs even though the lens to
subject distance is the same for all three photographs. In practice,
there is a tendency to move the camera closer with short lenses and
farther away with long lenses, which adds an actual linear perspec-
tive change and makes the differences in perspective more dramatic.

Cropping. Any cropping that is done after the negative has been
made tends to weaken the perspective. Enlarging only a portion of
a negative causes the magnification and the correct viewing distance
to increase at a greater rate than the actual print size and, therefore,
the distance at which it will tend to be viewed. Trimming a print
that has already been made will, by reducing its size, encourage
people to view it from a closer position even though the correct
viewing distance remains unchanged. A limit is reached with small
prints where the viewer experiences difficulty in attempting to focus
his eyes at very close range and abandons the attempt to even ap-
proximate a distance equal to the print diagonal.

Wide-angle effect. Viewing prints at other than the correct viewing
distance not only causes the linear perspective to appear weak or
strong, but also causes the shape of some objects to appear unnat-
ural. This effect is most noticeable near the edges of photographs
made with short focal length wide-angle lenses. Three-dimensional
objects appear to be stretched out of shape, in directions radiating
away from the centre of the photograph, when the camera back and
lens are in their normal positions. The wide-angle effect is most
obvious with objects having regular shapes, such as spheres. It is
also apparent on heads located close to the edges of group photo-
graphs made with short focal length wide-angle lenses (Fig. 161).
 Although there is no wide-angle effect when prints are viewed
from the correct positions, a spherical object is recorded on the film
as a circle only when the centre of the image of the sphere is located
on a line from the lens perpendicular to the film. At other positions
the image is recorded as an oval with increasing elongation as the
distance between the image and the perpendicular line increases.
 When the camera back is swung or tilted, or any of the rising-
falling or lateral adjustments are used, the centre of radiation is the
point where a line drawn from the lens perpendicular to the film
intersects the film (Fig. 162). Viewed from the correct position, the

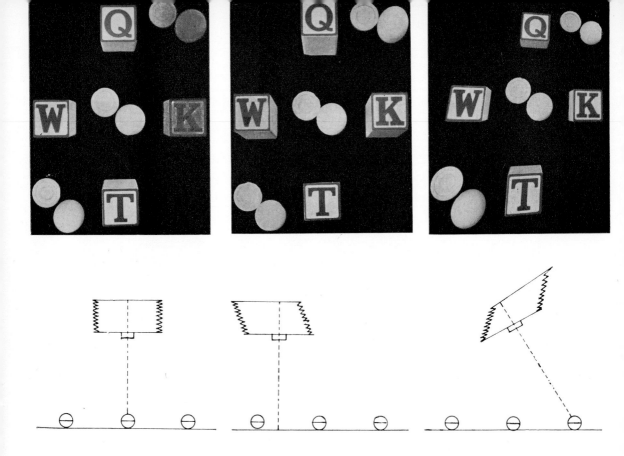

oval is seen at an oblique angle that makes it appear as a circle, whereas at larger distances it is seen for what it actually is, and the spherical object appears to be misshapen. The reader can observe how the appearance of an oval changes with the angle at which it is viewed by tilting the book while observing the oval in Fig. 163. At the appropriate angle the oval will appear as a circle, and as the book is tilted farther it will again appear as an oval with the direction of elongation at right angles to the original direction.

Difficulty is often encountered in attempting to make a wide-angle photograph appear normal by viewing it from the correct position, especially if the photograph is 8×10 in. or smaller, due to the difficulty of focusing the eyes at close range, the unnatural convergence of the eyes for binocular vision, and the large angle the print subtends to the eyes.

Two-dimensional objects are free of the wide-angle effect. A wide-angle copy photograph of a drawing containing circles will represent the circles accurately even though the images are located in the extreme corners. The stretching of the image that occurs when the light rays strike the film at oblique angles in the corners is exactly offset by the compressing effect resulting from the lens viewing the parts of the subject at the same oblique angles (Fig. 164).

There are two methods of avoiding the wide-angle effect on photographs. The first is to use a lens of sufficiently long focal length so that the correct viewing distance corresponds to that generally as-

Fig. 162 *(left)*. A spherical object is recorded on the film as a circle only when the centre of the image of the sphere is located on a line from the lens perpendicular to the film

(Middle) Elongation of the image increases with displacement from the perpendicular line

(Right). A spherical object that is near the edge of a photograph can be recorded as a circle by tilting or swinging the back so that the central ray of light from the object is perpendicular to the film. This will exaggerate the elongation of images on the opposite side of the film

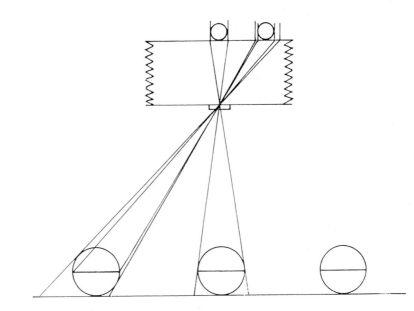

Fig. 163. An oval *(left)* is seen as a circle when viewed at the appropriate angle

Fig. 164. Images of two-dimensional objects are not susceptible to the wideangle effect *(above)*. The stretching, resulting from the light striking the film at an oblique angle, is counteracted by the lens viewing the object at the same angle

sumed by viewers (Fig. 165), and the other is to avoid locating the types of objects that reveal the wide-angle effect around the edges of the photograph. Since a standard focal length lens produces an angle of view of 53°, the outer portions of photographs made with short focal length wide-angle lenses that exceed this angle are the danger areas.

If too large a viewing distance produces the image stretching that is characteristic of the wide-angle effect, it would be expected that too small a viewing distance will produce a corresponding compression of the image in the corners. Although such a compression can occur, it does not present the same problem the wide-angle effect does, and in fact, it is seldom noticed. The images of spherical objects photographed with unusually long focal length lenses will deviate little in shape from circles regardless of their position on the print, and any appearance of compression of the circles in the corners will be due to viewing these parts of the print at oblique angles. The angles to the corners are not extreme enough to produce an obvious compression when the print is viewed from a distance equal to its diagonal, as can be expected, even though this is only a fraction of the correct viewing distance, based on focal length and magnification.

Trick perspective. Because three-dimensional space is represented by two dimensions on photographs, it is not difficult to deceive the

Fig. 165. Photograph showing the elimination of the wide-angle effect through use of a long focal length lens

131

Fig. 165A. An architectural scale model photographed in a studio (*left*), and the corresponding building that was constructed later – *Lawrence S. Williams, Inc.*

Fig. 166. Viewers tend to assume that the angles formed by the edges of the white card are right angles (*top*). Perpendicular view (*bottom*) reveals that one angle on the card is acute, the other obtuse

viewer, giving him an entirely false impression of the actual scene photographed. This is done when photographers use unusually long or short focal length lenses that almost force people to view the prints from incorrect positions, thus creating impressions of weak or strong perspective.

Previous experience plays a dominant role in the interpretation of photographs. Two lines that converge as they recede are assumed to be parallel unless there are conflicting clues. If the converging lines are the images of railroad tracks, there is a valid reason for assuming that the rails are actually parallel, but lines drawn on paper, and other abstract lines that are seen as converging are also assumed to be parallel when they may be actually parallel, converging, or diverging.

In a similar manner, if images of two objects are identical except for size, the object that appears smaller is assumed to be farther away and by a distance that seems appropriate for the size differential. The distance concept may be entirely false if one of the objects is actually larger than the other. In fact, the two objects may have been at the same distance from the camera. The reduction in size of all objects in a scene makes it possible to use models to create an illusion of a full scale situation. Extensive use of this technique has been made to depict disaster scenes in motion pictures. People also have a tendency to see ellipses as tipped circles seen in perspective, and angles that vary over a wide range on photographs tend to be visualized as right angles on the subjects (Fig. 166). These and other vagaries involved in the psychology of vision can often be used by perceptive photographers to increase the effectiveness of their photographs. When they interfere with the creation of a realistic effect, however, it may be necessary for the photographer to place greater emphasis on other perspective controls such as variation in the sharpness with distance as determined by depth of field, overlapping the images of objects at different distances, aerial perspective due to atmospheric haze, the alternation of light and dark tones with distance, the use of shadows obtained with appropriate lighting, and the inclusion of an object of known size to establish scale.

132

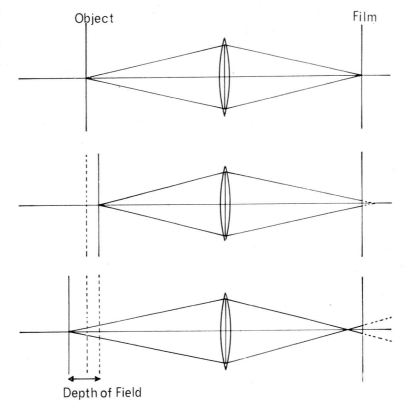

Fig. 167. Depth of field is the range of object distances over which objects appear acceptably sharp on the print when viewed at the normal viewing distance. The acceptable circle of confusion is the image of a point on an object located at the near or far limit of the depth of field range

Object Film

Depth of Field

Depth of field

Depth of field is the range of object distances over which objects appear acceptably sharp on the print when viewed at the normal viewing distance. A small depth of field, where objects in front of and behind the plane focused on appear unsharp, is often used to strengthen the perspective in a photograph, whereas a large depth of field is used where obtaining detail in all parts of the subject is the primary objective. A number of factors determine the actual depth of field obtained on a photograph, but since two of these factors (lens focal length and object distance) are closely related to the bellows· extension, and since depth of field is one type of perspective, it will be considered here.

Resolving power of the eye. Not all of the parts of a print that appear acceptably sharp at the normal viewing distance are actually equally sharp. When a camera is focused on a given distance, as in copying, for example, that is the only distance that is theoretically in sharp focus. In practice, however, the two-dimensional subject can be moved somewhat closer to the camera and somewhat farther away before a noticeable decrease in sharpness occurs. At the near and far positions, each point on the object is imaged as a circle rather than as a point, as illustrated in Fig. 167, but the eye sees circles smaller than a certain critical size as points. Even in the position of optimum focus, of course, the "point" image is actually a measurable circle due to the effects of lens aberrations, diffraction,

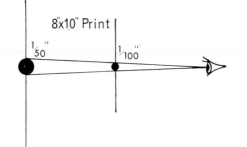

16"x 20" Print

8"x10" Print

$\frac{1}{50}$"

$\frac{1}{100}$"

and other factors, but with a good quality lens this circle is small in comparison to the circles that determine the limits of depth of field.

The largest circle that appears as a point to the eye is referred to as the acceptable circle of confusion. A diameter of 1/100 inch is often considered to be the largest circle that will appear as a point on a print viewed at a distance of 10 inches. If the print is a contact print, the same criterion applies to the negative, but if the print represents a 2 times enlargement from a smaller negative the acceptable circle of confusion on the negative is one half as large as it is on the print, or 1/200 inch. The degree of enlargement of the negative has no effect on the depth of field providing the image is not cropped. Although the circle of confusion increases at the same rate as the magnification of the image and will eventually exceed 1/100 inch, the viewing distance normally increases in proportion to print size so that the depth of field will remain essentially the same over a wide range of print sizes (Fig. 168).

Effect of viewing distance and cropping on depth of field. Viewing a print at closer range than the diagonal causes those parts of the image that appeared sharp at a normal viewing distance but were situated close to the near and far limits of the depth of field now to appear unsharp. The effective depth of field has been decreased just by looking at the print closer even though the print remains physically unchanged. Cropping an image reduces the depth of field in a similar way. If a 16×20 inch print is trimmed to 8×10 inches, observers will tend to view the cropped print at approximately one half the distance of the original print. Enlarging only a section of a negative produces exactly the same result.

We will not be concerned with formulae for calculating actual depth of field values. One of the important advantages of view cameras and single lens reflex cameras over other types is that the depth of field can be seen on the ground glass image, making it unnecessary to refer to tables, scales, or graphs. It is worth while examining a comprehensive depth of field graph, as we will do, to observe the effects some of the variables have on depth of field, however. A depth of field graph or table for a lens is accurate for only one film size. Using the lens with a different size film is the same as altering the cropping or viewing distance.

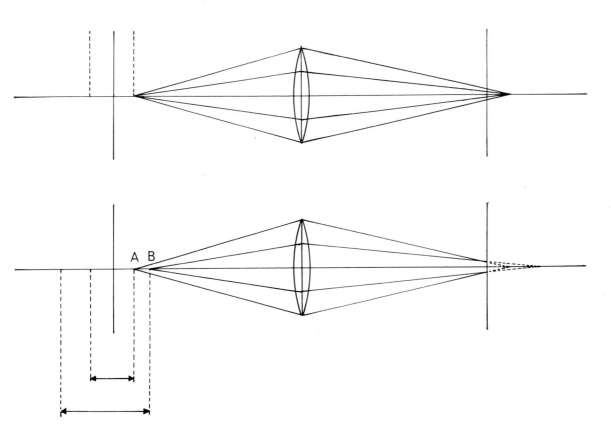

Depth of field controls

It is important, however, for view camera users to be familiar with the factors that affect depth of field and to understand the extent of the change in depth of field that each of these factors produces. There are three basic controls over depth of field — relative aperture, object distance, and focal length.

Relative aperture. Varying the relative aperture, or *f*-number, is usually the most convenient method of controlling depth of field, and the relationship between depth of field and the *f*-number is a simple one. As a lens is stopped down, the angle of the cone of light behind the lens from a single object point is decreased and the circle of confusion formed where the film intercepts the cone of light is reduced in size (Fig. 169). Thus, object points in front of and behind the plane focused on, which appear unsharp at a large aperture, may appear acceptably sharp when the lens is stopped down. The depth of field increases in direct proportion to the *f*-number, so that stopping a lens down from *f*8 to *f*16 doubles the depth of field. The relationship between depth of field (D) and *f*-number (*f*N) can be expressed as follows:

$$\frac{D_1}{D_2} = \frac{fN_1}{fN_2}$$

To illustrate application of the formula, if a depth of field of 6 in.

Fig. 169 *(top)*. Stopping down reduces the size of the circle of confusion for an object point closer than the point focused on

(Bottom) Depth of field increases as a lens is stopped down. The circle of confusion for object point "B" with the lens stopped down is the same as for object point "A" with the lens wide open

135

is obtained with a lens wide open at $f5.6$, how far must the lens be stopped down to obtain a depth of field of 24 inches?

$$\frac{6}{24} = \frac{5.6}{fN_2}$$

$$fN_2 = 22.4$$

We can also observe the effect of stopping a lens down all the way. If a lens has a range of f-numbers from $f4.5$ to $f45$

$$\frac{D_1}{D_2} = \frac{4.5}{45} = \frac{1}{10,}$$

and the depth of field will be increased 10 times by stopping the lens down.

Altering the aperture is not always the complete answer to depth of field problems. More depth may be desired than can be obtained at the smallest aperture, or possibly less depth is wanted than is produced at the largest opening. Also, the f-number selected on the basis of depth of field may require an awkward or an impossible exposure time.

Object distance. Depth of field increases at a rapid rate as the object distance increases. This is evidenced by the difficulty that is experienced in obtaining sufficient depth of field on photomacrographs of three dimensional objects, where the required depth of field may be only a fraction of an inch. At the other extreme, a lens focused for a larger object distance may produce a depth of field that extends from infinity to within a few feet of the camera. The relationship between depth of field (D) and object distance (U) is:

$$\frac{D_1}{D_2} = \frac{(U_1)^2}{(U_2)^2}$$

Thus, doubling the object distance increases the depth of field four times, tripling the object distance increases the depth nine times, etc.

The camera position in relation to the subject is usually determined on the basis of image size and perspective, but situations are encountered where depth of field requirements are important enough to justify modifying the object distance. This is especially true when stopping the lens down does not produce sufficient depth. Increasing the object distance produces a net gain in depth of field even though

136

the image is cropped in printing to correspond to the image produced at the closer camera position. The increase in depth of field will not be as dramatic when the negative is cropped, however, as indicated by the absence of the square symbol in the relationship:

$$\frac{D_1}{D_2} = \frac{U_1}{U_2}$$

Changes in depth of field with the two controls considered so far, f-number and object distance (without cropping) are illustrated in the graph in Fig. 170. Distance focused on is represented by the 45° straight line, and the near and far distances that appear sharp are represented by a pair of curved lines for each designated f-number. The depth of field is indicated for two different object distances at $f16$. As observed previously with the depth of field — object distance formula, the depth of field is increased four times when the object distance is doubled. Relative depth in front of and behind the plane focused on is also shown by the graph, and the fallacy of the 1/3 rule can be observed. According to the 1/3 rule, there is twice as much depth behind the plane focused on as in front of it. Actually, when the depth of field is small (at large apertures and small object distances) the depth of field is distributed almost equally front and back. As the depth of field increases, a larger portion of the increase goes to the back. This imbalance in depth becomes most obvious when the depth of field extends back to infinity. Maximum depth of field resulting from changing object distance is obtained when the lens is focused on the nearest distance that will extend the depth of field to infinity. The distance focused on in this situation is known as the *hyperfocal distance*, and the near distance that appears acceptably sharp will be midway between the plane of sharpest focus and the lens (Fig. 171). Thus, to obtain the maximum depth of field when photographing a scene that includes a distant object with a view camera, the lens should be focused as close as possible while rendering the distant object acceptably sharp.

The effect that swinging or tilting the camera lens or back has on depth of field can be observed on the graph since the camera is actually focused on a series of object distances that vary from side to side with the swings and from top to bottom with the tilts. If the camera is adjusted so that the plane of sharp focus in the object

137

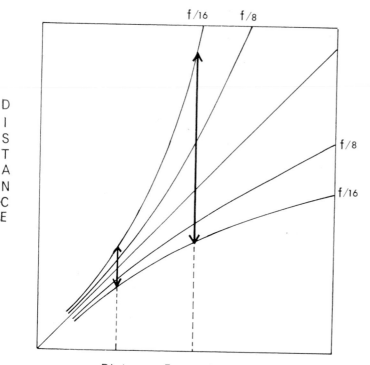

f/16 f/8

f/8

f/16

DISTANCE

Distance Focused on

Fig. 170. Depth of field graph, showing the results of changing object distance and *f*-number

space is at an angle of forty five degrees, for example, the depth of field will not only change from side to side or from top to bottom, but the near and far limits of the depth of field space will be curved to correspond to the limit lines on the graph (Fig. 170).

Focal length. An inverse relationship exists between depth of field and focal length. Although we can generalize that long focal length lenses produce less depth of field than short lenses, we must consider two situations in establishing a mathematical relationship. In the first situation the film size remains constant as the focal length is changed, and in the second situation the film size and focal length both change at a corresponding rate.

When the film size is kept constant, the depth of field varies inversely with the focal length squared, or

$$\frac{D_1}{D_2} = \frac{(f_2)^2}{(f_1)^2}$$

Thus, the depth of field increases at a very rapid rate as the lens focal length is decreased, as illustrated by a four times increase in depth that results when the focal length is halved. If a constant image size must be maintained, however, it will be necessary either to move the camera closer with the shorter lens or to enlarge and crop the negative in printing. Moving the camera closer will completely destroy any increase in depth obtained by using a shorter lens. In situations involving simultaneous changes in object distance and focal length, the depth of field will vary inversely with the scale of repro-

138

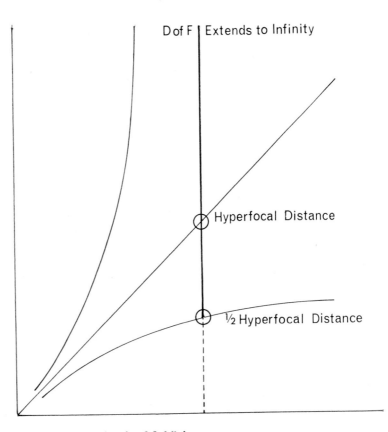

Fig. 171. Focusing a lens on the hyperfocal distance produces a depth of field from infinity to one-half the hyperfocal distance

D of F | Extends to Infinity

Hyperfocal Distance

½ Hyperfocal Distance

duction, and there is no advantage (with respect to depth of field) in altering these factors if the scale of reproduction remains constant.

Depth of field can be altered with focal length while maintaining a constant image size on the *print* by keeping the camera in one position and compensating for the differences in image size on the negatives in printing. If the same film size is used with two different focal length lenses, the negative made with the shorter lens must be both enlarged and cropped. If, however, a proportionally smaller film is used with the shorter lens, the cropping will be the same on the two negatives. The enlarged print from the smaller negative will have the larger depth of field, as indicated by the formula:

$$\frac{D_1}{D_2} = \frac{(f_2)}{(f_1)}$$

When more depth of field is needed than can be obtained by stopping a lens down, therefore, either of two methods may be used. First, move the camera farther from the subject without changing the lens. Enlarge the negative and crop in printing. Perspective and overall definition may be affected by these changes. Secondly, keep the camera in the same position and use a shorter focal length lens. Enlarge the negative and crop in printing. Perspective will not be affected, but there may be some loss in overall definition.

A special problem is encountered when the end product is a colour transparency rather than a print. If the depth of field is not sufficient when the lens is stopped down and the nature of the subject is such

Fig. 172. Effective use of the depth of field pattern shown on the graph in Fig. 170, to obtain sharp images of the flasks and the man's face and hand

Fig. 173. An example of a scene where there is little to be gained by altering the angle of the plane of sharp focus with the tilt or swing adjustments
– *Neil Montanus*

that the camera swing and tilt adjustments cannot be used to provide the necessary depth, the photographer has little choice but to accept the inadequate depth of field or the smaller image resulting from a larger object distance or use of a shorter focal length lens (Fig. 173).

Depth of focus

Depth of focus is the distance the film plane can be moved without producing a noticeable change in sharpness of the image of an object point, as viewed on the print at a normal viewing distance. When focusing a camera on a two-dimensional subject, as when copying, the limits of the depth of focus are established where the size of the image of each object point equals the acceptable circle of confusion (Fig. 174). Information concerning depth of focus is important to camera and film manufacturers since this determines the extent of film buckle that is tolerable, and the precision that is required in the construction of cameras and film holders. Depth of focus provides the photographer with latitude in the precision required in focusing on a single plane.

The actual depth of focus can be determined as follows: Depth of focus = $2 \times$ (f-number) \times (acceptable circle of confusion). Thus, using 1/200 in. as the acceptable circle of confusion for 4×5-in. film and a relative aperture of $f11$, the depth of focus is approximately 1/9 in. Although photographers may seldom have occasion to calculate depth of focus, this simple formula helps to understand the basic concepts involved in its control.

Four significant relationships involving depth of focus follow:

1. Depth of focus increases as a lens is stopped down. This is a direct proportion as indicated in the above formula, so that stopping down from $f11$ to $f22$ doubles the depth of focus the same as it doubles the depth of field.

2. Depth of focus increases as object distance decreases. Although the marked f-number doesn't change as the subject to camera distance becomes smaller, the effective f-number becomes larger, and this value must be used in the above formula for small object distances.

3. Depth of focus is not affected by focal length. At the same f-number all focal length lenses subtend the same angular cone of

140

Object

Film

Depth of Focus

Fig. 174. Depth of focus is the distance the film plane can be moved before the image of an object point appears unsharp, as viewed on a print at the normal viewing distance

light. Note that the term focal length does not appear in the above formula.

4. Depth of focus increases as the film size increases. The viewing distance, and therefore the acceptable circle of confusion increase with negative size.

Depth of field and depth of focus are, of course, related, but we notice they do not respond in the same way to changes in object distance and focal length, items 2 and 3 above. Freedom in moving the subject within the depth of field space or the film within the depth of focus space can be used only once for a given photograph. If a subject exactly fills the depth of field space, then there is only one position the film can occupy, and there is no tolerance remaining for the photographer or the camera.

6

FILMS AND FILTERS

A recommendation that is frequently made to photographers who are concerned about obtaining the best possible image quality is to use the largest film that is practicable for each picture making situation. To match the image size on a contact print from an 8×10 inch negative, a 4×5 inch negative must be enlarged two times, a $2\frac{1}{4} \times 3\frac{1}{4}$ inch negative approximately three and a half times, and a 35mm negative approximately eight times.

This does not necessarily mean that image definition will decrease in proportion to negative size. Just as the acceptable circle of confusion that determines the limits of depth of field is seen as a point by the eye, any improvements in the factors that affect image definition beyond critical values will be lost upon the viewer. Also, film size is only one of a number of factors that determine image definition. While it is possible to obtain excellent results with smaller film sizes by establishing more nearly optimum conditions for the other factors, the photographer handicaps himself by using an unnecessarily small film, and eventually a point is reached where the limitations of the small film cannot be offset. The increased magnification required in printing small negatives not only reveals the inherent limitations of the film, but also increases the seriousness of shortcomings in craftsmanship, such as dust, scratches, overexposure, and imperfect retouching. In practice, however, view camera users often find it desirable or necessary to use the smaller film sizes for such reasons as economy, convenience, and special production requirements. We will consider in this chapter some of the more important influences over image definition and other aspects of image quality.

Definition

If photographers used only large film and made contact prints, there would be little need to be concerned about the choice of film with respect to definition. It is only when negatives are enlarged or when contact prints are examined with a magnifier, that the variations in definition resulting from the use of different films become apparent. Definition is the impression of clarity of detail that is received by an observer when viewing a photograph.

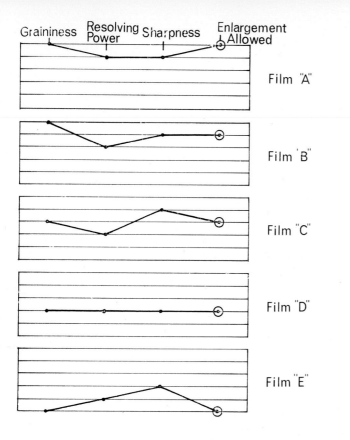

Graininess | Resolving Power | Sharpness | Enlargement Allowed

Film "A"

Film "B"

Film "C"

Film "D"

Film "E"

Fig. 175. Chart of film factors that affect definition

One major film manufacturer rates its films with respect to the three characteristics that are most closely related to definition — *graininess, resolving power* and *sharpness*. Graininess is a distinctive feature on prints that have been greatly enlarged, where it becomes apparent that the silver image is heterogeneous and uniform tones on the subject are recorded with a random-patterned variation in density. It is more difficult to identify and distinguish between resolving power and sharpness on a typical photographic print. Resolving power is related to the ability of film to record fine detail, and can be measured by photographing a test target containing alternate light and dark parallel lines that vary in width and spacing. Sharpness refers to the abruptness of the change in density in crossing the edge of a well resolved image, such as the image of the edge of a razor blade that is in contact with the film. If a photographic copy is made of a page of printed material containing type of various sizes, the resolving power of the film will influence the legibility of the small print, and the sharpness of the film will affect the appearance of the edges of the letters.

Graininess, resolving power, and sharpness ratings for five different films are illustrated in Fig. 175. The top of each chart represents the quality of the variable that contributes to good definition — that is, minimum graininess, maximum resolving power, and maximum sharpness. Although there is a certain interrelation among the three factors as evidenced by the limited spread of the ratings on each film, they are sufficiently independent to result in variations in oppo-

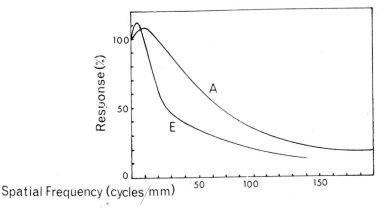

Fig. 176. Modulation transfer curves for films "A" and "E" on the chart in Fig. 175. Film "A" is advertised as a fine-grain film, and "E" as a fast film

Fig. 177. Sensitometric strip, used in plotting a film's characteristic curve

site directions. The "enlargement allowed" rating is based on a consideration of all three of the other ratings. The relative importance of graininess, resolving power, and sharpness depends considerably upon the nature of the photograph and its use. Although resolving power and sharpness tend to dominate the recording of fine *detail*, graininess is more closely associated with the *quality* of the photographic image. Fortunately, fine grain, high resolving power, and high sharpness are not incompatible, and all three can be incorporated into a film. It is only when an incompatible factor such as high speed or a large exposure latitude is required that it is necessary to sacrifice one or more of the qualities that produce good definition. Modulation transfer curves, discussed briefly in Chapter 4 in conjunction with lenses. can also be made for films. The curves are plots of contrast against lines per millimetre of the image of the test target. Modulation transfer curves for two films are shown in Fig. 176.

Tone reproduction characteristics

Relationship of the tones of the photographic image to the corresponding tones of the original scene is influenced by a number of factors including camera flare and the choice of printing paper, but the effect that film characteristics have on tone reproduction is especially important. The way a given film reproduces subject tones can be modified with variations in the exposure level and the degree

145

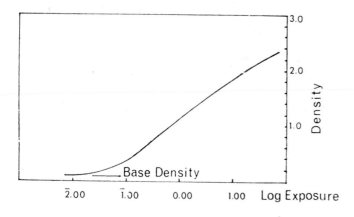

Fig. 178 A. Characteristic curve for a conventional film

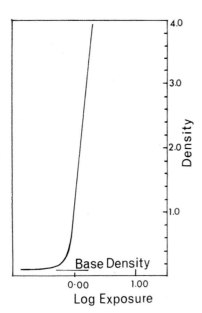

Fig. 178 B. Characteristic curve for a high contrast film

of development. Certain aspects of its response, however, are established during manufacture.

Useful information about the way a film reproduces subject tones can be gained by examining its characteristic curve. To prepare a curve, film is exposed in a sensitometer where it receives a series of known exposures that increase by a constant factor. This produces steps of increasing density on the developed film, as illustrated in Fig. 177. A sensitometric strip is similar to a typical negative exposed in a camera except that the exposure received by each area of the strip is known, and the strip receives a wider range of exposures than the typical negative. The density of each step is measured with a densitometer and is plotted against the log exposure received by the film in that area.

Characteristic curves for many films are supplied by film manufacturers, and a comparison of the curves for different films reveals significant differences in shape. The curves for a conventional camera film and a high contrast film intended for copying printed and line originals are shown in Fig. 178. The more gradual slope of the straight line portion of the curve for the conventional film indicates that this film will record a wide range of subject luminances as different densities, whereas the steep slope of the high contrast film indicates a tendency to record subject tones as either clear film or as a very high density. A comparison of the images formed with conventional and high contrast films with a low contrast subject is shown in Fig. 179. High contrast film also can be used to photograph

146

Fig. 179. Comparison of images form-
ed with conventional film *(left)*, and
high contrast film *(right)* with a low
contrast subject – *Charles Arnold*

Fig. 180. Use of high contrast film to
obtain a dramatic abstract effect
with a subject having a normal range
of tones – *Robert F. Tescione*

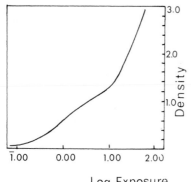

3.0

2.0

1.0

Density

1.00 0.00 1.00 2.00

Log Exposure

Fig 181. Characteristic curve for a film designed for copying continuous-tone or a combination of continuous-tone and line originals

conventional subjects when a dramatic abstract effect is desired in preference to a realistic interpretation. This application of high contrast film is illustrated in Fig. 180.

Gamma is the slope of the straight line portion of the characteristic curve, and is a measure of the degree of development. A straight line that forms an angle of 45° with the log E axis has a gamma of 1.0. Negatives with a gamma of 0.7 to 0.8 generally print best on normal contrast paper providing the other factors that affect contrast of the negative image, such as the lighting ratio and exposure, are in the normal regions. High-contrast films have gammas that range from approximately 4 to 10, and even higher.

Not all films have a single straight line connecting the toe and shoulder regions. The curve for a special film designed for copying continuous-tone photographs is shown in Fig. 181. This film has a combination of normal and high-contrast emulsions. Copies of continuous-tone photographs made on conventional normal-contrast films tend to have too little contrast in tne highlight area even though the contrast is satisfactory for the remaining tones. This is due to the flattening effect of the toe portion of the printing paper curve. Although highlight flattening can be prevented by increasing print exposure so the highlights move from the toe to the straight line of the curve, this results in a print that appears abnormally dark unless the print is viewed under strong illumination or is chemically reduced. Placement of the highlight areas on the high-contrast portion of the copy film curve increases the contrast of these areas only, resulting in a more accurate reproduction of the full range of tones of the original.

Characteristic curves for many general purpose type films are so similar that there can be no valid reason for selecting one over another in regard to tone reproduction, but it should be noted that a film with a long straight line on the characteristic curve will have more exposure latitude before the highlights "block up", and since the darker areas of subjects are normally recorded on the toe portion of the curve, differences in the shape of the toe will affect the tonal rendering. Portrait films tend to have long toe regions with a gradual slope that will hold low-contrast detail in the darker areas, whereas the higher contrast straight line is used to record the more important skin and highlight tones (Fig. 182).

148

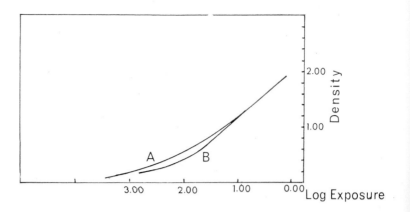

Fig. 182. Characteristic curves for a portrait film (A) and a general purpose film (B)

Colour sensitivity

When making a photographic copy of a black and white print, the colour sensitivity of the film is not important. Colour sensitivity may or may not be important when making black and white photographs of coloured objects, depending upon the saturation of the subject colours, and other factors, such as the viewer's concept of how the colours of recognizable subjects should be recorded in terms of shades of gray. In colour photography, colour sensitivity of the film becomes critical, and relatively small variations in colour sensitivity can make the difference between a successful photograph and one that is unacceptable.

Early camera films were sensitive only to blue light (and invisible ultraviolet radiation). These *blue-sensitive* films rendered blue colours lighter on the print than they appeared to the eye, and green and red colours darker. People became so accustomed to seeing white skies and dark lips that such effects were accepted as being natural. Blue-sensitive films are still being made. The limited colour sensitivity is entirely satisfactory for some types of photography, such as copying black and white originals, and the film can be handled under a fairly high level of safelight illumination in the darkroom. A wedge spectrogram for a blue-sensitive film is shown in Fig. 183. Relative sensitivity to different wavelengths is indicated by the height of the curves.

Orthochromatic Films. Extension of the colour sensitivity into the green region with sensitizing dyes produced the orthochromatic type films. Two improvements resulted from this change — the tonal rendering of subject colours was improved, and film speed was increased. Although red objects photograph too dark (in terms of the print) with orthochromatic films, the colour rendering is satisfactory for many subjects, and orthochromatic films are still being used long after the introduction of panchromatic films. The darker skin tones obtained on orthochromatic films appeals to some photographers for portraits of men, even though more retouching is required than on panchromatic film. Reluctance of some photographers to change from developing by inspection to the time-temperature method also adds to the continued popularity of orthochromatic films. The colour rendering of orthochromatic film can

149

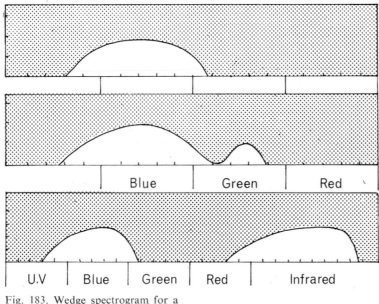

Fig. 183. Wedge spectrogram for a
blue-sensitive film

Fig. 184. Orthochromatic film

Fig. 185. Infrared film.

be approximately duplicated on panchromatic film by using an appropriate filter. A wedge spectrogram for an orthochromatic film is shown in Fig. 184.

Panchromatic Films. Most general purpose black-and-white films now being manufactured are of the panchromatic type. Panchromatic films are sensitive to all visible colours, and although there are variations in colour sensitivity among different panchromatic films, they generally record subject colours with tones of gray that correspond closely enough on the print to the visual brightness of the original colours to appear natural to the viewer. Colour response of film must be related to the colour characteristics of the illumination it is used with. Panchromatic films tend to be too sensitive to red and blue with tungsten illumination, and too sensitive to blue in daylight. Wedge spectrograms for a panchromatic film with tungsten light and daylight are shown in Fig. 186. In an attempt to obtain maximum film speed, high red sensitivity has been incorporated into some panchromatic films, with the result that red objects photographed with tungsten illumination may be rendered too light, but ordinarily the deviations involved in photographing colours with panchromatic film are observable only on colour test charts. A realistic effect is not always desirable, and the photographer can exercise considerable control over the recording of subject colours by his choice of film, by controlling the colour characteristics of the illumination, and by using filters.

Infrared Film. The value of infrared film is that it does *not* produce a realistic effect. Since it is exposed by radiation the eye cannot see,

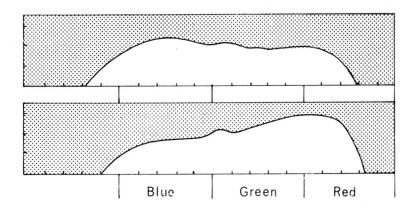

Fig. 186. Panchromatic film with daylight (*top*) and tungsten (*bottom*)

| Blue | Green | Red |

the resulting tonal rendering is often surprising and dramatic. Blue sky contains little infrared radiation, and therefore appears dark on the print, as do shadow areas that receive illumination from blue sky. Chlorophyll in plants reflects a much higher proportion of infrared than visible radiation, causing green foliage to appear nearly white on infrared photographs. Haze that obscures distant detail to the eye, and with blue-sensitive, orthochromatic, and panchromatic films, has little effect on infrared radiation. In addition to its use in the production of unusual and dynamic photographs, infrared film's ability to record detail the eye cannot see makes it a very useful material for camouflage and crime detection, medical photography, industrial photography, and other technical and scientific applications. The wedge spectrogram for an infrared film in Fig. 185 reveals that this film is sensitive to ultraviolet and part of the visible spectrum in addition to infrared. All radiation except the infrared is usually prevented from reaching the film by means of an appropriate filter. If a filter is not used, the infrared effect will be obscured, and the photograph may appear as though it was made on a conventional film.

Two special precautions are necessary when using infrared film. First, since the colour sensitivity of conventional exposure meters differs considerably from the response of infrared film, exposure meter readings cannot be depended upon to indicate the correct camera exposure settings. Preliminary exposure tests and bracketing

Fig. 186A. (*Left*) Photograph made on infrared film. A filter that transmits infrared radiation and absorbs short-wavelength radiation, to which infrared film is also sensitive, was used. (*Right*) Comparison photograph made on panchromatic film – *Donald L. Smith.*

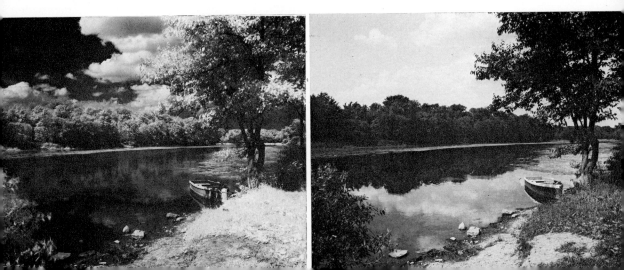

of exposures are recommended for best results. The second precaution concerns image definition. Lenses that are well corrected for visible colours may have significant aberrations with infrared radiation, and the infrared image generally comes to a focus farther behind the lens than the visible image. A precise focus correction cannot be given, but an increase of the image distance by 1/400 after focusing visually is recommended for the first trial. Small apertures are suggested to minimize the effects of focusing errors and aberrations.

Ultraviolet Radiation. Photographic emulsions are inherently sensitive to the invisible, short-wavelength ultraviolet radiation. Considerable ultraviolet is present in daylight, and it may affect the tonal rendering of blue sky, causing it to appear lighter on the print than to the eye. To expose a film entirely by ultraviolet radiation, a filter must be used over the lens that will absorb the visible light and transmit ultraviolet radiation, or the photograph must be made in a darkened room using an ultraviolet lamp.

Unlike infrared, which penetrates haze, ultraviolet emphasizes the haze on photographs of distant scenes. The appearance of haze can be minimized with conventional film by using a filter that absorbs the ultraviolet radiation, although the effect is not as dramatic as with infrared film.

Some materials reflect and absorb ultraviolet radiation and visible light in different proportions, thus providing the photographer with an additional means of detecting things not visible to the eye. Although photographic emulsions are sensitive to all wavelengths of ultraviolet radiation, only the longer ultraviolet wavelengths are transmitted through most photographic lenses. Quartz lenses are used when it is necessary to make photographs with the shorter wavelength radiation. Some objects convert invisible ultraviolet radiation into visible light, a phenomenon known as fluorescence. Photographs of fluorescent objects are best made with a filter over the lens that will *absorb* all ultraviolet radiation, since this will tend to reduce the contrast between the fluorescent object and the surrounding. For this type of ultraviolet photography, the film is exposed with the visible light resulting from fluorescence.

152

Blue Sensitive

Yellow Filter

Green (& Blue) ''

Red (& Blue) ''

Base

Fig. 187. Cross-section of a typical colour film

Colour sensitivity of colour films

Most colour films contain three emulsion layers. The colour sensitivity of the emulsions is controlled so that only one of the three primary colours — red, green, and blue — is recorded on each. Since photographic emulsions are inherently sensitive to blue light, colour films generally consist of blue, blue-and-green, and blue-and-red sensitive emulsions, with a yellow filter to prevent the blue light from reaching and exposing the last two emulsions (Fig. 187). Speed and characteristic curves for the three emulsions must be balanced so that acceptable colour reproduction is obtained when the film is exposed with illumination of the poper colour temperature. Extensive changes in colour temperature, as in switching from daylight to tungsten illumination, go unnoticed with black and white panchromatic films except when comparison prints are made or when special colour test charts are photographed. A similar change in illumination with a colour film designed for use in daylight will cause the image to appear much too yellow. Colour films have been manufactured for use with various types of illumination — namely, daylight, 3200 K, photoflood, flash, and electronic flash. It is impossible for film manufacturers to provide colour films balanced for all types of illumination photographers may want to expose colour film by, including tungsten and fluorescent lamps that vary in colour temperature over a wide range, and the many variations in daylight at different times of the day and with different weather conditions. When it is necessary to use a reversal type colour film with illumination other than that for which it was balanced, appropriate colour filters must be used over the camera lens (Fig. 188).

Negative type colour films have considerable latitude so that they can be exposed to various types of illumination without a filter, and the corrections can be incorporated at the printing stage. Complications are encountered when two different colour temperature light sources are used in the same photograph, as when an interior architectural photograph includes a window and an outdoor view. Use of light sources indoors that approximate the colour temperature of daylight, such as blue tungsten lamps or flashlamps, or electronic flash offer a solution to this problem. Blue flashlamps and electronic

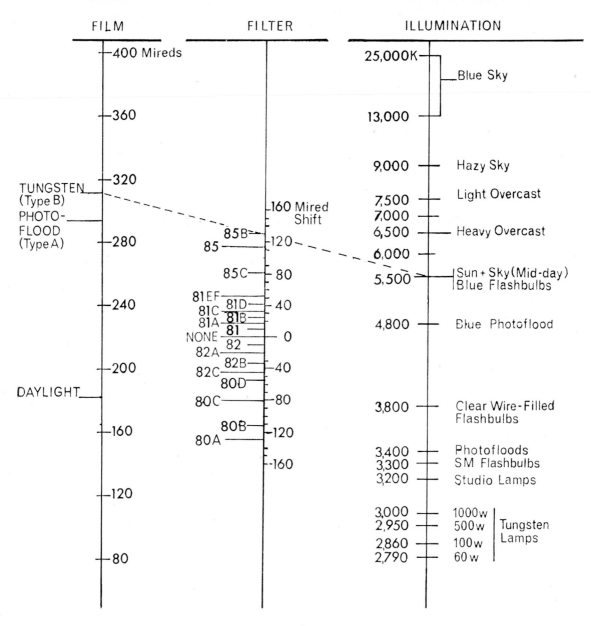

Fig. 188. Nomograph for choice of appropriate colour filter with various colour film and light source combinations

flash are also used to reduce the lighting ratio by filling in the shadows with colour photographs made in direct sunlight.

Filters

There are three fundamental types of photographic filters—colour filters that selectively absorb radiation of certain wavelengths, neutral density filters that absorb all wavelengths of visible radiation equally, and polarizing filters that absorb polarized light.

Colour filters vary one from another in the range of wavelengths of radiation absorbed, and in the extent to which the radiation is ab-

Fig. 189. Spectrum of white light

Green

Cyan Yellow

Blue Red

400 500 600 700
 nm

Magenta

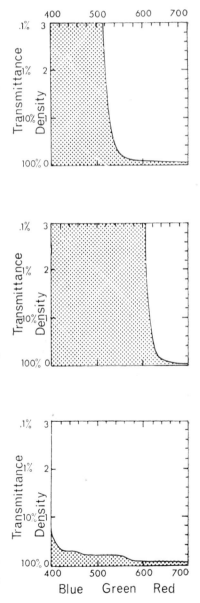

Fig. 190. Filter absorption curves for three filters showing a variation in the range of wavelengths absorbed *(top and middle)* and a variation in the relative amount of absorption *(middle and bottom)*

sorbed. Thus, one filter may absorb only blue light while another absorbs blue, green and cyan light, and with two filters that absorb cyan light, the absorption may vary from complete to so little that the filter may appear to the casual observer to be a piece of plain glass or gelatin. These variations are revealed in the three absorption curves in Fig. 190, in which wavelengths are plotted on the horizontal axis against density on the vertical axis.

Colour nomenclature. Except for scientific and technical applications of filters, photographers usually prefer to describe the action of filters in terms of colours of light rather than wavelengths. The colour terms that are most useful in discussing filters and colour photography are *red, green, blue, yellow, cyan*, and *magenta*. All of these colours except magenta are found in the spectrum of white light. Red, green, and blue are referred to as the *additive primary col-ours*, since by adding the proper proportions of these three colours of light, white light or the visual effect of any ordinary colour can be produced. Thus, yellow, which is located between red and green in the spectrum, can be produced by mixing red and green light (Fig. 189). Cyan, which is between green and blue in the spectrum can be duplicated by mixing these two primary colours, and magenta, which does not appear in the spectrum, can be obtained by mixing red and blue light. Placing the names of the primary colours at the points of a triangle and the colours formed by combining two primary colours on the straight lines connecting them may be helpful in visualizing the relationship of these six colours (Fig. 191). Any pair of colours that appear opposite each other on the diagram, such as blue and yellow, can be combined to form white light, and are known as complementary colours. This diagram will be used again as an aid in predicting the effect filters will have on the way subject colours are recorded.

Use of filters with black and white films

Photographers can exercise considerable control over the way colours are recorded on the film, and therefore on the print. Before attempting to determine the effect that various filters will have on

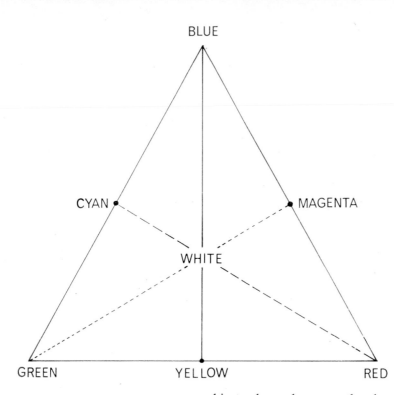

BLUE

CYAN

MAGENTA

WHITE

GREEN

YELLOW

RED

Fig. 191. Triangular arrangement of primary and secondary additive colours as an aid to determining the results of mixing various colour combinations of light

subject colours, however, the photographer should have a good concept of how the film will record the colours without filters. Although panchromatic films do not record colours as tones of gray that correspond exactly with their visual lightnesses, they are close enough for the photographer to predict the results with reasonable accuracy if he can concentrate on the lightness of the colours and ignore their hues. Thus, a gray object and a blue background may provide vivid colour contrast to the eye but be recorded as identical tones of gray on the negative and print. If the photographer can anticipate this loss of tonal separation, he is in a position to decide whether he wants the blue background rendered lighter or darker than the object, and which filter to use. In making judgments of this type, however, photographers should keep in mind that panchromatic film tends to record reds and blues slightly lighter than the eye sees them in tungsten illumination, and blues slightly too light in daylight. In addition, the ultraviolet radiation from blue sky causes it to appear lighter on the print than it appears to the eye.

Predicting Filter Effects. There are several methods for predicting the effect a filter will have in lightening or darkening subject colours. Since the first application of filters for most photographers is in darkening blue sky, they learn from the filter instruction sheet and from experience that the darkening effect increases from light yellow to dark yellow to red filters. A second method is to look at the subject through the filter, which will cause colours to appear lighter and darker to the eye in much the same way as they will on the print.

The degree of success of this method depends upon the similarity of colour response of the film and the eye, and upon the viewer's

156

Fig. 192 *(top)* Weak tonal separation (arrow) between gray object and blue background on panchromatic film without a filter

(Middle) A blue filter lightens the background, increasing tonal separation

(Bottom) A red filter darkens the background. This increases the tonal separation in the area indicated on the no-filter photograph, but decreases it elsewhere

Fig. 193. Attempt to predict the tone with which blue sky will be recorded using *(from top to bottom)* no filter, a yellow filter, a red filter, and a blue filter with panchromatic film. The black pointer indicates the closest visual match. Invisible ultra-violet radiation accounts for the discrepancy on the no-filter photograph

Fig. 194. Filters transmit their own colour and absorb other colours, both as isolated colours and as components of other colours

Red Filter

ability to isolate the brightness quality of the colours. Figure 193 illustrates the accuracy with which it is possible to predict the tonal rendering of colours. In the first photograph, made without a filter, the marker identifies the step on the gray scale that appeared to be the closest brightness match to the blue sky background. The film's sensitivity to ultraviolet radiation caused the sky to be recorded slightly lighter on the print than it appeared to the eye. The scene was then viewed through three filters and the closest brightness match was again selected for each. The three photographs, made through the filters on panchromatic film, reveal that the gray scale step selected visually was also the closest photographic match.

A third method for predicting the effect a filter will have on a photograph is based on an understanding of the fundamental action of a filter in absorbing and transmitting colours. For quantitative information of this nature, it is necessary to refer to the density-wavelength absorption curves, but since most of the filters used for tone control can be classified as one of the six colours mentioned previously — red, green, blue, yellow, cyan, and magenta — it is more useful to become familiar with the general absorption and transmission characteristics of filters corresponding to these colours.

Filters transmit their own colour and absorb other colours. Thus, a red filter transmits red light, including the red component of white, magenta, and yellow light, while absorbing blue and green light — both as isolated colours and as components of other colours (Fig. 194). In terms of the image on black-and-white prints, filters lighten their own colour and darken others. It is easy to understand why a red filter will darken blue and green subject colours on the print, because the filter absorbs these colours and reduces exposure of the film in these areas. Since a filter cannot transmit more light of a given colour than falls on the filter, it is not so apparent how a red filter lightens red subject colours until it is noted that the exposure is increased when a filter is used, to maintain the same negative density in neutral (gray) areas. If a red filter transmits essentially all of the red light and the exposure must be multiplied by 3, for example, to compensate for the absorption of blue and green light from a gray scale, then the red image areas receive three times the exposure with the filter that they did without, and they appear lighter on the print.

Effect on Complementary and Mixed Colours. Anticipating the effect, that red, green, and blue filters have on yellow, magenta, and

Fig. 195. In reference to the print, a filter will lighten objects of the same colour and also the colours adjacent to it, and darken other colours

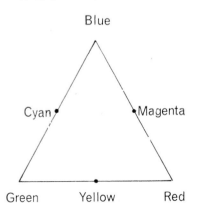

cyan subject colours is not quite as simple as when only the primary colours are involved, except when the filter and subject colours are complementary. A red filter is complementary in colour to cyan, and therefore absorbs most of the light from cyan subject areas, causing them to appear darker on the print. When the same red filter is used to photograph magenta (red-blue) subjects, the filter absorbs the blue and transmits the red. If we simplify the situation by assuming equal amounts of red and blue in the magenta subject and equal amounts of red, green, and blue in the gray scale, the red filter will lighten the magenta on the print because the filter transmits a larger proportion of the magenta light (1/2) than of the light from the gray scale (1/3). The change in tone is more subtle than in the preceding examples, however, and if the magenta contains more blue than red, instead of equal amounts, the effect of the filter will be less, and may disappear entirely.

Subject colours are usually a mixture of two or more of the basic colours. Objects that we loosely identify as red often reflect appreciable amounts of blue and green light in addition to red, for example. This is one of several factors that make it difficult to predict the degree of lightening or darkening that will result from using a certain filter. Typical "blue" sky contains a considerable proportion of green light, and even some red. If blue sky contained only blue light, efficient red, green, and yellow filters would all be equally effective in absorbing the blue and darkening the sky on the print. Determination of the relative absorption and transmission of subject colours, and the lightening or darkening effect of filters, may be facilitated by referring to the triangular chart of the six basic colours (Fig. 195). A filter lightens objects of the same colour and also the colours adjacent to it on the chart, and darkens the remaining colours. For example, a green filter lightens green, cyan and yellow and darkens blue, magenta and red. If a photographer wants to increase the contrast between red letters on a yellow background, making the red darker on the print, the chart reveals that although a green, a cyan, or a blue filter darkens the red, only the green filter simultaneously lightens the yellow.

In addition to the purity of the subject colours other important factors that affect the amount of tonal change that results from using a filter are the absorption characteristics of the filter, the spec-

tral energy distribution of the light source, and the colour sensitivity of the film.

Although filters are often classified on the basis of the intended use or other characteristics, colour filters vary in two respects – in the range of wavelengths absorbed, and in the completeness of absorption. The first of these two variables determines which subject colours are lightened and which are darkened, and the second determines the extent of lightening or darkening. Thus yellow filters are available in several different strengths, which can be used to obtain various degrees of darkening of blue sky. While strongly coloured filters will produce dramatic changes in tone only with highly saturated subject colours, subtle changes can be obtained by using weak filters. *Correction* filters are normally weak filters that absorb only enough of the appropriate colours to minimize the discrepancy between the tonal rendering of colours with panchromatic film and the visual brightness of the colours. A green correction filter is usually required in tungsten light and a yellow correction filter in sunlight.

Neutral density filters

Neutral density filters absorb all colours equally, so that the tonal rendering of colours is not affected. They provide the photographer with a third control, in addition to shutter speed and relative aperture, over film exposure. Neutral density filters are especially useful when it is necessary to use a large aperture (to obtain a shallow depth of field), a slow shutter speed (for intentional blurring of moving objects) or to prevent overexposure with high levels of illumination. Transmittance of neutral density filters decreases by a factor of 2 for each increase in density of 0.3.

Neutral density filters are sometimes calibrated in equivalent stops. Thus a 0.3 N.D. is 1 (stop), 0.6 N.D is 2 (stops), etc. When exact changes in exposure of film in a camera are required, neutral density filters offer certain advantages over the conventional aperture and shutter speed controls. Variations in aperture and shutter speed may introduce complications involving reciprocity law failure or changes in shutter efficiency so that the desired change in density is not obtained. Also, since most shutters do not produce intermediate ex-

161

Fig.196. Polarizing filters designed for use in front of the camera lens (small circle) and in front of the light source (large circle) in comparison with 0.3 and 0.6 square neutral density filters

WRATTEN ND FILTER 0.30

WRATTEN ND FILTER 0.60

posure times when set between the marked speeds and intermediate aperture settings can only be estimated, neutral density filters provide a means for obtaining small changes in exposure. A difficulty is sometimes encountered with electronic flash in that the shutter cannot be used effectively to control exposure due to the short duration of the flash. Neutral density filters can be used to control the exposure with electronic flash when a large aperture must be used to obtain a desired limited depth of field, or a desired degree of diffusion with a soft focus lens.

Another useful application of neutral density filters is to compensate for the difference in speed of two films that are to be exposed to the same subject. For example, Polaroid prints are often used to check lighting, arrangement of the subject, depth of field, and exposure before exposing colour film. If the speed of the Polaroid film is four times that of the colour film, a 0.6 N.D. filter would be placed over the camera lens for exposure of the Polaroid film and removed for exposure of the colour film.

Polarizing filters

Polarizing filters appear quite similar to neutral density filters, and when used to photograph a scene containing only unpolarized light, the effect is the same — that is, the intensity of the light is reduced, and there is no change in the tonal rendering of subject colours.

The polarizing particles in the filter are all oriented in the same direction so that they function as light slits. Light vibrating in the same direction as the slits is transmitted freely, while light vibrating at right angles is completely absorbed (Fig. 197). Since unpolarized light vibrates in all directions radially from the line of travel, some of the light is absorbed, and the light that is transmitted becomes polarized.

Rotating the filter has no effect on the image when the light reaching the filter is unpolarized. Light from glare reflections on most non-metallic surfaces is almost completely polarized at certain angles — 30 to 40 degrees to the surface, depending upon the material. Such polarized light reflections can be almost completely eliminated by rotating the filter until the slits are at right angles to the plane of vibration of the polarized light (Fig. 198). The effect can be seen by looking through the filter or by examining the ground glass image with the filter in front of the lens. There is no change in the reflection from metal objects because that light is not polarized. Placing a polarizing filter over the light source, however, produces a polarized light reflection on metal that can be removed by rotating the two filters at right angles to each other (Fig. 199).

As the angle of the camera to non-metallic surfaces deviates from the angle of maximum polarization, the control of reflections with a single polarizing filter over the lens decreases (Fig. 200). With a second polarizing filter over the light, however, reflections can be minimized on both the metal and non-metal surfaces (Fig. 201). This

Fig. 197 (left). Orientation of particles in polarizing filters cause them to function as light slits. Unpolarized light (below) vibrates in all directions radially from the line of travel

(Right) Polarizing filters for light sources in uncrossed (left) and crossed positions

Fig. 198 Polarization of light by a non-metallic surface, and the absorption of the polarized light with a polarizing filter.

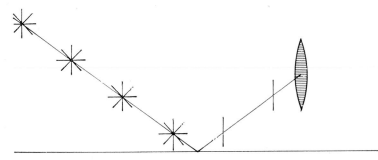

Non-Metallic Surface

When photographed at the appropriate angle, glare reflections on non-metallic surfaces can be effectively eliminated with a polarizing filter in front of the camera lens

(Below) Metallic surfaces do not polarize reflected light

(Left) Glare reflection on metallic ruler and non-metallic background

Metallic Surface

164

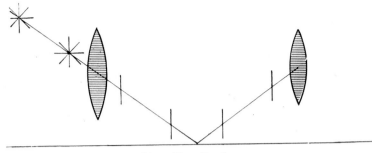

Fig. 199. Placing a polarizing filter over the light source produces a polarized light reflection on metal that can be removed with a polarizing filter in front of the camera lens

Metallic Surface

(Right) Elimination of glare reflection on non-metallic background and painted markings on ruler with one polarizing filter

(Below right) Reduction of glare reflection from metallic surface with crossed polarizing filters in front of the light source and the lens

(Bottom left) Glare reflection from surface containing black and gold printed areas

(Bottom centre) A single polarizing filter in front of the camera lens eliminates reflections from all except the gold printed areas

(Bottom right) Elimination of glare from all areas requires the addition of a crossed polarizing filter in front of the light source

Fig. 200. The effectiveness of a single polarizing filter in eliminating a glare reflection varies with the angle. At 90°, there is no difference between the no-filter photograph and the one with a filter *(above)*. At an intermediate angle *(top left)*, a single filter reduces the glare *(left)*

Fig. 201. Complete elimination of the reflection at an intermediate angle requires two polarizing filters *(bottom left)*

Fig. 202 *(opposite)*. An example of attractive reflections that should not be eliminated with a polarizing filter – *Neil Montanus*

Fig. 203 *(lower opposite)*. Polarizing filters are effective in darkening blue sky on colour photographs – *Lawrence S. Williams*

technique is useful in making photographic copies of photographs on high-sheen textured paper and oil paintings that produce a multitude of small glare reflections when copied in the conventional manner. Glare reflections should not always be considered undesirable. They can contribute much to the appearance of texture, form, and general attractiveness of many subjects (Fig. 202).

Blue sky is another source of polarized light that can be controlled with a polarizing filter over the camera lens. The polarization varies over the hemisphere of sky that can be viewed from an open position, reaching a maximum in the band that is photographed when the camera lens axis is at right angles to a line from the camera to the sun. This method of controlling the rendering of blue sky has three advantages over the use of colour filters.

1. Variations in the degree of darkening can be obtained with a single filter by rotating the filter.

2. The monochromatic rendering of other subject colours on black-and-white film is not affected.

3. The polarizing filter can be used with colour film (Fig. 203).

166

7

EXPOSURE AND EXPOSURE METERS

Variations in camera exposure of black-and-white film affect image contrast and definition in addition to the more obvious change in image density. Seldom is there a single *correct* exposure. The range of camera exposures that produce acceptable results varies due to such factors as the nature of the subject, the lighting, characteristics of the film, development, and the discriminating judgment of the viewer. As a result, the range of acceptable exposures may be as low as 1 : 2 and as high as 1 : 100 or higher.

The prints in Fig. 204 were made from negatives receiving exposures that increased by a factor of 2. Reasonably satisfactory results were obtained on normal contrast printing paper from negatives representing a 1 : 32 ratio of camera exposures. If large scale enlargemets were made, some of the denser negatives would be less satisfactory due to a loss of definition and the long print exposure times required. Large negatives, which require little or no enlargement, suffer the least from defects resulting from overexposure.

Different contrast grades of printing paper make it possible to compensate to some extent for the changes in contrast resulting from underexposure and overexposure of the negative, thus extending the acceptable range. If a normally exposed negative prints satisfactorily on normal contrast paper, an *under*exposed negative will require a higher contrast paper. An *over*exposed negative may be either flat or contrasty, depending upon the degree of overexposure. It can be observed in the exposure series in Fig. 204 that image contrast increases with increased exposure of the negative up to a point, levels off, and then decreases with gross overexposure. Use of published film speeds tends to produce negatives that are in the region of increasing contrast. The local loss of contrast in the shadows resulting from underexposure and in the highlights with overexposure cannot be fully corrected by using a higher contrast printing paper.

Effect of incorrect exposure

The major image defects resulting from incorrect exposure of black-and-white film are loss of definition and change in contrast. The most common and most serious defect resulting from incorrect

exposure is the loss of contrast and detail that occurs in the darker areas of the subject due to underexposure. There is more latitude on the overexposure side before the highlights "block up", resulting in a loss of detail. It is for this reason the expression "It is safer to overexpose than to underexpose" is well founded. Even moderate overexposure, however, has a subtle effect on graininess, resolution and sharpness which becomes apparent to the viewer as a loss of definition on prints made at large magnifications.

Negative-type colour films suffer the same defects with underexposure and overexposure as black-and-white films, with the additional complication that colour balance of the image is also affected. Such shifts in colour can seldom be fully corrected in printing because the changes are not uniform from the highlights to the shadows. As with black-and-white films, moderate overexposure produces less objectionable defects than underexposure. Changes in contrast with exposure are more serious with colour negatives because colour printing papers are not made in contrast grades.

Reversal-type colour films have considerably less exposure latitude than the negative type. Plus or minus half stop deviations from the correct exposure are about the maximum that will be tolerated with conventional subjects and moderate lighting ratios. Part of the small exposure latitude of reversal colour films results from the requirement that the image must usually appear realistic in respect to brightness and contrast under standardized viewing conditions. It is sometimes possible to obtain a good colour print or photomechanical colour reproduction from a transparency that appears slightly too dark when viewed directly.

Exposure meters

Photographers must be able to determine the correct exposure with considerable precision when using films that have small exposure latitude. Even with films having large exposure latitude, the reward of consistently obtaining negatives that are capable of producing excellent prints with the least effort makes mastering this critical step of the picture-making process worthwhile. Unfortunately, there are so many factors that can affect the density of the photo-

Fig. 204. Beginning at the top left, each consecutive photograph represents an increase in the film exposure by a factor of 2. The second print in the second row was made from the calculated normal exposure negative (Prints made on normal contrast paper.)

171

graphic image that the only way the photographer can be absolutely certain he has exposed the film correctly is to process the film and examine the resulting image. This technique is not uncommon in the field of advertising photography where the standards are high and deadlines must be met.

The relatively long processing times reduces the attractiveness of this procedure with colour films. Modifications that reduce the delay while still providing reliable information about the exposure (and other factors) are either to develop an exposed trial sheet of the colour film in a fast acting black-and-white developer. evaluating the resulting negative silver image, or to expose Polaroid film, using a neutral density filter to compensate for the difference in film speed. When it is not practicable to employ any of these safeguards, photographers usually bracket the exposure to be sure of having one correctly exposed negative or transparency. Bracketing becomes an expensive and time consuming procedure, however, when the photographer is involved in photographing a number of different views.

Exposure meters make it possible to obtain consistently satisfactory exposures providing the photographer tests his equipment and material, learns to compensate for the miscellaneous variables that affect the results, and masters the techniques of using the meter with various types of subject.

It cannot be assumed that all exposure meters function perfectly. A meter that reads one stop too high or too low can cause considerable damage before the cause of the difficulty is identified. A meter that is suspected of being inaccurate should be checked against several other meters with a standard light source, such as a transparency viewer. The following data show the results of such a comparison test with 40 exposure meters.

Although most of the meters agreed within plus or minus one third stop, 8 meters gave readings beyond this range, with a difference between the minimum and maximum readings of nearly 6 stops.

Accuracy at the centre of the scale does not assure accurate readings at other positions on the scale. The extremities should be regarded with suspicion. Neutral density filters with densities of 0.3 0.6, 0.9, etc. (the equivalent of full stop variations in light intensity) can be used to check the accuracy of the entire scale. With a light source that places the needle at the top marking on the scale, the

fN	Number of meters	fN	Number of meters
	METER ACCURACY COMPARISON TEST		
4.5	1	12.7	1
5		14	
5.6		16	1
6.3		18	2
7		20	3
8		22	26
9		25	3
10	1	29	1
11		32	1

addition of the neutral density filters over the meter cell in the order of increasing density should depress the needle by full stop decrements. A record should be made of any discrepancies and appropriate compensations made on future readings. Any disagreement of readings in the overlap area of high and low scales of the meter should also be noted. The American Standard for Photographic Exposure Meters, PH2.12–1961, contains recommendations for meter manufacturers concerning design and performance. Some meter manufacturers include test results, showing the accuracy of the meter at various positions on the scale, with each meter they make.

Another type of meter shortcoming that can result in incorrect exposures is a significant difference in the colour sensitivity of the meter and the film. Thus, if a meter has relatively high red sensitivity and low blue sensitivity, compared with the film, reflected light readings from red objects and blue objects will result in underexposure and overexposure respectively. This has been one of the shortcomings of the cadmium sulphide cell exposure meters, which have gained considerable popularity in recent years. Higher sensitivity of the cadmium sulphide meters makes it possible to take readings in dimmer light than with the selenium type. The difference in colour sensitivity of the two types of meters is illustrated in Fig. 205. Some of the newer cadmium sulphide meters have been modified with filters to minimize the imbalance of colour sensitivity, with some sacrifice in overall sensitivity. Major differences in colour sensitivity of two meters can be detected by comparing readings made with the

Fig. 205. Spectral sensitivity curves for panchromatic film *(top)*, selenium cell exposure meter *(middle)*, and cadmium sulphide cell exposure meter *(bottom)*

UltraViolet Blue Green Red

two meters through red, green, and blue contrast filters. Less harm will result from using a meter that has a poor balance of colour sensitivity with incident light readings (or reflected light readings from an 18% gray card) than with reflected readings directly from subjects, some of which may be strongly coloured.

Exposure meter usage

Many different methods of using exposure meters have been proposed and are being widely used. Assuming that his exposure meter is accurate, the photographer is still faced with the problem of deter-

mining the type of meter reading that will produce the best result for each photograph he makes. Photographers who specialize in one type of work, studio portraiture for example, find that they obtain more consistent results by using only one type of meter reading. Photographers who are confronted with a wide variety of picture making situations, such as industrial photographers, find that no one method will meet all of their needs.

"Reflected light reading" is the term applied to an exposure meter reading made with the cell of the meter aimed toward the subject. The fact that this term is a misnomer in situations where the subject is transparent or translucent and is illuminated from behind, and where the subject is emitting the light rather than being illuminated from an external light source is of no consequence in practice.

Mid-tone reflected light reading

Reflected light exposure meters are calibrated to produce the best exposure when the reading is taken from a medium-tone area. An 18% reflectance gray is generally accepted as representing a medium tone between white and black. Thus, if a photograph is made of a gray scale on reversal colour film as indicated by a close-up reflected light reading from the intermediate step that reflects 18% of the light, the image on the processed film will appear to be a good reproduction of the gray scale, and the 18% gray step will be rendered as an appropriate medium density. If, however, the reflected light reading had been made from the white end of the gray scale, that step would be recorded as a medium density, and the image of the gray scale would appear much too dark. Conversely, a reading from the black end would record that step as the same medium density, and the image of the gray scale would appear much too light.

This illustrates a major weakness of reflected light readings. It is very difficult for a person to look at a typical scene containing highlights and shadows, and areas that vary in reflectance and colour, and select the mid-tone area from which the reflected light reading should be made. Actually, the scene may not contain a suitable area. When photographing a white object, such as a teacup, against a white background with shadowless lighting, for example, exposing

175

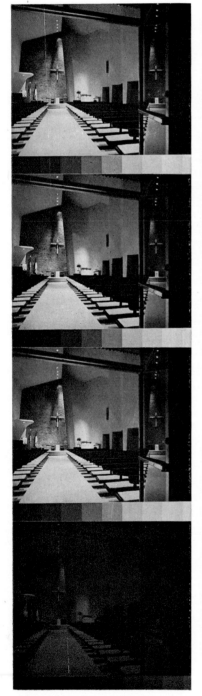
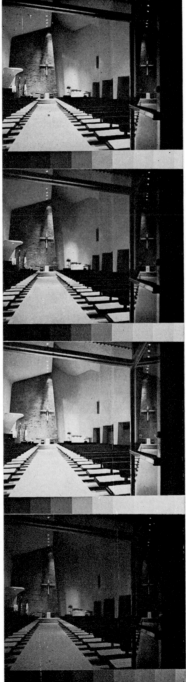

Fig. 206. Discrepancies between exposure meter and film colour sensitivities are indicated for a cadmium sulphide meter *(left)* and a selenium meter *(right)* by variations in print density. From top to bottom: no filter, green filter, blue filter, red filter. Copy negatives were made of a black and white print and a gray scale through the various filters on the basis of incident meter readings made through the same filters. Negatives were gang printed. A dark print therefore represents a thin negative, which results from the meter having a relatively higher sensitivity to that filter colour than the film

for a medium tone in the scene will produce a transparency that is much too dark for the same reason that exposing for the white end of the gray scale resulted in overall underexposure. Substituting an artificial mid tone (an 18% reflectance gray card) eliminates most of the difficulties involved in this method of using the exposure meter. It is important to place the gray card close to the subject and to aim it half way between the main light and the camera when making the reading.

Calculated mid-tone, or brightness-range method

Another method of avoiding the problem of determining the best area from which to make a close up mid-tone reading is to make two readings, one from the lightest area where detail is desired and the other from the darkest, using a position half way between the two readings to determine the aperture and shutter settings. It should be noted that the calculated mid tone is not an arithmetic average of the two light readings. Since exposure meter scales and calculator dials normally have the same progression as the f-numbers on lenses whereby each major division represents an increase or decrease in light intensity by a factor of 2, the mid value can be selected either on the scale or the dial of the meter, or on the lens.

The calculated mid-tone method is designed to centre the tones on the most useful part of the film's characteristic curve, retaining detail over the maximum range of subject contrast. This feature is especially valuable with negative materials where the controls at the printing stage provide the opportunity to make changes in the density of the image and to introduce local variations with dodging and burning techniques. With reversal colour films, it is not as important to have detail in the most extreme highlight and shadow areas — especially if the areas are small — as it is to render important intermediate tones appropriately.

Key-tone method

There is no reason why reflected light readings cannot be made from lighter or darker areas than the 18% gray card, providing an

177

appropriate compensation is made. It may be desirable to make a reading from a white area, either because there is not enough light to obtain a reading from the gray card, or because a gray card is not available. Since a typical white surface reflects about 90% of the light (five times as much as the 18% gray card) compensation can be made by dividing the film speed by five, dividing the light reading by five if the numbers on the meter scale are proportional to light intensity, or multiplying the indicated exposure by five by adjusting the aperture or the shutter speed.

A recommendation has appeared in some publications that when there is an uncertainty concerning the area from which a reflected light reading should be made, an area of principal interest should be selected. This recommendation is valid only if the proper compensation is made for areas that are lighter or darker than an 18% gray. For example, a not uncommon practice is to make meter readings from a person's face or hand and then double the indicated exposure on the basis that the average person's skin reflects approximately 36% of the light. Although this procedure is basically sound, variations in the reflectance of the skin of different individuals can result in significant exposure errors.

A more sophisticated approach to the key-tone method is to identify important reference points on the meter dial. Weston exposure meters use "U" and "O" markers to locate the limits of the range of scene luminances that can be recorded satisfactorily. Although films vary in respect to this characteristic, the 1:128 ratio established by the "U" and "O" positions is sufficiently realistic to be useful both for colour films and for black-and-white films with normal development. If a meter reading is taken from a dark area and the "U" position on the dial is set opposite this reading, this area of the image on reversal colour film will be dark but with visible detail. On negative film, this area will be thin but with printable detail. Thus, a "U" position reading is useful to determine the least exposure that will produce a printable negative. The "U" and "O" positions are probably more useful in determining if it is necessary to modify the lighting to retain detail, or to purposely lose detail in specific areas after the shutter and aperture settings have been determined on the basis of a mid-tone or incident reading than for determining the shutter and aperture settings. For example, if a completely white

background is required for a photograph, a reflected light reading from the background must fall above the "O" position on the dial.

These concepts can be applied to any exposure meter by noting that the "U" position represents 1/16 (4 stops under) and the "O" position represents 8 times (3 stops over) the reading opposite the normal pointer. With Ansel Adams' Zone System, the dial is divided into 10 zones which are identified by numbers and by patches of paper of varying shades from white to black which are used to relate reflected light readings from selected parts of the scene to the tones of the corresponding parts of the image on the print or transparency.[1]

Camera position reflected light reading

One of the most popular methods of using the exposure meter is to make a reflected light reading from the camera position. With the exception of the "spot" meters, which are capable of reading relatively small areas from a distance, most meters include roughly the same area as normal focal length lenses. Meters integrate the light from all parts of the scene that are included within their angles of acceptance. The camera position reflected light reading will produce satisfactory exposures with scenes composed of a good balance of light and dark tones, but will produce underexposure with scenes in which light tones dominate and overexposure when the dark tones dominate. Meter instruction books caution the user to tilt the meter down to avoid including the bright sky area. Most exposure meters that are built into cameras have large angles of acceptance, although some are designed to minimize the effect of light from the sky.

Those who are familiar with the inherent shortcomings of the camera position reflected light method are often surprised at the high percentage of acceptable photographs that are produced with this method in practice. It is incapable, however, of producing consistently good exposures with a variety of subjects as required by professional photographers.

[1] White, M., Zakia, R., and Lorenz, P. *The New Zone System Manual.* Dobbs Ferry, NY: Morgan and Morgan, 1976. Dowdell, J., and Zakia, R. *Zone Systemizer.* Dobbs Ferry, NY: Morgan and Morgan, 1973.

Incident light reading

Incident light meters are designed to measure the light falling on the subject rather than the light that is reflected. Since the incident meter ignores the subject, exposure of the film is based on the assumption that the subject is normal with respect to reflectance. Therefore, an incident light reading can be expected to produce the same exposure as a reflected light reading from an 18% gray card. This comparison test should be made with meters that can be used for both incident and reflected light readings. The simplicity and reliability of incident type readings have made this method popular with professional photographers. Obviously, incident meters must be positioned where the illumination is the same on the meter as it is on the subject. In the studio, this usually requires placing the meter as close as possible to the subject being photographed. The illumination outdoors is often the same at the camera as it is at the subject, making it unnecessary to leave the camera position to take the reading.

Thought must be given to the direction in which the incident meter is aimed, with respect to the camera and the main light source. Meters that have hemispherically shaped diffusers over the cell should normally be aimed directly at the camera, regardless of the position of the light sources. The reasoning is that if the main light is first placed close to the camera and then gradually moved in an arc to the side and then behind the subject, maintaining the same distance from the subject, the exposure should be increased as the shadow areas increase in size and importance. An automatic compensation is made with meters equipped with hemispheric diffusers because progressively less of the diffuser receives light as the source is moved to the side. Meters equipped with flat diffusers should be aimed half way between the camera and the main light source, the same as the gray card with reflected readings, although the flat attachment is provided with some meters only for the purpose of determining lighting ratios. To determine the correct angle for meters having diffusers that are neither flat nor hemispherical, make comparison incident readings and a reflected light reading from a properly positioned 18% gray card with a subject that is illuminated by a single light placed ninety degrees to one side.

Modifications of the exposure resulting from incident light

readings (or reflected-light, gray-card readings) is occasionally desirable because of the nature of the subject. Although detail can be retained in both white objects and black objects that are photographed together on reversal colour film according to an incident or a gray card meter reading, these areas may not be recorded with the ideal densities we would prefer and could obtain by photographing the objects separately and modifying the exposure.

Limitations of meter readings

Although comparable results can be obtained with reflected light and incident light readings with most subjects, neither method can be used successfully in all picture making situations. Incident light readings, for example, cannot be used where the subject is emitting the light, as with certain types of advertising display signs, molten metal, or any incandescent, fluorescent, or phosphorescent object. Similarly, transparent and translucent objects illuminated from behind (a stained glass window, for example) are not suited to incident type readings. There are situations where it is difficult or impossible to place an incident meter where it will measure the light falling on the subject, as when photographing store display windows at night or a distant sunlit scene with the camera in a shaded area.

Reflected light readings are also unreliable or difficult to make in some situations. Conventional reflected light exposure meters are incapable of accurately reading the reflected light from small objects. They also encounter difficulty with distant or otherwise inaccessible scenes that do not contain a good balance of light and dark tones. Although "spot" meters are capable of reading smaller areas, they require more judgement on the part of the photographer in interpreting the reading unless it is made from an 18% gray card — which is esentially an incident type reading.

Exposure with flash

Special problems are encountered in exposing film correctly with flash light sources due to the short duration of the flash. Conventional exposure meters cannot measure light of such short duration,

181

but special meters have been designed for this purpose. Battery-powered and alternating-current models of electronic flash meters are available. Electronic flash meters are normally operated by placing the cell at the subject and measuring the incident light. Since electronic flash tubes can be flashed repeatedly, there is usually no problem in flashing the light to obtain a meter reading before exposing the film.

Conventional exposure meters can be used with electronic flash units that have built-in modelling lights. Since the meter reading is made for the modelling light and the film is exposed with the flash, it is necessary to establish a conversion factor. The meter dial can be used conveniently for this conversion. After making a meter reading with the modelling light, determine the f-number that will expose the film correctly by trial, guide number, or electronic flash meter. (The choice of shutter speed does not affect the exposure with electronic flash except with high shutter speeds and relatively long-duration flash units.) The shutter speed that corresponds to this f-number on the meter dial is noted and identified with a marker. The correct f-number, on future meter readings, is found opposite this marked shutter speed.

Expendable flashbulbs present an even more difficult exposure problem since it is not practicable to flash additional bulbs for the sole purpose of determining the lens and shutter settings. Although cameras are being produced that automatically control the exposure with flashbulbs by interlocking the diaphragm and the focusing mechanism, or a more intricate system that measures the light and adjusts the exposure time while the film is being exposed, the most widely used exposure control system is the guide number. Guide numbers can be reliable and they are easy to use with a single flashbulb at or near the camera since the f-number is determined by dividing the guide number by the flash to subject distance. The complexity of the situation when two or more flashbulbs, possibly with different light outputs, are used at different angles and distances is indicated by the following formula, which takes these variables into account to compute the f-number to be used.

$$f\text{-number} = \sqrt{\cos A \left(\frac{G_A}{D_A}\right)^2 + \cos B \left(\frac{G_B}{D_B}\right)^2 + \text{etc.}}$$

Where: A, B = angle of flash to lens axis
G_A, G_B = guide number
D_A, D_B = distance from flash to subject

Fortunately there are other methods for achieving satisfactory exposures. A system that is being used successfully when a number of flashbulbs are necessary to obtain sufficient light or a desired lighting effect, is to arrange the lighting with tungsten lamps, take a meter reading, then substitute flashbulbs for the tungsten lamps to expose the film after applying the appropriate conversion factor as outlined above for modelling lights with electronic flash.

8

CONTROL OF IMAGE DENSITY

A number of factors can cause the image on film exposed in a camera to be either too light or too dark, even though the exposure meter was accurate and the reading was made correctly. Some of these factors can be anticipated and compensated for prior to exposing the film, while others may be difficult to detect.

Bellows extension

Since the marked f-numbers on photographic lenses are calibrated on the basis that the image distance is equal to one focal length, focusing on distances closer than infinity reduces the illumination and results in underexposure of the film. A commonly used rule is that compensation should be made when the subject is closer than 10 focal lengths from the camera. Then, the exposure error due to the increased bellows extension is 23%, or about 1/4 of a stop.

It is easy to overlook this factor with long focal length lenses. A 30-in. focal length lens, for example, requires compensation for subjects closer than 25 feet. Compensating only when the bellows is obviously extended is a dangerous procedure since a 400% error will be encountered with a modest 6-in. bellows extension on a camera equipped with a 3-in. focal length lens, and the actual lens-to-film distance is not a valid criterion with telephoto lenses.

Several methods can be used to determine the amount of compensation that is necessary:

1. Calculate the *effective* f-number, and find the corresponding exposure time on the meter dial.

$$\text{Effective } f\text{N} = \text{Marked } f\text{N} \times \frac{\text{Image Distance}}{\text{Focal Length}} = f\text{N} \times \frac{v}{f}$$

2. Calculate the exposure factor and make an appropriate change in the exposure time or the f-number setting.

$$\text{Exposure Factor} = \frac{(\text{Image Distance})^2}{(\text{Focal Length})^2} = \frac{v^2}{f^2}$$

or

$$\text{Exposure Factor} = (\text{Scale of Reproduction} + 1)^2 = (R+1)^2$$

3. Dial and slide rule calculators and tables that eliminate the need for calculations are available.

Fig. 206. An exposure factor ruler

1 2 4 8 16 32

4. The simplest solution is to prepare a ruler calibrated in expo-
sure factors for each focal length lens used. By aligning one end
of the ruler with the lens, the exposure factor can be read off the
scale at the film plane (Fig. 206).

Reciprocity law failure

According to the reciprocity law, the density of the photographic
image depends upon the total amount of light received by the
emulsion, and is not influenced by the actual values of the two
variables that determine photographic exposure, illuminance and
time. It has long been known that the images produced with long
exposure times with low levels of illumination, and short exposure
times with high levels of illumination were often not the same as the
images produced with intermediate values. Reciprocity law failure
may appear as a change in density, a change in contrast, and in the
case of colour films, a change in colour of the photographic image.
Therefore, compensations for the failure may involve the use of filters,
and modifications in exposure and development of the film.

The most serious result of reciprocity law failure with black-and-
white films is the loss of density with long exposure times. The extent
of failure of the reciprocity law, and therefore the amount of compen-
sation that is necessary, varies with different emulsions. The data in
the first table, published approximately 20 years ago[1] as being
appropriate for typical films being manufactured at that time, agree
with current recommendations for some films now being manufac-
tured, including Ilford Pan F Film and Kodak Commercial film.
The data in the right-hand table which are now recommended for
most of Kodak's general-purpose films including Plus-X Pan Film
and Tri-X Pan Film, reveal dramatic increases in the exposure time
factors. Note, for example, that an indicated exposure time of 100
seconds requires an adjusted exposure time of 1200 seconds or 20
minutes, with a 30% reduction in developing time to prevent an in-
crease in contrast.[2]

Film manufacturers have some control over the reciprocity law
failure characteristics of photographic emulsions, and can therefore

[1] Dunn, J. *Exposure Manual.* New York: Wiley, 1951, p. 54.
[2] Eastman Kodak. *Professional Black-and-White Films.* Rochester, NY: Author., 1976, p 27.

Indicated Exposure Time	Exposure Time Factor	Indicated Exposure Time	Exposure Time Factor	Developing Time Adjustment
1 sec.	1.25	1 sec.	2	−10%
5 sec.	1.5			
15 sec.	2.0	10 sec.	5	−20%
45 sec.	2.5			
2 min.	3.0	100 sec.	12	−30%
5 min.	4.0			
10 min.	5.0			
20 min.	6.0			
40 min.	8.0			

produce films and plates for various ranges or exposure times, from exposures through a telescope that may extend to several hours to the short exposure times with electronic flash. Separate negative colour films are made specifically for long and for short exposure times. The effective speed fo the long exposure film is three times as large at 1/10 second exposure as at 60 seconds. Although changes occur in the colour of the images with different exposure times, the changes can be compensated for at the printing stage providing the recommended limits have not been exceeded. With reversal colour films, the colour compensation must be made by using filters over the camera lens. Both the exposure and the colour corrections are critical with reversal colour films. The recommendations by the film manufacturer should be checked since they may change from one emulsion to another of the same make of film.

Shutter efficiency

Changes in shutter efficiency and the effective exposure time can result in overexposure of the film by nearly 100% with between-the-lens shutters. Since the ratio of the effective exposure time to the marked time is highest with combinations of high shutter speeds and small apertures, the greatest danger occurs when using fast reversal colour films in sunlight or other situations where the level of illumination is high. The following chart indicates the exposure error that can be expected at different combinations of shutter speeds and diaphragm openings with typical between the lens shutters. Compensation for the exposure error can be made by stopping the lens down by the amount indicated.

Light and dark subjects

Camera exposures based on incident or mid-tone reflected light readings may not produce as much detail as desired in predominantly light or predominantly dark subjects. The general recommendation is to increase the exposure by one-half stop for dark objects and to decrease the exposure by one-half stop for light objects, but even larger changes are required occasionally.

CORRECTIONS FOR CHANGES IN SHUTTER EFFICIENCY

Lens closed down by (stops)	Additional stopping down required (stops) at shutter speeds of			
	1/50	1/100	1/200	1/400
1	0	0–1/4	1/4	1/2
2	0	1/4	1/4	3/4
3	0	1/4	1/2	3/4–1
4	0	1/4	1/2	1
5	0	1/4	1/2	1
6	0–1/4	1/4	1/2	1
7	0–1/4	1/4	1/2	1

Flare

Non-image-forming light that reaches the film has the effect of increasing the exposure level. Attempts to compensate for flare light by reducing the camera exposure will be only partially successful, however, since contrast of the image is also affected. Flare light can be minimized by using a coated lens, keeping the lens clean, using an efficient lens shade, and blackening any reflective areas on the inside of the camera and the lens shade. Flare cannot be completely eliminated, however, and may become a serious problem when a subject is photographed in front of a bright background or when light sources or glare reflections are located within or near the picture area. It is difficult for the photographer to determine how much adjustment he should make in the camera exposure to compensate for unavoidable flare light except on the basis of tests and previous experience. The effect of flare light can be demonstrated by photographing a subject first against a dark background and than against a bright background, keeping all other factors the same (Fig. 207).

Lens transmission

Transmission variations among new photographic lenses of professional quality can be expected to be small. Lenses manufactured according to American National Standards Institute recommendations must be within plus or minus 10% accuracy in the area of the effective aperture, and lens coatings have minimized transmission variations resulting from surface reflections. This should not be ruled out as a possible source of exposure difficulty, however, as significant variations have been observed in some new lenses and variations may be encountered later due to wear of the iris diaphragm mechanism.

It may be desirable to increase the camera exposure on negative films to compensate for the decrease in image illumination toward the corners of the film with some wide-angle lenses. Normally it is better not to compensate when using reversal colour film, since this will cause overexposure in the more important central area. Tilting the lens to alter the plane of sharp focus, however, will reduce the illumination in the centre of the film.

Fig. 207. Flare is minimized by using a black background and an efficient lens shade *(top left)*. Flare increases with substitution of a white background *(top right)*, and removal of the lens shade *(bottom left)*. The addition of a white bellows liner caused almost total destruction of the image on a normal print. A heavier print *(bottom right)* reveals the effect of flare light on image contrast

Density

Log Exposure

Fig. 208. Characteristic curves showing the effect of non image forming light on the photographs in Fig. 207

Shutter accuracy

Since shutters are intricate mechanical devices, they must be considered as a potential cause of exposure error. Shutters that completely fail to operate are less dangerous than those that develop moderate errors in timing, especially when the errors are erratic or vary with different shutter speed settings. Shutters are often affected by temperature changes, dirt, physical abuse, and normal wear. Extended periods without use occasionally cause a shutter to stick open or to operate too slowly the first time it is released. Although gross errors can be detected by listening to the shutter as it is operated, precision testing and repair work should be done by the shutter manufacturer or by a trained repairman who has the necessary specialized equipment.

Film speed

Manufacturing variations may result in significant differences in film speed between two packages of the same type of film. One major film manufacturer has established the equivalent of plus or minus one-half stop of the rated speed as the acceptable limits. Thus there is the possibility of a change in film speed by a ratio of 2 to 1. This exposure problem can be solved satisfactorily by purchasing a quantity of film with the same emulsion number and refrigerating it to minimize the changes that would occur if stored at room temperatures.

Processing conditions can also change effective film speeds. Fortunately, the processing of reversal colour films is highly standard-

ized, and the need for exacting control is emphasized in the processing instructions. Most black-and-white films can be developed in a wide variety of developers. The use of a fine-grain developer, for example, may result in a considerable loss in effective film speed. Developing film to a higher or lower than normal gamma, for the purpose of modifying density or contrast of the negative, because of inaccurate developing data for the developer-film combination, or because of carelessness in controlling the conditions of development, will increase or decrease the effective film speed. Accurate information concerning effective film speeds for other than normal development is seldom available to the photographer.

Although the change in exposure required to maintain a constant density in a given area can be determined from characteristic curves, photographers usually resort to the trial-and-error, or bracketing approach. As a rough guide, it is recommended that the effective film speed should be doubled when the film is developed to a gamma 0.3 higher than normal, and divided by 4 for a gamma 0.3 lower, to retain approximately the same shadow density as a normally exposed and normally developed negative.

Film processing

The production of consistently high quality negatives requires careful attention to three aspects of film processing — use of processing solutions that will produce the desired characteristics in the image, achieving an appropriate degree of development, and obtaining a uniformly developed image that is free from imperfections. The best processing of film is being done where the volume is sufficiently large to justify the use of automatic or semi-automatic equipment. and where an effective quality control system has been adopted. The need for a high degree of standardization in all three of the above areas for the processing of colour film is stressed emphatically by film manufacturers. A corresponding standardization could be used to advantage by individual photographers for processing black-and-white negatives, although the variations that can be achieved with different developing formulae and with changes in the degree of development can be valuable when used appropriately.

190

Film developers

Film characteristics that can be modified with different developers are the same as some of the characteristics considered by the photographer in selecting a film—graininess, resolving power, sharpness. film speed, and contrast. Photographers have been intrigued over the years with the idea that the choice of developer plays a major role in the quality of the photographic image, and there has been an endless search for the "perfect" developer. The amount of change that can be effected with different developers is limited, however, and an improvement in one of the characteristics often necessitates a sacrifice in another. General-purpose developers recommended by film manufacturers are designed to provide the best compromise of the controllable film characteristics, Thus, consideration should be given to the relative advantages and disadvantages of changing the developer, the film, or both when confronted with special requirements.

The most widely used types of special developers are fine-grain, high-contrast, low-contrast, maximum film speed, rapid, high-temperature, and monobath. True fine-grain developers generally require relatively long developing times to obtain normal contrast images, and an increase in exposure is usually necessary to maintain normal density. The change in image colour that is characteristic of most fine-grain developers makes it more difficult to judge the effective printing contrast of the negatives. A decrease in graininess does not necessarily improve the definition of the image, as the sharpness and resolving power may be affected adversely.

High-contrast developers are not capable of producing the extremely high contrast need for making line copies with general purpose film, but they can increase the contrast moderately to compensate for low-contrast scenes without the long developing times that would be required with standard developers. The fog level also tends to be high with extended development in a general-purpose developer.

Lower contrast can be obtained with standard developers by reducing the time of development, but only with a sacrifice in film speed. Some low-contrast developers retain shadow detail and produce lower contrast images without exposure modifications. Com-

pensating type developers reduce the contrast more in the dense areas than in the thinner areas of the negative (in comparison with normal development) thus preventing bright highlights from blocking up without producing an excessively flat appearance in the medium and darker areas of the print.

Most maximum film speed developers achieve the effective increase in film speed by developing to a higher than normal gamma, an effect similar to that obtained by extending the developing time in a standard developer. This modification in the degree of development reduces the exposure latitude so that less than the anticipated exposure results in a loss of shadow detail, and more than the anticipated exposure results in excessive contrast. Compensating type developers, however, are capable of producing an increase in effective film speed at normal gammas.

Rapid developers make it possible to reduce the developing time to the range of 1 to 2 minutes, and even shorter when necessary. The major difficulty encountered with short developing times is in controlling the degree of development accurately. Rapid developers tend to increase the graininess and the fog level, and uniformity of development is more difficult to achieve in the short developing time.

High-temperature developers are designed to permit films to be developed at temperatures as high as 110° F without the excessive softening that occurs with standard developers. Improvements in emulsion making in recent years have reduced the danger of processing at moderately elevated temperatures. As a result, the recommended processing temperatures of some colour films have been increased with a corresponding reduction in the processing times.

When a developing solution in used repeatedly, it is necessary to make allowances for the change in activity. Compensation can be made by increasing the time of development or by adding replenisher. Pre-exposed sensitometric film strips can be processed periodically to detect changes in activity.

Degree of development

Gamma has long been the conventional measure of degree of development. Gamma is defined as the slope of the straight line of the

192

Fig. 209. Characteristic curves showing development of film to five different gammas

characteristic curve, and it is useful because it is a simple objective concept that takes into account the various factors that determine the degree of development—developer activity, time, temperature, and agitation—for a given emulsion. Thus, two sheets of film will receive comparable development if they are both developed to the same gamma even though one is developed in a tray at 70° F with constant agitation, and the other is developed in a different developer in a tank at 65° with intermittent agitation. Development recommendations for general purpose photography are usually based on a gamma of 0.7 to 0.8 (Fig. 209).

It is convenient to think of camera *exposure* as the photographer's control over *density* of the negative image and *development* as the control over negative *contrast*. This oversimplification of the relationship of these factors can be misleading. Illustrating the effect that variations in camera *exposure* have on negative *contrast*, the series of negatives made with alterations only in the camera exposure (Fig. 204) produced prints that ranged from very flat to slightly contrasty when processed normally and printed on normal contrast paper. A fundamental shortcoming of the gamma concept is that it is based entirely on the slope of the straight line portion of the characteristic curve, whereas normally exposed negatives make considerable use of the toe portion. As the camera exposure is decreased, more of the subject tones fall on the toe portion of the curve, and the overall contrast decreases.

Even without exposure variations, however, films having curves with different shaped toe regions will not produce comparable negatives when developed to the same gamma. *Contrast index* is a measurement of the degree of development that is designed to minimize variations in printing contrast of negatives due to differences in toe regions. Contrast index is the slope of a straight line connecting two points on the characteristic curve that represent the maximum and minimum densities normally used to make high quality negatives.[1] The curves in Fig. 210 illustrate how two different negatives can have the same contrast index and density range, but significantly different gammas.

A number of factors may make modifications in the degree of development desirable, such as unusually flat or contrasty scenes,

[1] *Kodak Handbook News*, 64–3.

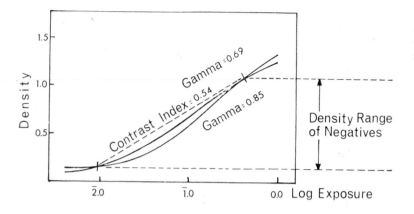

Fig. 210. Characteristic curves illustrating the relationship between contrast index and density range for two negatives

unusual camera flare conditions, variations in printing equipment and printing paper, the desire for an unrealistic effect, and to improve the contrast of underexposed and overexposed negatives.

Uniformity of development

Development of general purpose films is usually stopped considerably short of completion. For this reason, film is susceptible to variations in the rate of development in different areas, resulting in areas of uneven density on the negative and on the print. Fortunately, such variations in development are often camouflaged by detail in the subject, but they become apparent when they occur in an area of the subject that has a uniform medium tone, such as blue sky.

The following are major causes of uneven development.

1. Failure to immerse the film quickly and uniformly in the developer. This defect occurs frequently with daylight sheet-film and roll-film tanks that require the developer to be poured through an opening at the top after the film has been inserted.

2. Uneven restraining action of the byproducts of development. The byproducts are heavier than the developer and flow down across the surface of film developed in a vertical position, and may gather in pools on film developed in a tray unless agitated properly.

3. Obstructions on the surface of the film. Airbells, fingers holding the film during development, oil from fingers, or two films in contact during development prevent the developer from coming freely in contact with the emulsion.

4. Lack of uniformity in supplying fresh developer to all areas. Overagitation often causes this defect when conditions are such that flow patterns are established.

Appropriate agitation of the film during development is essential Constant agitation produces the most uniform results with tray development, shuffling the film when two or more sheets of film are developed together. Although less convenient for processing quantities of film, with greater danger of film sticking together or being scratched, tray processing is capable of producing more uniform development than tank processing. Presoaking the film in water tends

194

to minimize the danger of the film sticking together. The number of sheets of film that can be processed safely at one time in a tray depends on the development time and on the manual dexterity of the photographer.

Intermittent agitation is required with tank processing of sheet and roll films, after agitating constantly for the first 15 seconds or so at the beninning of development. Insufficient agitation causes streaking from settling of development byproducts, and excessive agitation causes flow patterns. Changing the direction of agitation by lifting sheet and roll film (processed in open top tanks) out of the solution and draining alternately toward opposite sides, and by alternately inverting and rotating closed roll-film tanks, minimizes streaking. Nitrogen - burst agitation, i.e. nitrogen gas released periodically near to the bottom of the tank to bubble up through the solution, is an effective and convenient method of agitating, especially when coupled with an automatic timing device. The periods of agitation should be relatively brief—as short as one second every 10 seconds with nitrogen burst to 5 seconds ever 20 to 60 seconds with manual agitation. The film should remain undisturbed between periods of agitation.

The need for effective agitation during development has prompted investigations into a wide variety of techniques including brushing the surface of the film, rocking and vibrating the developing tank with mechanical devices, moving agitating vanes close to the film surface, applying pressurized developer with jets, using ultrasonic vibrations, and feeding the film between rollers immersed in the developing tank.

A gray card containing white and black patches makes an excellent subject for testing uniformity of development. The effects of no agitation, intermittent, and constant agitation of sheet film in hangers with tank processing are illustrated in Fig. 211 in comparison with tray processing of sheet film using constant agitation. Intermittent agitation of roll film in a small tank and processing in a roller-transport type automatic processor with roller agitation are compared in Fig. 212. (The prints were made on higher than normal contrast paper to emphasize the unevenness.) Different films vary in their susceptibility to uneven development under identical conditions.

Although development is the most critical step in the processing

Fig. 211. Development of sheet film in a conventional tank with hangers: no agitation *(left)*, constant agitation *(upper middle)* recommended intermittent agitation *(lower middle)*, and intermittent agitation with the developing time extended to produce gamma infinity *(bottom)*. Development of sheet film in a tray with constant agitation. *(right)*

of film, carelessness in the remaining steps jeopardizes the image. The specific instructions for processing colour films must be followed carefully for all steps of the procedure to avoid a possible loss of quality, including colour effects. With black-and-white films, incomplete fixation allows some of the opalescent silver halides to remain in the negative with possible degradation of the printed image. Gross over-fixation will have a bleaching effect on the silver image. Incomplete washing, although not immediately apparent, will eventually result in a discoloration and change in density of the image. There is a danger in uneven drying of negatives since the density is affected by the rate of drying. Allowing drops of water to remain on the emulsion side of the negative can result in drying marks that will be difficult if not impossible to remove.

Printing

The printing process is capable of both degrading and enhancing the photographic image that has been formed on the negative. Loss of quality occurs mostly as a decrease in image definition, a change in tonal gradation, and unevenness in density. There need be little loss in quality with the contact printing process since the image-forming light does not pass through an optical system, and uniform illumination can be produced with little difficulty. Disadvantages of contact printing—lack of control over image size, cost of the larger film that is necessary to obtain a larger print, and the absence of some of the controls that are available in projection printing—outweigh the advantages in the minds of many photographers. Loss of quality can be minimized in projection printing by being aware of the problems that exist, and by conducting some simple tests involving the equipment and the photographer's technique.

It is just as important to have a good quality lens on the enlarger as it is on the camera. Enlarging lens aberrations are normally minimized for the distances encountered in enlarging. It is for this reason that camera lenses are not generally recommended for use on enlargers, although in practice an expensive camera lens may perform better than an inexpensive or moderately priced enlarging lens. Shortcomings most frequently encountered with less that top quality

enlarging lenses are generally poor definition, a difference in focus at the centre and the corners of the easel, and poor covering power. Chromatic aberration, which may or may not cause a loss of definition on black-and-white prints (depending upon the spectral sensitivity of the paper and whether there is a difference between the visual and the effective focus) will cause colour fringing and a loss of definition on colour prints.

Enlarging a test negative of the type illustrated in Fig. 213 enables a photographer to evaluate his enlarging lenses in a direct and practical way. Two prints should be made at the maximum aperture with the image focused first at the centre of the easel and then at one corner. If curvature of field is revealed on the first two prints, additional prints should be made at all smaller f/stops with the image focused at a point between the centre and one corner of the easel. A marker placed on the lens aperture scale at the largest opening that produces satisfactory definition will serve as a reminder not to use the lens at larger openings. Factors other than the lens quality that may contribute a loss of definition are—deviation of the negative from a flat plane, inaccurate focusing, lack of parallelism of negative, lens board and easel, and vibrations. All of these difficulties can be effectively eliminated.

Fig. 212. Development of roll film in a small tank with recommended intermittent agitation *(top)*, and in a roller transport type automatic processor *(bottom)*

Flare light in the enlarger is a hazard to the tonal gradation of the photographic image as is flare light in the camera. Actually, such non-image-forming light is more dangerous in the enlarger because it has its greatest effect on the highlight areas, whereas camera flare reduces the contrast most in the shadows. Any appreciable veiling over of the brightest highlights on prints tends to have a disturbing effect on viewers. It is for this reason that soft-focus or diffused photographs are more attractive when the effect is introduced at the negative-making rather than the print-making stage.

The best methods for minimizing flare light in printing are:

1. Use a coated lens and keep it clean.

2. Eliminate sources of possible reflections within the enlarger, between the negative and the lens.

3. Mask the negative down to the area that will be included on the print.

The effect of flare light resulting from failure to mask off the area around the negative in a glass carrier is illustrated in Fig. 214. The

197

SOLAR
CRITICAL FOCUSING
CHART
BURKE & JAMES Inc.

1 INCH

Fig. 213. A print made from an enlarging test negative can be used to evaluate the enlarging lens.

narrow clear border around negatives will transmit enough light to cause a noticeable change in the print. Even the area on the negative that is being printed is a possible source of flare light, especially in situations where objects are photographed against dark backgrounds, resulting in large areas of low density on the negatives.

An interesting comparison test that will reveal the total effect of all factors in projection printing that influence the tonal relationships of the image is to make a contact print and a 1:1 scale projection print from the same negative on the same printing paper. Although flare light reduces image contrast, the projection print may have more contrast than the flare free contact print. This is due to the *Callier effect*, a proportionally larger scattering of the light away from its direction of travel through the lens by the dense areas of the negative than by the thin areas. The amount of increase in contrast depends upon several factors, including graininess of the negative image and diffuseness of the illumination. The largest increase would be obtained with a grainy negative in an enlarger equipped with a point light source and an efficient condenser. The difference in contrast obtained with typical condenser enlargers equipped with opalized lamps, and diffusion enlargers range from being barely perceptible to the approximate equivalent of one contrast paper grade.

Uniformity of illumination of contact and projection printers can be tested easily by exposing a piece of photographic paper, without using a negative, so that a medium density is obtained when the paper is developed for the normal time. Professional type contact printers

Fig. 214. Prints made from a line negative with the glass negative carrier masked down to the area printed *(left)*, and to the edges of the negative but not including the clear border *(centre)*. No mask was used for the print on the right.

containing a large number of lamps and one or more layers of diffusing glass are capable of providing extremely uniform illumination. It is more difficult to provide uniform illumination with enlargers. A variety of diffusing and reflecting systems and several types of light source are used on diffusion-type enlargers as attempts to solve the problem of providing uniform light of sufficient intensity to permit reasonably short exposure times. Condensers have an advantage of being able to utilize the light output of the lamp more efficiently than diffusion systems, and at the same time they compare favourably with respect to uniformity of illumination.

Combining the factors

To obtain the best possible photographic image, it is necessary for the photographer to run down a written or mental checklist to determine whether compensation should be made for any of a number of factors including bellows extension, reciprocity law failure, shutter efficiency, and a light or a dark object. A nomograph published by the Eastman Kodak Company takes four important factors into account in providing the photographer with the recommended contrast index for black-and-white negatives for printing on normal contrast paper.[1] The four factors are (a) the type of enlarger or the negative density range desires, (b) the subject luminance range in stops, (c) the type of film, and (d) the camera lens flare level. In addition, exposure adjustment necessitated by development to a higher or lower than normal contrast index is indicated. Different nomographs are provided for films having short-toe and long-toe characteristic curves. A nomograph for a long-toe film is shown overleaf.

[1] Eastman Kodak. *Kodak Professional Black-and-White Films.* Rochester, NY: Author, 1976, pp. 16–21.

199

Contrast Control Nomograph

KODAK Films with Long Toe Characteristic Curves

*These are the typical negative density ranges that result when normal luminance range subjects (7 stops range) are exposed with moderate flare level lenses and developed to the contrast index shown in the left scale.

**Some film and developer combinations may require more or less exposure adjustment than these average values shown here, especially when the adjusted contrast index is less than .45 or greater than .65. Some of the finest-grain developers cause a loss in film speed that must be considered in addition to the losses caused by developing to a lower contrast index.

9

VIEW CAMERA TYPES

The ideal situation for a photographer who is considering buying a view camera is to work under a variety of conditions with each of the numerous brands and models now being made. It is unlikely that he can fully appreciate the advantages and the limitations that result from the differences among the cameras without this experience. An examination of the features and specifications of a number of view cameras and a few closely related cameras, however, will reveal the more significant differences.

Cost

The cost of basic view cameras without lenses and accessories varies over a wide range, with the extremes approaching a 10 to 1 ratio. Adding a variety of lenses and accessories can further increase the cost far beyond the cost of the camera itself. One of the hand-held cameras that have at least some of the adjustments on the lens and back will generally be satisfactory for the photographer who has only occasional use for view camera features. Although the movements on such cameras are usually limited, they may be adequate for the situations the photographer will encounter. Some hand-held cameras, in fact, have more adjustments than the least versatile of the view cameras, although their cost may exceed the total cost of a separate conventional hand-held camera and a simple view camera.

Versatility and ability to use large film are features that boost the cost of view cameras. View cameras in 8×10-in. and larger sizes typically cost two to three times as much as the 4×5-in. and smaller view cameras produced by the same manufacturer. Although reducing backs are available for the larger cameras, the higher cost and bulk make such cameras poor choices for the photographer who never encounters situations requiring the larger film. A few view cameras are constructed on the modular principle whereby most or all of the parts can be interchanged. This permits the conversion of a 4×5-in. camera into an 8×10-in. simply by substituting a different back and bellows, or increasing the maximum bellows extension by adding extensions to the camera bed and the bellows (Fig. 216). Cameras of this type tend to be more expensive than cameras designed as a unit, but may prove to be less expensive and more

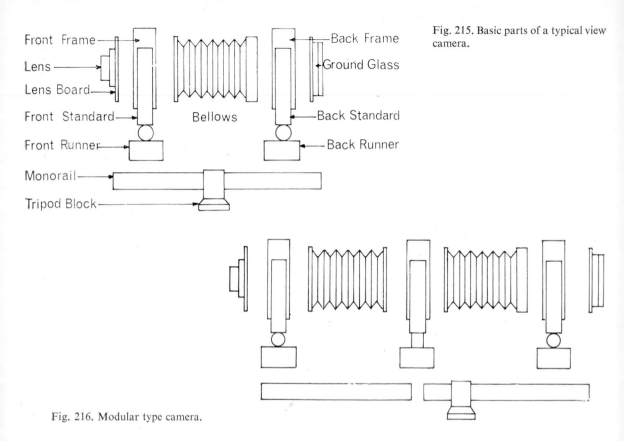

Front Frame
Lens
Lens Board
Front Standard
Front Runner
Monorail
Tripod Block

Back Frame
Ground Glass
Back Standard
Back Runner

Bellows

Fig. 215. Basic parts of a typical view camera.

Fig. 216. Modular type camera.

convenient than purchasing two or more separate cameras for photographers who must be prepared for a wide variety of picture making situations.

Some of the differences in cost of view cameras can be attributed to engineering and manufacturing details that affect their usefulness and convenience. Sturdiness, light weight and compactness of storage, conveniently located and easily operated controls, calibrated adjustments, spirit levels, revolving back, and other refinements are features that may be well worth an extra investment to the busy photographer.

Interchangeable backs

In the early days of photography all photographic emulsions were coated on glass plates. Flexible base sheet films have replaced glass plates for all but those specialized types of photography that require extreme dimensional stability or emulsion characteristics that are available only on glass plates. Photographers are now offered a wide variety of emulsions in many different forms, and the more versatile view cameras have provisions for utilizing most of these.

The double sheet-film holder has been the most widely used type of film holding device for view cameras in recent years (Fig. 217). It offers photographers the advantages of being able to expose and process

Fig. 217. Double sheet-film holder

single pieces of film and of being able to switch rapidly from one type of emulsion to another, such as from black and white to colour. The larger sizes of film are manufactured only in sheet film form. Major disadvantages of sheet-film holders are that they constitute an additional expense, especially when the photographer must be prepared to expose a large quantity of film during a short period of time, an extra operation is required to load the film in the holders in a darkroom, and bulk and weight are added to the camera kit for location assignments.

Alternative methods of exposing individual pieces of 4×5 and $2\frac{1}{4} \times 3\frac{1}{4}$-in. film are the film pack and the Grafmatic Film Holder Film packs contain 16 pieces of film on a thin, flexible base. The film pack can be placed in an adapter (a light-tight enclosure with a dark slide) in daylight. Paper tabs that protrude from one end of the film pack are pulled to remove the opaque paper protective cover and to move each piece of film to the rear of the pack after it has been exposed. Although the film pack can be disassembled in a darkroom to remove one or more pieces of film, some manual dexterity is required to complete the operation successfully. Film is more expensive in pack than in sheet form, it is not supplied in all emulsion types, and some people find it more difficult to process the thin, flexible film.

Grafmatic Film Holders contain six thin metal sheaths that are loaded with conventional sheet film in a darkroom (Fig. 219). The six sheets of film can be exposed in rapid sequence without removing the holder from the camera. The advantage of the Grafmatic Film Holder over the double sheet-film holder is convenience rather than economy. Grafmatic Film Holders and film-pack adapters can be used with universal type backs (which have sliding bars to hold the attachments on two edges) and with spring type backs that accept conventional film holders providing there is sufficient flexibility to accommodate the extra thickness.

There are several methods for obtaining small format negatives on sheet film. Modular design cameras allow the substitution of smaller back standards and bellows. This system has the advantage of producing a lighter and more compact camera when smaller film is used, but it tends to be an expensive modification of the camera. A second method of providing for smaller sheet film is to change only the back panel that contains the ground glass. On some cameras,

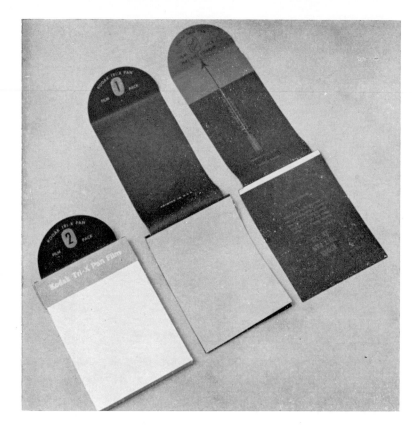

Fig. 218A. Film pack *(left)*, piece of film with attached paper pull-tab *(centre)*, and safety cover with attached pull-tab *(right)*.

however, the back panel and the back standard are both integral parts of the camera and cannot be removed. A third system consists of devices that allow two or more exposures to be made on a single sheet of film. The most satisfactory of these are the sliding type that move the film for each exposure, making it unnecessary to re-align the camera, and utilizing the image area near the centre of the circle of good definition. Backs that produce as many as 8 images on 4×5-in. film have been made. A popular format with portrait photographers has been the split 5×7, producing two 3½×5-in. negatives. Other combinations are—two images on 8×10, two images on 4×5, four images on 5×7, and three images on 4×5. The last combination utilizes dark slides with cutout sections. Slides can be cut by the photographer to meet his individual needs.

Cameras that are designed to use conventional 4×5-in. double sheet-film holders will also accept the Polaroid 4×5 Film Holder (Fig. 220). Since this is the largest Polaroid Film currently produced, photographers who are using film sizes larger than 4×5 inches must use reducing backs.[1] Polaroid materials are used not only as a means of checking lighting, exposure, focus, and other details before exposing conventional black-and-white or colour film, but Polaroid

[1]There is a danger that the reducing back may not position the film in the same plane as the larger back.

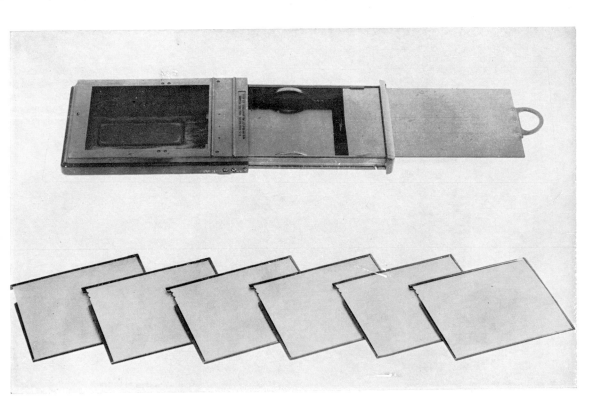

Fig. 219. Grafmatic Film Holder *(above and below right)* holds six sheets of film in metal sheaths.

Fig. 218B. Film pack adapter.

Fig. 221. Roll film holder of traditional design is thicker than sheet-film holder, and curves film backward over roller before it reaches the exposure position.

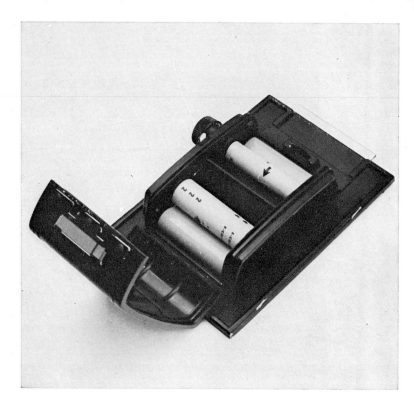

Fig. 221. Roll film holder of traditional design is thicker than sheet-film holder, and curves film backward over roller before it reaches the exposure position.

Fig. 220. Polaroid 4 × 5 Film Holder.

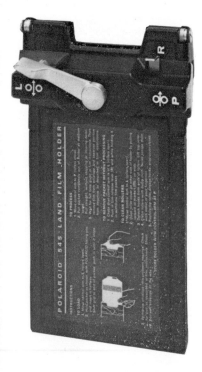

prints and transparencies are also used as end products, and one type of material produces conventional negatives.

A 4×5-in. section in the centre of a larger format is often adequate for checking exposure and some other aspects of the image, but if the photographer is concerned with checking the arrangement and lighting for the entire format area, it will be necessary to substitute a correspondingly shorter focal length lens. Ingenious photographers produce the equivalent of 8×10-in. Polaroid prints by exposing four 4×5-in. prints in such a way that each print records one fourth of the 8×10-in. format, and then joining the prints together with tape. Polaroid films are also available in smaller than 4×5-in. sizes in roll and pack form. Polaroid Roll Film Holders can be used with all view cameras that can be equipped with a universal type back, but they are too thick to be accommodated by spring type backs.

Roll film and 35mm film offer the advantages of economy and convenience over sheet film when large quantities of negatives or transparencies are made. The smaller formats are occasionally required for use in a slide projector or other special application. Most roll-film holders are considerably thicker than the conventional sheet-film holders, and therefore can be used only with cameras equipped with universal type backs, which allow the ground glass to be removed (Fig. 221). One roll-film holder (with both the supply and take-up spools located at one end) is shaped like a conventional sheet-film holder and can be used with all 4×5-in. view cameras (Fig. 222). Since roll-film formats are smaller than 4×5 in. it is necessary to draw lines or use a mask on the ground glass to

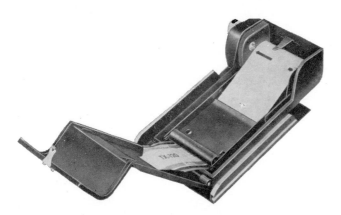

Fig. 222. This roll film holder has both supply and take-up spools located at one end. The film travels in a straight line until after it is exposed.

indicate the size and position of the aperture in the roll-film holder, unless a back with a smaller ground glass is used. Camera backs with sliding ground glass and roll-film holder eliminate the need to remove either from the camera, thus reducing the delay between focusing and exposing.

A further refinement is the use of a single-lens reflex camera body attached to the view camera back. The image can be composed and focused with the reflex viewing system, eliminating the need for making any adjustments between focusing and exposing. With most reflex camera bodies, exposure of the film can be controlled either with the between-the-lens shutter on the view camera or with the focal plane shutter in the reflex camera body. The less expensive barrel mounted lenses can be used if the focal plane shutter is used exclusively. Reflex camera bodies in 35mm, $2\frac{1}{4} \times 2\frac{1}{4}$, and 4×5 inch sizes are being used on view cameras, although most view cameras do not have provisions for this type of film holding device.

In addition to the backs that accept the conventional lengths of 35mm film (20 and 36 exposures) and 120 or 220 roll film (8 to 20 exposures) backs are available that hold as much as 100 ft. of 35mm film (700 double frame or 1400 single frame exposures) and 100 ft. of 70mm film (330 $2\frac{1}{2} \times 3\frac{1}{4}$ inch exposures).

View cameras equipped with universal type backs can be converted into enlargers. It is only necessary to remove the ground glass, and add a negative carrier and a light source to produce a versatile enlarger (Fig 223). The camera tilt and swing adjustments provide extensive control over image shape when control is required at the printing stage.

The holder described above is shaped like a conventional sheet-film holder and can be used with any back that accepts 4×5 inch sheet-film holders

Camera bed

The camera bed serves as a support for the lens and back standards. Flatbeds, which were used on most of the early view cameras, have now been largely replaced by monorails. There are manufacturing advantages in the monorail, since it is less complex, with a single support bar and single focusing track. Rigidity, a desirable feature in view cameras, varies considerably among monorail cameras, depending upon the gauge of the metal, the surface area of contact

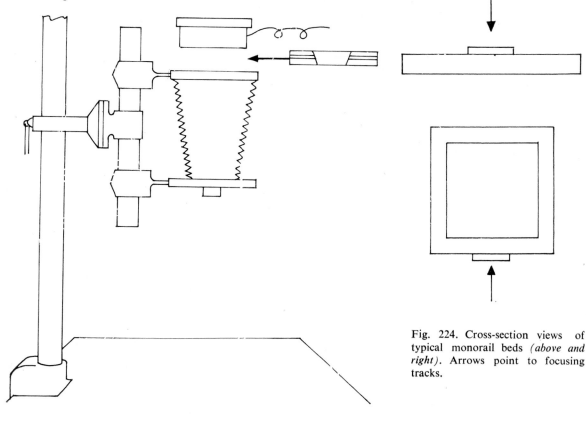

Fig. 223. View camera converted into an enlarger.

Fig. 224. Cross-section views of typical monorail beds *(above and right)*. Arrows point to focusing tracks.

between moving parts, mechanical design, and precision of manufacture. The desire to keep the weight of view cameras as light as possible is not compatible with maximum rigidity, although the use of light weight metals has helped to satisfy these two objectives.

A long bed is required when using long focal length lenses and for close-up work. At other times a long bed is a disadvantage, since it increases the bulk of the camera and the carrying case. Also, if the bed extends too far in front of the lens it will project into the picture area with wide-angle lenses, and an excessive length of bed extending behind the camera interferes with focusing and composing on the ground glass. Various length monorails are provided for some cameras, to allow the photographer to substitute a longer or a shorter bed when difficulties or limitations are encountered. Although interchangeable monorails are normally provided in only two or three standardized lengths, at least one manufacturer will provide any length bed the photographer requests. The manufacturer of a view camera that is equipped with a non-interchangeable and relatively short monorail bed features compactness in the advertising, and minimizes the limitations of the short bed by supplying telephoto type lenses in the longer focal lengths.

Cross-section views of typical monorails are shown in Fig. 224. Cylindrical beds require a guide to keep the lens and back standards

Fig. 225. The protruding focusing track limits the turning of the monorail *(right)*. Some models have a wide slot in the clamp to permit limited turning. Unlimited turning is provided by a collar around the monorail and a different type of clamp.

from revolving sideways around the bed. Alignment is usually maintained with a recessed or a protruding focusing track that is engaged by wheels in the focusing runners. On the other hand, there is an advantage in being able to revolve the monorail and the entire camera for the purpose of changing the angle of the image on the ground glass. This can be accomplished most easily with cylindrical monorails that have recessed focusing tracks because the bed can be revolved without limit by releasing the tension of the clamp on the tripod block. A limited amount of turning of the monorail is provided on some cameras with protruding focusing tracks by placing a wide slot in that portion of the clamp (Fig. 225).

Sliding tripod blocks, which allow the clamp to be fastened in any position on the bed, have several advantages over the fixed type:

1. Balance of the camera can be maintained more easily.
2. Projection of the bed into the picture area can be avoided by

209

keeping the lens runner near the front of the bed, adjusting the position of the tripod block to avoid interference with focusing with the back runner.

3. Obtaining the minimum lens-to-film distance needed with short focal length lenses can be facilitated on some cameras by removing the tripod block clamp from between the front and back runners and placing it behind the back runner.

4. Focusing on close-up objects is simplified by moving the entire camera rather than the front or back runners. A focusing type mechanism is incorporated into the tripod blocks of some cameras for this purpose.

5. Attaching the tripod block at either end of the bed occasionally allows the photographer to place the camera in a position that would not otherwise be possible, owing to obstructions that interfere with placement of the tripod (Fig. 226).

One monorail view camera has the tripod block permanently attached to the bottom of the bed in such a way that there is no interference with the focusing runners. There is no provision, however, for attaching the tripod at any position other than the centre of the bed.

Since flatbed view cameras have two tracks and runners, they tend to have good rigidity, although as with monorail cameras, this depends largely on the design and construction of the individual camera (Fig. 227). Bed length can be altered on most flatbed cameras through a system of overlapping or telescoping beds, or by attaching extension

Fig. 227. Flatbed view camera.

beds to the front or back of the basic bed. Even with the *rigid* type flatbed, the overall length of the camera tends to be small when compressed for storage compared with monorail cameras, and the *folding* type flatbed can be made quite compact. One 11×14 inch folding flatbed view camera that can be extended to 43 inches, is only 9½ inches thick when stored. The bulk of some monorail cameras can be reduced by detaching the bellows and rotating or tilting the front and back standards so they are more in line with the monorail (Fig. 228).

Greater stability is required in some situations than can be obtained with conventional portable view camera and tripod equipment. This problem is most serious when the lens-to-film distance is large—whether photographing distant subjects with long focal length lenses or close-up subjects with shorter lenses. A second tripod block can be added to the bed on some view cameras, making it convenient to support the camera with a tripod at each end of the bed. Although manoeuvrability is reduced, an appreciable increase in stability is achieved with two tripods (Fig. 229). Tripod blocks with hinged clamps are the easiest type to remove and to attach at different locations on the bed (Fig. 232).

A pan-tilt device is built into the tripod block on one brand of view camera. Many tripods feature built in pan-tilt heads, although they are sold as separate accessories also. Consideration should be given to the pan-tilt device, since its features affect the versatility and convenience of use of the view camera. Cameras that do not

Fig. 228. Monorail with folding front and back standards.

Fig. 229. Use of two tripod blocks and tripods for additional rigidity (*right*).

Dual clamp increases rigidity of monorail

Fig. 230. Device to facilitate attaching a view camera to a tripod.

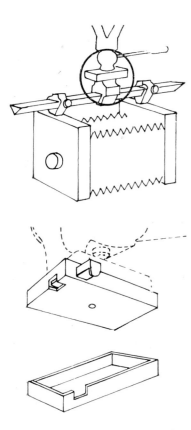

have fully revolving backs or revolving monorail beds require a pan-tilt head that tilts sideways as well as forward and back. There is a significant advantage in having a separate control and lock for each of the three possible movements—pan, forward tilt, and side tilt.

Rigidity that is built into the view camera is sometimes sacrificed at the pan-tilt head. Not only must the device be sturdy enough to support the heavier view cameras, but it must have positive acting locks on the adjustments. A frequent source of difficulty is the screw that attaches the camera to the pan-tilt head. The awkward location of the frequently too-small knob makes it difficult to apply enough pressure to eliminate play at this point. The better designed tripods have large knobs or separate levers that enable the camera to be clamped tightly to the tripod. The screw and socket method of attaching cameras to tripods has the advantage of standardization, so that equipment produced by different manufacturers can be used together. Matching the screw to the tripod socket, especially in dim light, can be a time consuming and annoying process, however. Consideration has been given to this by some manufacturers, and components have been made that can be aligned easily and locked into place quickly and firmly (Fig. 230).

Film rotation

Two methods of rotating the film have been mentioned—the horizontal tilt on pan-tilt heads, and revolving monorail beds. Both of

these methods have the disadvantage of changing the position of the lens in relation to the subject, making it necessary to realign the camera (Fig. 231). The film can be rotated on cameras equipped with *reversible* backs by removing the back, rotating it 90° and replacing it. *Revolving* backs allow the ground glass and the film to be rotated without removing the back from the camera.

With 360° revolving backs, the film can be placed in intermediate positions in addition to vertical and horizontal (Fig. 233). The more limited type of revolving back that cuts off the corners of the image except in the vertical and horizontal positions is used mostly on press type cameras where the compactness of a smaller bellows is more essential. Because 360° revolving backs require appreciably larger bellows than reversible backs, they are seldom used on the larger sizes of cameras. Several manufacturers of 8×10 inch and larger view cameras offer the revolving back feature on accessory reducing backs for smaller film sizes but not on the larger standard backs.

Fig. 231. Change in the lens position with a revolving monorail bed.

Fig. 232. Hinged clamp permits tripod block to be moved from between the front and rear standards to any location on the monorail.

Bellows

Bellows serve as a light-tight seal between the lens and the film. Small hand-held cameras can make use of a more rigid device because the required changes in distance between lens and film are relatively small. Focusing mounts are sometimes supplied with short

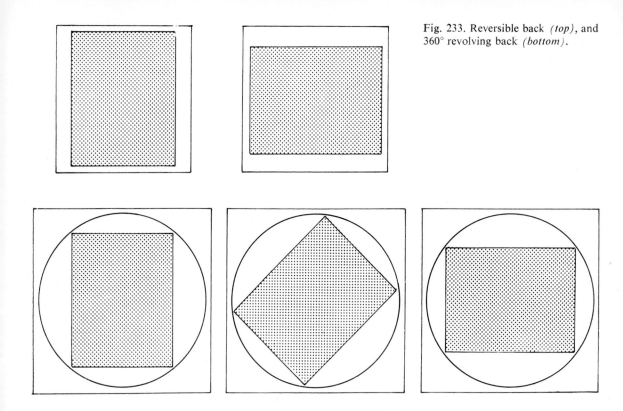

Fig. 233. Reversible back *(top)*, and 360° revolving back *(bottom)*.

focal length wide-angle lenses for view cameras since the small changes in image distances involved require a highly precise focusing mechanism. In fact, the bellows and bed have been eliminated from one "view" camera designed for exclusive use with a wide-angle lens.

For a view camera that is to be used in a variety of situations, the bellows should be long enough to permit use of the full length of the bed, and yet be capable of being compressed sufficiently for the shorter focal length lenses. Also, the bellows should be flexible enough to minimize interference with the adjustments on the lens and the back, and yet sturdy enough not to sag and cut off part of the image.

Although view camera bellows are invariably long enough to permit use of the full length of the bed when the adjustments are zeroed some bellows restrict the amount of adjustment of the lens and back that can be made (Fig. 234). Such restrictions are unfortunate when the tilts or swings are used to control the plane of sharp focus because a greater change in the angle of the lens or back is needed to achieve a certain effect with a large bellows extension than when the lens and film are close together. This restriction can be eliminated with view cameras that are constructed on the modular principle by adding bellows and bed units as needed (Fig. 235). Use of an auxiliary frame at the junction of the bellows provides the necessary support to prevent sagging. Restriction of the adjustments due to binding of the bellows with short focal length lenses can be minimized on some cameras by substituting a flexible bag type bellows, or a newer type

Fig. 234. Bellows limitation prevents
use of full length of the monorail
when tilt adjustments are not zeroed
and when rising front is elevated.

combination regular and bag bellows. Recessed lens boards also
help to minimize this difficulty.

Focusing

Rapid adjustment of the distance between the lens and the film is
desirable when setting up a view camera for use, and when changing
from one focal length lens to another. For precision focusing, how-
ever, a mechanism that changes the distance slowly is required. Pro-
visions for making both rapid and fine adjustments are found on a
number of view cameras. The rapid adjustment is usually obtained
either by disengaging the gears or releasing the tension on the focus-
ing mechanism. One camera has a combination of friction and

Fig. 235. Bellows length can be inc-
reased on modular type cameras by
attaching additional bellows units.

215

Fig. 236. Five different arrangements for focusing used on various view cameras.

geared focusing movements. Rough focusing is accomplished quickly by sliding the lens or back standard along a monorail, and fine focusing is then obtained with a short geared track attached to each standard.

Although it is not essential to have focusing mechanisms on both the lens and the back, such an arrangement does offer advantages. Camera balance can be maintained more readily, it is easier to make small adjustments in the size of the image on close-up photographs, and convenience of operation is improved. Focusing on hand-held cameras is usually accomplished by moving the lens. Some studio and view cameras have focusing adjustments only on the back.

Five different arrangements for focusing are illustrated in Fig. 236. The bottom drawing represents the most versatile arrangement in that the lens and back can be adjusted individually and both can be moved simultaneously with the focusing mechanism in the sliding tripod block. Dual left and right hand focusing knobs are provided on some flatbed view cameras, and a single focusing knob can be placed on either the left or the right side on some monorail cameras (Fig. 237.).

Adjustable tension locks on the focusing mechanism help the photographer to focus by providing the desired amount of resistance. It is important to have positive action locks to prevent accidental changes in the lens-to-film distance after the camera has been focused because a certain amount of pressure is usually applied to the camera in such subsequent operations as stopping the lens down, cocking the shutter, inserting the film holder and pulling the slide. Gravity alone can affect the focus on some cameras when they are tilted up or down if there is insufficient locking tension. Maximum rigidity of the lens and back standards is obtained on most view cameras only when the focusing adjustments are locked firmly.

Calibration marks on the camera bed are useful for determining the bellows extension, for positioning the lens and film on the basis of calculations, for determining the best position for the lens or film with subjects requiring a large depth of field, and other applications where precision is required. Calibrations are generally placed on cameras that are intended primarily for copying, such as graphic arts cameras, since they greatly simplify obtaining images at specified scales of reproduction. One view camera has an optical bench type

Fig. 237. View camera with reversible
focusing control.

monorail with calibrations the full length of the bed. Another camera
has a separate ruler that can be stored inside the hollow monorail,
and a third camera has short calibrated focusing tracks on the lens
and back standards but without calibrations on the bed to measure
the lens-to-film distance. Most view cameras do not have any type
of focusing calibration, and photographers occasionally place pencil
or other markings on the bed as the need arises.

When precise measurements are necessary, the exact position of
the film plane must be known. This position is marked on the back
of at least one view camera. Image distance must be measured to the
rear nodal plane of the lens, but since the position of the nodal plane
varies with different lenses, it is not possible to place a universal
marking on the lens standard. Once the position of the back nodal
plane is determined, its distance from the lens board can be marked
on the lens board for future reference. This distance should then be
added to (when the nodal plane is in front of the lens board) or sub-
tracted from the film-to-lens-board measurements.

The ground glass

There are three significant variations in view camera ground glass-
es. The first, ruled lines, aid in the alignment of the camera with
vertical or horizontal lines of the image. Although the lines may
occasionally interfere with judging the overall effect on the ground
glass, they are invaluable when it is essential to fully correct converg-
ing image lines. An alternative method is the use of a ruled acetate
grid that can be placed over an unruled ground glass when needed.

Although reducing backs equipped with ground glass of the ap-
propriate size are frequently used with the smaller film formats, it is
sometimes more satisfactory to make use of lines on the full-size
ground glass to indicate the position that will be occupied by the
smaller film during the exposure. Ruled acetate overlays are supplied
with some roll-film backs designed to be used with 4×5-in. view
cameras.

Other typical situations that are well suited to the use of markings
on the ground glass, or use of transparent or translucent overlays,
are multiple exposures and working from artists' layout sketches,

both of which often require precise positioning of the images. Temporary lines can be applied to the smooth side of the ground glass with a glass-marking pencil. More durable lines can be obtained by marking on the ground side with pencil or ink.

A second variation in ground glasses is in the treatment of the corners. Rapidly extending or compressing the bellows on a camera may cause them to bulge or collapse from the resulting change in air pressure unless the camera has an air escape. The pressure acts as a brake on the rapid focusing movement, and may cause physical damage to the bellows. Cutting off the corners of the ground glass is one method of avoiding this difficulty. Another method that is being used is to incorporate a light-trapped air vent into the body of the camera.

Difficulty may be encountered with cornerless ground glass because the photographer cannot check the image in this area, and defects may appear on the negative that were not visible at the time the image was being composed on the ground glass. Open corners offer another advantage, however, in that the photographer can view the lens from the position that will be occupied by the corners of the film to check on vignetting by the lens barrel and the lens shade (Fig. 238). This is especially important when rising-falling or lateral shift adjustments are used on either the lens or the back, or when the lens is tilted or swung. When severe vignetting does occur, the photographer can determine if it will be eliminated by stopping the lens down, or whether it will be necessary to modify the camera adjustments.

Fig. 239. Basic design of Fresnel lenses.

218

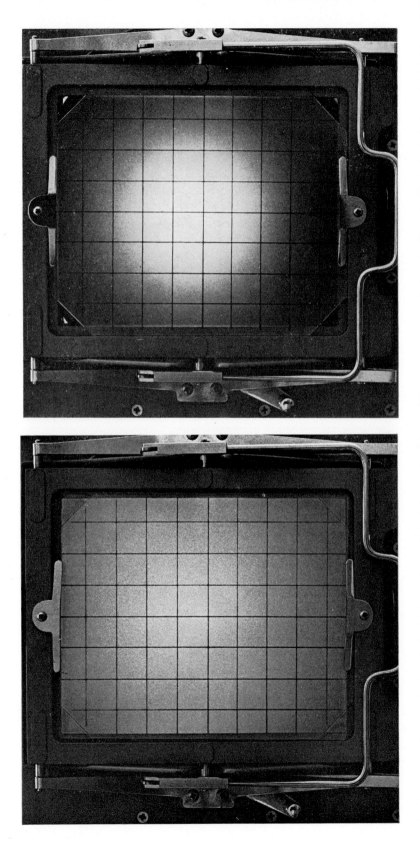

Fig. 240. Ground glass without Fresnel lens appears uneven in brightness.

Fig. 241. Brightness variation is minimized with addition of a Fresnel lens in front of the ground glass.

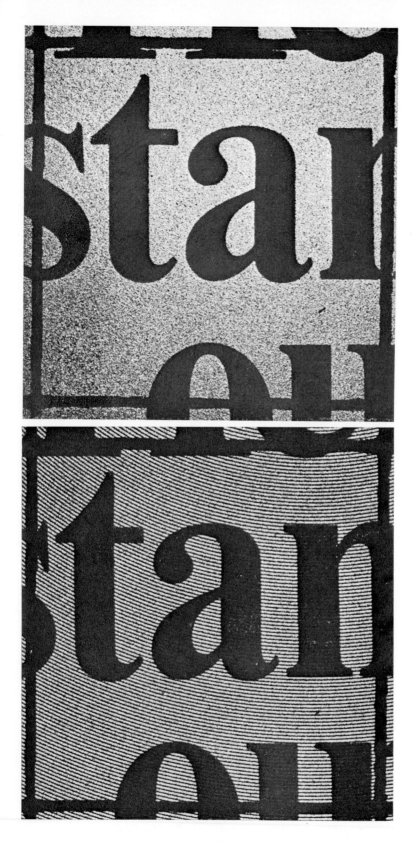

Fig. 242. Close-up photographs of images formed on a ruled ground glass without a Fresnel lens and with a Fresnel lens correctly positioned.

Fig. 243. Orientation of Fresnel lens and ground glass.

Ribbed Surface

Ground Surface

Lens Axis

The third variation in ground glasses is in the incorporation of Fresnel lenses (Fig. 239). A ground glass without a Fresnel lens produces a significantly brighter image on that part of the ground glass that is in a direct line between the eye and the camera lens (Fig. 240). The bright area moves about on the ground glass as the photographer moves his head, but it is often difficult for him to evaluate the image in its entirety due to the variations in brightness. Coarse-grain ground glass produces a less noticeable image hot spot, but increases the difficulty of focusing on fine detail, as compared with fine-grain glass. Fresnel lenses, when placed close to the ground glass, refract the light in a way that minimizes the differences in brightness at the centre and the corners of the ground glass (Fig. 241).

The ridges in the Fresnel lens are usually barely perceptible with the naked eye, but become quite obvious when viewed through a magnifier, appearing as dark lines (Fig. 242). Although the lines can interfere with focusing on fine detail, they serve a useful function when the image is viewed through a magnifier because it becomes obvious when the magnifier itself has not been properly focused. Fresnel lenses will function—with respect to equalizing image brightness—when placed either in front of or behind the ground glass, but caution should be exercised when adding a Fresnel lens or when replacing a broken ground glass that the ground focusing surface is in the correct position. Adding a Fresnel lens in front of the ground glass on some backs will move the focusing surface of the ground glass by the thickness of the Fresnel lens, and the focusing surface will no longer be in the film plane. When Fresnel lenses are supplied with the camera as original equipment, they are normally placed in front of the ground glass as shown in Fig. 243, where the plastic ridges are protected from dirt and abrasion. Focusing difficulties may be encountered if the Fresnel lens is used in a position where the ridged surface is not in contact with the ground surface of the ground glass, since images can be seen on both the ridged and the ground surfaces (Fig. 244).

Extraneous light that falls on the ground glass from behind the camera may obscure the image formed by the lens. Focusing cloths and focusing hoods are the two most commonly used devices for shielding the ground glass from this light. Focusing hoods have an advantage in convenience since they can be left on the back of the

Fig. 244. Image formed with a Fresnel lens incorrectly positioned behind the ground glass. Ridges are less noticeable, but formation of images on two separated surfaces makes accurate focusing difficult.

An image is formed on the Fresnel lens alone, as shown below.

Fig. 245. Aerial image with ground glass and Fresnel lens removed.

camera in a compact, folded position, and they spring open ready for use at the touch of a button. Although some focusing hoods are an integral part of the camera, most can either be swung away or removed entirely, a desirable feature since they sometimes interfere with viewing the image at the edges of the ground glass and with the use of a magnifying glass.

Magnifying glasses are normally used as separate accessories, to be held in position by the photographer. One view camera, however, has provisions for attaching a magnifier to the back of the camera with a light-tight focusing bellows, and also for supporting the magnifier in the desired position to free the hands for adjusting the camera. A reflex focusing magnifier is also available that enables the photographer to focus and view the image when the back of the camera is close to a wall or other obstruction, or when the camera is in a high, low, or other position that would make normal viewing of the image on the ground glass awkward or impossible (Fig. 246).

Focusing hoods are used most widely on 4×5-in. and smaller cameras, but they are used on cameras as large as 5×7 and 8×10 in. Features that facilitate the use of focusing cloths are clips to hold one edge of the focusing cloth firmly in position on the back of the camera—a necessity when working under windy conditions, and a wire frame that extends behind the camera to hold the cloth, thus making it unnecessary for the photographer to support the cloth on his head.

Fig. 246. Reflex focusing magnifier.

Camera movements

View cameras vary considerably in the number of movements they have, and also in the extent of those movements. The least versatile of the view cameras, with respect to movements, is a camera designed for use with a short focal length wide-angle lens that has only one adjustment—a rising-falling front. Even on view cameras that have all of the possible adjustments, the necessity of having the lens close to the film plane with very short focal length lenses reduces the freedom of movement of the adjustments, and in some situations the restrictions are so severe that the adjustments become useless.

Both the front and the back of view cameras have four possible basic movements (tilt, swing, lateral shifts, and rising-falling) for a total of eight. Of the cameras now being mass produced, about half a dozen representing different manufacturers, have all eight of these adjustments. Among the cameras that do not have all of the adjustments, the most commonly omitted ones are the back shift and the rising falling back. Various combinations of adjustments used on different cameras are shown below. Omission of one or two of the ad-

COMBINATIONS OF ADJUSTMENTS

| | Adjustment available (X) on camera: | | | | | | | | | |
	1	2	3	4	5	6	7*	8*	9*	10*
Lens tilt	X	X	X		X	X	X	X		
Lens swing	X	X	X	X	X	X	X	X		
Lens shift	X	X	X	X		X	X	X		
Rising-falling front	X	X	X	X	X		X	X		X
Back tilt	X	X	X	X	X	X	X		X	
Back swing	X	X	X	X	X	X	X			
Back shift	X	X								
Rising-falling back	X									X

7* Press camera
8* Press camera
9* Portrait camera
10* Wide-angle view camera

224

justments does not necessarily impose a handicap on the photographer, since there are some duplications of functions. For example, absence of lateral shifts on the front and back can be compensated for by aiming the camera to one side and then swinging the lens and back parallel to their original positions. All of the adjustments are desirable, however, for maximum control, versatility, and convenience. Almost all modern view cameras have a minimum of five of the eight possible adjustments, with the exception of those that are intended for specialized or limited types of work. Included in the chart on page 224 are cameras that are classified as "portrait" cameras, with no adjustments on the front, and "press" cameras, some of which have no adjustments on the back.

Variations in mechanical limitations on front and back swing and tilt adjustments result in a range of maximum adjustments from 12° to "unlimited" on cameras now being made. "Unlimited" means that the front or back can be swung or tilted 90°, or so far that optical and aesthetic limitations will be reached before the mechanical limitations.

Full utilization of the movements built into a camera may also be limited by a binding of the bellows when the front and back are close together, or by tautness of the bellows when they are fully extended. The chart below lists the specifications for 12 representative view cameras from seven different manufacturers. Several

TILT AND SWING SPECIFICATIONS

	Degree of movement for camera:												
	1	2	3	4	5	6	7	8	9	10	11	12	13*
Lens tilt	U	U	30°	U	30°	30°	U	26°	—	25°	25° 10°	U	15°
Back tilt	U	U	30°	30°	30°	30°	U	26°	35°	25°	25° 10°	U	15°
Lens swing	U	U	12°	U	20°	20°	U	12°	—	45°	35°	30°	15°
Back swing	U	U	12°	25°	20°	20°	U	12°	65°	45°	35°	30°	15°

13* Press camera U = Unlimited

Fig. 247. Maximum angles of tilt *(top)* and swing *(middle)* are reduced when both adjustments are used simultaneously *(bottom)*

cameras have more freedom in tilt adjustments than in swing adjustments, and all of the cameras with one exception have identical limitations on the corresponding front and back adjustments. One press camera is included. It has larger swing adjustments than two of the view cameras, but smaller tilt adjustments. It should be noted, however, that the 15° adjustment specified for the press camera can be realized only when the tilt adjustment or the swing adjustment is used alone, not when the two are used simultaneously (Fig. 247).

Lateral shift adjustments range from approximately 1/2 in. to 3 in. in each direction on 4×5-in. cameras and up to 4 in. on 8×10-in. cameras. The possible displacement of the lens and the film on cameras that have adjustments on both the front and the back is the sum of the two individual adjustments, so that a camera with a 2-in. lens shift and a 2-in. back shift can produce the same effect as a camera that has a 4-in. lens shift and no shift on the back. Specifications for lateral and vertical movements on 15 cameras including a press, a wide-angle view, and a 35mm camera are given below.

LATERAL AND VERTICAL SPECIFICATIONS

					Movement (in.) for camera:										
	1	2	3	4	5	6	7	8	9	10	11	12	13*	14*	15*
Lens shift (Each way)	$1^3/_4$	$1^3/_4$	$^7/_8$	4	—	—	$1^3/_4$	$^5/_8$	2	2	$2^1/_2$	3	1	—	$^7/_{16}$
Back shift (Each way)	$2^5/_8$	$3^1/_2$	$^7/_8$	—	—	—	2	$^5/_8$	—	—	$2^1/_2$	3	—	—	—
Front rise/fall (Total)	$6^1/_2$	$5^1/_8$	4	5	$4^3/_8$	$6^1/_2$	$4^3/_4$	3	3	—	2	U	$1^3/_4$	$1^1/_2$	$^7/_8$
Back rise/fall (Total)	$6^1/_2$	7	—	—	—	—	$3^1/_2$	—	—	—	2	U	—	—	—

13* Press cameras 15* 35mm camera

14* Wide-angle view camera U = Unlimited

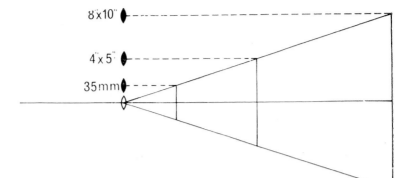

Fig. 248. Equivalent lens displacements for 35 mm, 4×5 inch, and 8×10 inch cameras.

Whereas lateral adjustments are always equal in magnitude in both directions, the rising and falling movements are seldom equal. Such a requirement would result in a bulkier camera. Inequality of movement is of no importance when the front and back both have rising-falling adjustments, since the effect of a falling lens can be obtained by raising the back. Many cameras do not have this adjustment on the back, however. When a situation requires an extensive falling lens movement with these cameras, an alternative method must be used, such as tilting the bed of the camera down and tilting the lens board and back to vertical positions. The drop bed on press cameras is used for the same effect. Suspending a view camera upside down converts the usually generous rising front into a falling front. Typical of the difference in the amount of rise and fall is a 3-in. rise and a 1-in. fall on a camera with a total movement of 4 in. As shown on the chart on page 226, the total rising-falling movement varies on different view cameras from 2 in. to 7 in., with one camera offering "unlimited" movement by adding extensions to the front and back standards.

The effectiveness of moving the lens laterally or vertically to alter placement of the image on the film depends not only on the amount of the movement, but also on the size of the film. For example, raising the lens 4 in. on a view camera with 4×5-in. film in the horizontal position will move the image of a distant object 4 in. upward, that is, from the bottom edge of the film to the top edge. Raising the lens the same distance with 8×10-in. film will still move the image up 4 in., but this is only one half the width of the larger film. Thus, a 7/8-in. lens movement on a 35mm camera corresponds to $3\frac{1}{2}$ in. on a 4×5-in. camera, and 7 in. on an 8×10-in. camera (Fig. 248). It should be noted that the different directions of movement of the lens on the 35 mm camera are obtained by mounting the lens in one of twelve positions of rotation on the camera. The lens, therefore, is mounted in an intermediate position to obtain the simultaneous effects of a rising front and a lateral shift, reducing the vertical and lateral displacements of the lens from the maximum that can be obtained when only one of the two adjustments is required.

On-axis pivoting of the tilts and swings is generally considered desirable because this method minimizes the amount of refocusing and recomposing required after using the adjustments (Fig. 249). All

Fig. 249. Camera tilted downward at the subject plane with tilt adjustments zeroed and the image focused at the centre of the ground glass.

Ideally, refocusing would not be necessary when the lens board or back is tilted to the correct angle to obtain overall sharpness.

Appearance of the image after tilting the lens board on a camera with the tilting pivot located at the runner. Extensive refocusing is required.

view cameras have the swing adjustments on-axis, but there is a variation in the treatment of the tilts. One camera has the points of rotation for both the front and the back tilts located at the bottom of the standards, close to the camera bed. On-axis lens tilt and off-axis back tilt are used on a couple of cameras. An optional accessory that substitutes a tilt adjustment at the runner is available for one camera that normally tilts on-axis, and another camera tilts at two different points, providing 10° of tilt on-axis with an additional 25° at the runner. An additional advantage of the dual tilt system as used on the Kardan B view camera is that the lens and back can be positioned beyond the ends of the monorail for an increased bellows extension. An objection to on-axis tilting of the back of the camera is that the side supports tend to interfere with the insertion and removal of the film holder when horizontal format photographs are made with the back tilted to an extreme position (Fig. 251).

Appearance of the image after tilting the lens board on a camera with "on-axis" tilts, equipped with a commercial lens. A small amount of refocusing is required.

Appearance of the image after tilting the lens board on a camera with "on-axis" tilts, equipped with a telephoto lens. Extensive refocusing and repositioning of the image are necessary because the rear nodal point is located in front of the lens rather than at the pivot point.

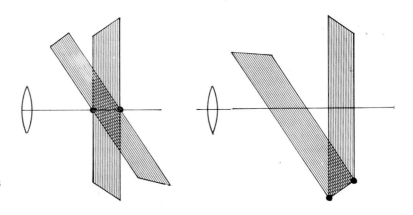

Fig. 250. Off-axis (*right*) and on-axis (*left*) tilting backs.

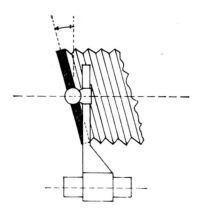

Mechanical stops, limiting the amount of tilt, are usually employed to prevent this situation from arising. This limitation of the on-axis tilts must be weighed against two disadvantages of the off-axis tilts. These are the inconvenience of making major changes in the focus and camera alignment, and the difficulty of bringing the lens close enough to the film to obtain a sharp image with a short focal length lens when the lens must be tilted forward or the film plane must be tilted back (Fig. 252). The Sinar p view camera effectively tilts on-axis without side supports through the use of rocker-shaped supports at the bottom of the standard. The Linhof L camera has on-axis tilts with supports on one side of the camera only which eliminates any possible obstruction on the other side.

There are three refinements that facilitate use of the tilt, swing, and lateral adjustments on view cameras: click stops indicate when each adjustment is in its zero position; calibrated markings indicate the displacement of each adjustment from its zero position; and spirit levels indicate when the front, the back, and the bed are perpendicular to, or parallel with the ground (Fig. 253). At the present time, only one brand of view camera has all of these features, and approximately half have none of the three.

Click stops are especially useful for rapidly returning adjustments to their zero positions without the necessity of checking visually. They are also useful for determining which side of the zero setting the adjustment is on, while examining the image on the ground glass. Calibrations on the tilts and swings are invaluable in situations where the front and back of the camera must be parallel to each other when they are not at the zero settings, and calibrations on all adjustments make it possible for the photographer to work to higher standards of precision. Spirit levels are used on the backs of many view cameras, but only a couple of cameras also have them on the front and on the bed. There are two other shortcomings with respect to spirit levels. They are often located on top of the camera where they cannot be seen when the camera is in a high position, and they frequently indicate only when the film plane is perpendicular to the ground, not when it is parallel.

Fig. 252. Difficulty may be encountered in bringing the lens and film close enough together to focus the image under some conditions when tilts pivot at the runners.

Lens boards

Standardization of the size of lens boards is a desirable feature because it eliminates an annoying problem involved in interchanging lenses. At least seven lens board sizes, ranging from $3\frac{1}{2} \times 3\frac{1}{2}$ in. to

9×9 in., are used on view cameras currently being manufactured. This variation creates no problem for photographers who use only one camera and one set of lenses. Those who want to use a lens on more than one camera generally either transfer the lens from one board to another, or else mount the lens permanently on the smallest lens board and use adapter lens boards on the other cameras. Although lens boards tend to increase in size with camera size, there is some overlapping so that the same lens board can be used on two different size cameras, as shown below:

Fig. 253. Calibrated tilt adjustment *(left)* and calibrated lateral shift, swing, and fine-focusing adjustments, and level bubbles *(right)*.

TYPICAL LENS BOARD SIZES

View camera film size (in.)	Lens board dimensions (in.)
$2\frac{1}{4}$ x $3\frac{1}{4}$	$3\frac{1}{2}$ x $3\frac{1}{2}$
4 x 5	4 x 4
	$4\frac{3}{4}$ x $4\frac{3}{4}$
	$5\frac{1}{4}$ x $5\frac{1}{4}$
8 x 10	$5\frac{1}{4}$ x $5\frac{1}{4}$
	6 x 6
	$6\frac{3}{4}$ x $6\frac{3}{4}$
11 x 14	6 x 6
	9 x 9

Some press type cameras and older view cameras use still other sizes of lens board than those listed. No attempt is made by view camera manufacturers to provide adapters for all smaller lens boards that are used on various cameras. However, most do provide adapters

Fig. 254. Accessory level that can be used to check the angle of the lens board, ground glass, and camera bed.

Fig. 255. Four way reversible off-centre lens board.

for their own line of cameras. The most versatile arrangement is a lens board containing an iris diaphragm that can be stopped down around the lens barrel and locked to hold the lens in position. One model will accept lens barrels up to 4 in. in diameter.

The standard shape for lens boards is square, although rectangular lens boards have been used on some earlier cameras. A few cameras are constructed so that the lens board, even though square, will fit in only one position. A bevelled edge on the bottom of the opening on the camera, for example, will prevent a lens board from being inserted except when a corresponding bevelled edge on the lens board is in the proper position.

The major advantage of the non-reversible lens board is that the photographer can locate and manipulate the controls on the lens more quickly when they are consistently in the same position. The reversible lens board has two major advantages. When the camera is in a high or otherwise awkward position, visibility of the shutter and aperture markings can occasionally be improved by changing the position of the lens board. Secondly, off-centre lens boards, which are sometimes used to extend the rising-falling and lateral adjustments on the camera, are fully effective only when they can be placed on the camera in all four positions (Fig. 255). Off-centre lens boards are especially useful with short focal length wide-angle

lenses, since bellows-bind frequently limits the vertical and lateral movements of the lens. Few view camera manufacturers offer off-centre lens boards for their cameras, although they can be prepared by the photographer from undrilled blank lens boards.

Recessed lens boards are a more common solution to the problem of the short lens-to-film distance with wide-angle lenses. Nearly all view camera manufacturers offer recessed lens boards as optional accessories, and two different recessed depths are offered by some. One view camera has a versatile recessed lens board that can be turned around and used as an extension cone.

Universal behind the lens shutters, offered as accessories for several cameras, enable the photographer to use the less expensive barrel mounted lenses rather than duplicating the cost of a separate shutter for each lens used. They also offer the advantage of producing consistent exposure times with all lenses. The fastest shutter speed, however, is generally 1/60 second or slower.

Lens hoods

Adjustable lens hoods (or lens shades) are offered as optional accessories for approximately half of the models of view cameras currently being manufactured. Hand-held cameras conventionally use rigid lens hoods that are attached to the lens barrel. There are disadvantages in using this type of lens hood on view cameras. A separate lens hood or adapter would be required for each of the interchangeable lenses. More important, a rigid lens hood that is efficiently designed for a lens in the normal position may cut into the field of view when the camera adjustments are used. Ideally, a lens hood should exclude all light that originates outside the angle of view of the lens-film combination. Thus, the shape of the opening in the lens hood should correspond to the film format, although a square opening is a sensible compromise with rectangular film. The distance from the front of the lens hood to the lens board can be adjusted with bellows-type lens hoods so that compensations can be made for changes in the angle of view. In addition, the more versatile of the adjustable lens hoods can be moved vertically and horizontally to compensate for changes in alignment resulting from use

Fig. 257. Swing-out filter holder.

of the camera adjustments. Consideration should also be given to the ease with which the lens hood can be removed or swung away because this is often necessary to gain access to the shutter and aperture controls. This is not necessary, however, with one universal behind-the-lens shutter that has projecting controls along the top edge and one side. A corresponding device on the lens board enables the photographer to stop the lens down quickly to a pre-selected *f*-number. Both the shutter and the aperture controls can be operated from behind the camera.

The method of supporting adjustable lens hoods varies—some are attached to the lens standard, and others to the camera bed. Neither method eliminates the need for readjusting the lens hood after making certain camera adjustments. A couple of cameras have the same swing, tilt, lateral shift, and rising front adjustments on the lens hood as on the front of the camera.

Another function served by the adjustable lens hood on a few view cameras is that of a matte box. Camera montages can be produced by placing black cutouts of the desired shapes on the front of the matte box to control the areas of the film that are exposed for each of two or more different subjects or views. The matte box is also used for special effects such as vignetting, and diffusing the image in local areas. Transparencies can be copied conveniently and with a minimum of degradation from reflections with a matte box, since it forms a light-tight enclosure between transparency and camera.

Fig. 258. Mirror attachment.

There are corresponding advantages in universal filter holders over individually fitted filters. A substantial saving can be effected by using one set of filters for all of the interchangeable lenses. Many view cameras have universal filter holders as optional accessories, although some may be combined with the rigid type of lens shade. The swing-out filter holder illustrated in Fig. 257 is convenient when it is necessary to remove the filter for focusing, composing, or other reasons. The filter holder shown also has a reducing ring for smaller size glass filters, and an attachment for square gelatin filters. Other universal filter holders have slots into which the filters are placed. These cannot hold a filter when it is temporarily removed.

Other attachments

Three other devices that can be attached to the camera bed or body are (1) a holder for close-up objects, (2) a copy board, and (3) a mirror holder. These attachments are offered as accessories for only a few brands of view cameras. The major advantage of attaching such devices to the camera rather than to a separate support, is that they retain their same relative position as the camera is moved, thereby minimizing aligning and focusing problems. The holder for close-up objects makes it possible to move the subject vertically and laterally with precision, without affecting the focus, and to control the subject-to-lens distance without affecting the alignment. It is much easier to maintain parallelism of copy board, lens board, and film plane when the copy board is attached to the camera.

Attaching a mirror at an angle in front of the lens allows the photographer to place the camera at right angles to its original direction (Fig. 258). This offers an advantage when the camera must be placed as far as possible from the subject to include the desired area, and there is an obstruction such as a wall behind the camera. High or low viewpoints can be obtained with a mirror by aiming the camera up or down without requiring the photographer to stand on a ladder or to lie down on the floor. A front-surface mirror must be used to obtain a satisfactory image. Since the image is reversed laterally by the mirror, precautions must be used to compensate when making prints, and to indicate the correct orientation of transparencies for viewing or for reproduction.

Microscope adapters are offered as accessories for a couple of view cameras. Although it is not necessary to use a camera lens when making photographs through a microscope, a device must be used to form a light-tight connection between the microscope and the camera. Shutters are incorporated into microscope adapters for view cameras.

Features and specifications

Eighty two view camera features are listed below, grouped under appropriate headings. These features were used to compare 56 view cameras that are currently being manufactured. A comparison chart follows the list of features.

Price

 1. List price (number 1 is lowest)

Type of back

 2. Standard spring
 3. Tension-release spring
 4. Universal

Film rotation

 5. Revolving back (360°)
 6. Revolving back (vertical and horizontal only)
 7. Reversible back
 8. Revolving bed

Provisions for various backs and film holding devices

 9. Double sheet-film holder
 10. Interchangeable back, back frame, and bellows
 11. Reducing backs for sheet film
 12. Divided back
 13. Grafmatic sheet-film holder
 14. Film pack adapter
 15. Polaroid 4 × 5 film holder
 16. Roll-film holder

17. Sliding roll-film holder and ground glass
18. 4 × 5 inch single-lens reflex camera body
19. $2\frac{1}{4}$ × $2\frac{1}{4}$ inch single-lens reflex camera body
20. 35mm film holder
21. 35mm single-lens reflex camera body
22. Enlarger light housing and negative carrier
23. Bulk 35mm or roll film magazine

Bed

24. Monorail
25. Flat—folding or sliding
26. Provision for adding an extension bed
27. Provision for substituting a short bed
28. Sliding tripod block
29. Provision for attaching a second tripod block
30. Pan-tilt device
31. Overall camera length
32. Minimum closure length

Bellows

33. Maximum extension (single bellows, or with extension bed and bellows)
34. Minimum lens-board-to-film distance (with flat lens board)
35. Provision for adding extension bellows
36. Wide-angle bellows

Focusing-composing

37. Ruled ground glass
38. Fresnel lens
39. Open corners on ground glass
40. Focusing hood: X (removable: XX)
41. Attached focusing magnifier.
42. Clamps to hold focusing cloth
43. Frame to support focusing cloth or focusing bellows
44. Focusing adjustments on lens and back standards
45. Optional right or left hand focusing
46. Fine and coarse focusing

47. Adjustable tension focus lock
48. Focus scale
49. Film plane marker

Tilts, swings, etc.

50. Lens tilt (degrees)
51. Lens swing (degrees)
52. Lens shift—each direction (inches)
53. Rising-falling front—total (inches)
54. Back tilt (degrees)
55. Back swing (degrees)
56. Back shift—each direction (inches)
57. Rising-falling back—total (inches)
58. On-axis tilts—front and back
59. Normal position click-stops: X (on all adjustments: XX)
60. Calibrated tilt and swing adjustments
61. Calibrated lateral adjustments
62. Spirit level on back standard
63. Spirit level on lens standard
64. Spirit level on bed

Lens boards and lens attachments

65. Lens board dimensions
66. Provision for smaller lens boards
67. Reversible lens board
68. Universal shutter
69. Recessed wide-angle lens board
70. Adjustable lens hood
71. Universal filter holder
72. Matte box
73. Attached holder for close-up objects
74. Attached copy board
75. Attached mirror holder
76. Microscope adapter
77. Remote control shutter
78. Remote control diaphragm

Miscellaneous

79. Weight (pounds)
80. Carrying handle
81. Carrying case
82. Provision for using as a hand-held camera

The cameras listed

$2\frac{1}{4} \times 3\frac{1}{4}$
1. Galvin 2. Arca-Swiss SL23B 3. Horseman C-7001B 4. Horseman C-7000
5. Cambo SC1 6. Super Technika V

4×5
1. Calumet CC-403 2. Nagaoka 3. Calumet CC-404 4. Prinzdorf 5. Orbit
OCC-403 6. Orbit OCC-404 7. Calumet CC-402 8. Omega 45E 9. Wista
Field 45 10. Nagaoka Model 2 11. Consolidated Anaca 12. Orbit OCC-402
13. Arca-Swiss Basic B 14. Arca-Swiss Basic A 15. Rittreck Multi Format 16.
Toyo View D45A 17. Kardan Standard 45S 18. Arca-Swiss Basic DP 19.
Wista 45N 20. Toyo Field 21. Toyo View D45M 22. Plaubel Peco Profia V
23. MPP 24. Cambo SCII 25. Mark VIII 26. Sinar F 27. Wista 45D 28.
Deardorff Special 29. Arca-Swiss Series 30. Kardan Super Color 31. Sinar C
32. Plaubel Profia Mark III 33. Sinar P 34. Kardan B 35. Kardan Master "L"
36. Master Technika

8×10
1. Rittreck Multi Format 2. Calumet C-1 3. Orbit OC-1 4. MPP 5. Deardorff
6. Toyo Field 7. Arca-Swiss Series 8. Kardan Super Color 9. Cambo SCIV
10. Plaubel Profia Mark III 11. Sinar C 12. Sinar P 13. Kardan B

11×14
1. Deardorff

Most of the cameras on the following chart are advertised as "view" cameras. A
few are advertised as "technical", "press", or "field" cameras, but are included
because of their view camera features.

The cameras are listed in the first column according to selling price within
film-format categories, with number "1" the least expensive. In the 4×5 cat-
egory, the range of prices is appproximately 1:12, for the basic cameras without
lenses and accessories. Although there are a number of 5×7-in. view cameras,
they have not been included on the following chart because they are all essentially
the same as corresponding 4×5 or 8×10-in. models made by the same manu-
facturer.

"X" means that the camera has that feature, or that it is available.
"—" means that the specific information was not available.
Numbered asterisks are used for qualifying comments:
 *1 Available only with reducing back.
 *2 Unlimited rise with extensions on standards.
 *3 A 4×5 extension back is available.
 *4 Base tilt or axis tilt.
 *5 Base tilt and/or axis tilt.
 *6 Back tilts on-axis without the use of side supports.
 *7 Back and lens tilt on-axis without the use of side supports.
 *8 Adjustable pivot point.
 *9 Dual rails.

VIEW CAMERA FEATURES AND SPECIFICATIONS

Size	Price category (1)	Standard spring (2)	Tension-release spring (3)	Universal (4)	Revolving back (360°) (5)	Revolving back (V-H only) (6)	Reversible back (7)	Revolving bed (8)	Double sheet-film holder (9)	Interchangeable back, etc. (10)	Reducing back, sheet film (11)	Divided back (12)
2¼ × 3¼	(1)	X					X		X			
	(2)		X				X		X	X		
	(3)		X						X		*3	
	(4)		X						X		*3	
	(5)	X					X		X	X		
	(6)		X			X			X	X		
4 × 5	(1)		X		X				X			
	(2)	X					X		X			
	(3)		X		X				X			
	(4)			X	X				X			
	(5)		X		X				X			
	(6)		X		X				X			
	(7)		X		X				X			
	(8)	X		X		X	X		X			
	(9)	X					X		X			
	(10)	X					X		X			
	(11)		X				X		X			
	(12)		X		X				X			
	(13)		X	X			X		X	X		
	(14)		X	X			X		X	X		
	(15)			X	X				X			
	(16)			X			X		X	X		
	(17)			X		X			X			
	(18)		X	X			X		X	X		
	(19)			X		X			X			
	(20)	X					X		X			
	(21)		X	X	X		X		X	X		
	(22)	X				X			X			
	(23)			X		X		X	X	X	X	
	(24)			X			X		X	X	X	X
	(25)			X		X			X			
	(26)			X			X	X	X	X	X	X
	(27)			X		X			X			
	(28)	X			X		X		X		X	X
	(29)		X	X			X	X	X			
	(30)		X	X				X	X	X	X	X
	(31)		X	X			X	X	X	X	X	
	(32)		X	X			X	X	X	X	X	
	(33)		X	X			X	X	X		X	X
	(34)		X	X			X	X	X		X	X
	(35)			X			X		X		X	X
	(36)			X		X			X	X	X	X
8 × 10	(1)	X							X		X	
	(2)		X		*1		X		X		X	X
	(3)		X		*1		X		X		X	X
	(4)	X		*1		*1	X	X	X	X	X	
	(5)	X			*1		X		X		X	X
	(6)	X					X		X		X	
	(7)		X				X		X	X	X	
	(8)		X				X	X	X	X	X	X
	(9)	X		*1			X		X	X	X	*1
	(10)		X	*1			X	X	X	X	X	
	(11)		X	*1			X	X	X	X	X	X
	(12)		X	*1			X	X	X	X	X	X
	(13)		X	*1			X	X	X	X	X	X
11 × 14	(1)	X			*1		X		X		X	*1

240

		13	14	15	16	17	18	19	20	21	22	23
	(1)	Grafmatic sheet-film holder	Film-pack adapter	Polaroid 4 × 5 holder	Roll-film holder	Sliding roll-film holder	4 × 5 SLR camera body	2¼ × 2¼ SLR camera body	35mm film holder	35mm SLR camera body	Enlarger accessories	Bulk 35mm or roll film
		Price category										
2¼ × 3¼	(1)		X		X							
	(2)		X		X							
	(3)	X		X	X	X						
	(4)	X		X	X	X						
	(5)		X		X							
	(6)		X		X						X	X
4 × 5	(1)	X	X	X	X							
	(2)		X	X								
	(3)	X	X	X	X							
	(4)	X	X	X	X	X						
	(5)	X	X	X	X							
	(6)	X	X	X	X							
	(7)	X	X	X	X							
	(8)	X	X	X		X						
	(9)			X	X	X						
	(10)	X	X	X	X							
	(11)		X	X	X							
	(12)	X	X	X	X							
	(13)	X	X	X	X	X						
	(14)	X	X	X	X	X						
	(15)					X						
	(16)	X	X	X	X	X						
	(17)	X	X	X	X	X					X	
	(18)	X	X	X	X	X						
	(19)	X	X	X	X	X						
	(20)		X	X	X	X						
	(21)	X	X	X	X	X						
	(22)	X	X	X								
	(23)	X	X	X	X	X						
	(24)	X	X	X	X	X	X					
	(25)	X	X	X	X	X						
	(26)	X	X	X	X	X		X	X	X	X	
	(27)	X	X	X	X	X						
	(28)		X	X	X							
	(29)	X	X	X	X	X	X	X				X
	(30)	X	X	X	X	X					X	X
	(31)	X	X	X	X	X		X	X	X	X	
	(32)	X	X	X	X	X						
	(33)	X	X	X	X	X		X	X	X	X	
	(34)	X	X	X	X	X						X
	(35)	X	X	X	X	X					X	X
	(36)	X	X	X	X	X					X	X
8 × 10	(1)											
	(2)	*1	*1	*1	*1							
	(3)	*1	*1	*1	*1							
	(4)	*1	*1	*1	*1							
	(5)		*1	*1	*1							
	(6)		*1	*1	*1	*1						
	(7)	*1	*1	*1	*1	*1	*1	*1				
	(8)	*1	*1	*1	*1	*1				*1	*1	
	(9)	*1	*1	*1	*1	*1		*1				
	(10)	*1	*1	*1	*1	*1						
	(11)	*1	*1	*1	*1	*1		*1	*1	*1	*1	
	(12)	*1	*1	*1	*1	*1		*1	*1	*1	*1	
	(13)	*1	*1	*1	*1	*1						*1
11 × 14	(1)											

Size	Price (1)	Bed									Bellows	
	Price category	24 Monorail	25 Flat-folding or sliding	26 Extension bed	27 Short bed	28 Sliding tripod block	29 Second tripod block	30 Pan-tilt device	31 Overall camera length	32 Minimum closure length	33 Maximum extension	34 Minimum extension
$2\frac{1}{4} \times 3\frac{1}{4}$	(1)	X		X	X	X			9	9	14	$3\frac{1}{4}$
	(2)	X		X		X			11	11	23	$2\frac{1}{2}$
	(3)		X						8	$3\frac{1}{2}$	$10\frac{1}{2}$	—
	(4)		X						8	$3\frac{1}{2}$	$10\frac{1}{2}$	—
	(5)	X		X	X	X	X	X	$11\frac{1}{2}$	$11\frac{1}{2}$	20	$2\frac{1}{2}$
	(6)		X						$12\frac{1}{2}$	$3\frac{3}{4}$	$12\frac{1}{2}$	—
4×5	(1)	X				X			20	20	16	4
	(2)		X						13	$2\frac{1}{2}$	13	$2\frac{1}{2}$
	(3)	X				X			26	26	22	4
	(4)								—	5	24	—
	(5)	X				X			20	20	16	4
	(6)	X				X			26	26	22	4
	(7)	X				X			11	11	$7\frac{1}{4}$	2
	(8)	X				X			$18\frac{1}{2}$	$18\frac{1}{2}$	18	$3\frac{1}{2}$
	(9)								12	3	12	$1\frac{3}{4}$
	(10)		X						13	$2\frac{1}{2}$	13	$2\frac{1}{2}$
	(11)	*9							10	10	10	—
	(12)	X				X			11	11	$7\frac{1}{4}$	2
	(13)	X		X					16	16	32	$3\frac{1}{2}$
	(14)	X		X					16	16	32	$3\frac{1}{2}$
	(15)										14	3
	(16)	X		X		X	X		17	17	34	$4\frac{1}{2}$
	(17)	X				X			$17\frac{3}{4}$	$17\frac{3}{4}$	$17\frac{3}{4}$	—
	(18)	X		X					16	16	32	$3\frac{1}{2}$
	(19)		X						$11\frac{1}{2}$	—	$11\frac{1}{2}$	$3\frac{1}{2}$
	(20)		X						$12\frac{1}{2}$	4	$12\frac{1}{2}$	$2\frac{3}{4}$
	(21)	X		X		X	X		20	20	34	$4\frac{1}{2}$
	(22)	X		X	X				$17\frac{1}{2}$	$17\frac{1}{2}$	35	—
	(23)	X		X	X	X	X		18	18	36	—
	(24)	X		X	X	X	X	X	18	18	36	3
	(25)		X						17	4	17	$2\frac{1}{2}$
	(26)	X		X	X	X	X	X	12	12	36	—
	(27)		X	X					$11\frac{1}{2}$	—	—	$3\frac{1}{2}$
	(28)		X						22	9	22	$3\frac{1}{2}$
	(29)	X		X		X	X		16	16	32	3
	(30)	X		X		X			$12\frac{1}{2}$	$12\frac{1}{2}$	25+	—
	(31)	X		X	X	X	X	X	12	12	36	—
	(32)	X		X	X	X	X		$21\frac{1}{2}$	$21\frac{1}{2}$	43	3
	(33)	X		X	X	X	X	X	12	12	36	—
	(34)	X		X	X	X	X	X	$12\frac{1}{2}$	$12\frac{1}{2}$	40+	2
	(35)	X		X		X		X	$19\frac{3}{4}$	$19\frac{3}{4}$	27+	—
	(36)		X						16	$4\frac{1}{3}$	16	—
8×10	(1)										18	$6\frac{1}{2}$
	(2)		X			X			35	8	34	$4\frac{1}{2}$
	(3)		X			X			35	8	34	$4\frac{1}{2}$
	(4)	X		X	X	X	X		18	18	36	—
	(5)		X			X			30	$4\frac{1}{4}$	30	$3\frac{1}{2}$
	(6)		X						$25\frac{3}{4}$	$6\frac{1}{8}$	$25\frac{3}{4}$	$3\frac{3}{8}$
	(7)	X		X		X	X		18	18	35	4
	(8)	X		X	X	X			25	25	40	—
	(9)	X		X	X	X	X	X	30	30	29	4
	(10)	X		X	X	X	X		$21\frac{1}{2}$	$21\frac{1}{2}$	43	3
	(11)	X		X	X	X	X	X	12	12	36+	—
	(12)	X		X	X	X	X	X	12	12	36+	—
	(13)	X		X	X	X	X	X	25	25	40+	2
11×14	(1)		X						42	6	42	5

Size	Price	Bellows		Focusing-Composing								
	(1)	35	36	37	38	39	40	41	42	43	44	45
	Price category	Extension bellows	Wide-angle bellows	Ruled ground glass	Fresnel lens	Open corners on ground glass	Focusing hood: X (removable: XX)	Attached focusing magnifier	Focusing cloth clamps	Focusing bellows or frame	Front and back focusing	Right or left focusing
$2\frac{1}{4} \times 3\frac{1}{4}$	(1)											
	(2)	X	X	X		X	XX	X			X	
	(3)				X		XX					X
	(4)				X		XX					X
	(5)	X	X	X							X	
	(6)			X	X		XX	X				X
4×5	(1)			X		X			X		X	
	(2)										X	
	(3)			X		X		X			X	
	(4)						XX					
	(5)			X		X			X		X	
	(6)			X		X		X			X	
	(7)		X	X		X			X		X	
	(8)						XX	X		X	X	X
	(9)											
	(10)										X	
	(11)			X							X	X
	(12)		X	X		X			X		X	
	(13)		X	X		X					X	
	(14)		X	X		X					X	
	(15)	X					XX				X	
	(16)	X	X		X		XX	X			X	X
	(17)			X	X		XX	X		X	X	
	(18)		X	X		X					X	
	(19)						XX					
	(20)			X	X		XX					X
	(21)	X	X	X	X		XX	X			X	X
	(22)		X	X	X		XX				X	
	(23)	X	X				XX				X	
	(24)	X	X	X							X	
	(25)						XX					X
	(26)	X	X	X	X	X	XX	X		X		X
	(27)	X	X				XX					
	(28)			X	X	X					X	
	(29)	X	X	X	X	X	XX	X			X	
	(30)	X	X	X	X		XX	X		X	X	X
	(31)	X	X	X	X	X	XX			X	X	X
	(32)	X	X	X	X			X		X	X	X
	(33)	X	X	X	X	X	XX	X		X	X	X
	(34)	X	X	X	X		XX	X		X	X	
	(35)	X	X	X	X		XX	X		X	X	
	(36)			X	X		XX	X			X	
8×10	(1)										X	
	(2)			X					X	X		X
	(3)			X					X	X		X
	(4)	X	X				*1				X	
	(5)					X					X	
	(6)			X	X		*1	*1				X
	(7)	X	X	X		X				X	X	
	(8)	X	X	X				*1		*1	X	X
	(9)	X	X	X							X	
	(10)	X	X	X	X			X			X	X
	(11)	X	X	X	X	X	XX	X			X	X
	(12)	X	X	X	X	X	XX	X			X	X
	(13)	X	X	X			*1			X	X	
11×14	(1)					X					X	

Size	Price category (1)	46 Fine and coarse focusing	47 Adjustable tension focus lock	48 Focus scale	49 Film plane marker	50 Lens tilt	51 Lens swing	52 Lens shift, each direction	53 Rising-falling front, total	54 Back tilt	55 Back swing	56 Back shift, each direction
2¼ × 3¼	(1)		X			30°	30°	$\frac{3}{4}$	$1\frac{1}{4}$	30°	30°	
	(2)		X	X		40°	90°	$1\frac{1}{4}$	$2\frac{1}{4}$	40°	90°	$1\frac{1}{4}$
	(3)		X	X		15°	15°	$\frac{1}{2}$	1	10°	10°	
	(4)		X	X		15°	15°	$\frac{1}{2}$	1	10°	10°	
	(5)		X			30°	90°	1	*2	30°	90°	1
	(6)	X	X	X	X	$\frac{15}{30}$		$\frac{1}{2}$	2	15°	15°	
4 × 5	(1)	X	X			90°	12°	1	4	90°	12°	1
	(2)	X	X			$\frac{12}{45}$			2	$\frac{20}{55}$	10	
	(3)	X	X			90°	12°	1	4	90°	12°	1
	(4)					—	—		4	—	—	
	(5)	X	X			90°	12°	1	4	90°	12°	1
	(6)	X	X			90°	12°	1	4	90°	12°	1
	(7)	X	X			90°	12°	1	4	90°	12°	1
	(8)	X	X	X		30°	20°	$1\frac{1}{3}$	$3\frac{1}{2}$	30°	20°	$1\frac{1}{3}$
	(9)		X			$\frac{30}{40}$	30		$2\frac{1}{4}$	$\frac{30}{40}$	30	
	(10)		X			$\frac{28}{45}$	8°		$2\frac{3}{4}$	$\frac{26}{55}$	10	
	(11)		X			90°	90°			90°	90°	
	(12)	X	X			90°	12°	1	4	90°	12°	1
	(13)		X			90°	90°	$3\frac{1}{4}$	3	90°	90°	$2\frac{1}{2}$
	(14)		X			90°	90°	$3\frac{1}{4}$	3	90°	90°	$2\frac{1}{2}$
	(15)		X			$\frac{30}{50}$	30°	$\frac{1}{2}$	4	$\frac{25}{55}$	15	$1\frac{1}{4}$
	(16)		X			30°	90°	$1\frac{1}{4}$	$3\frac{1}{2}$	30°	90°	$1\frac{1}{4}$
	(17)	X	X		X	90°	90°	2	$2\frac{3}{4}$	90°	90°	2
	(18)		X			90°	90°	$3\frac{1}{4}$	3	90°	90°	$2\frac{1}{2}$
	(19)			X		15°		$1\frac{1}{4}$	2	15°	15°	
	(20)		X			$\frac{15}{90}$	8°	$\frac{1}{3}$	$1\frac{3}{4}$	$\frac{15}{90}$	8	
	(21)		X			30°	90°	$1\frac{1}{4}$	$3\frac{1}{2}$	30°	90°	$1\frac{1}{4}$
	(22)					35°	90°	$1\frac{3}{4}$	5	35°	90°	$1\frac{3}{4}$
	(23)	X	X	X		90°	30°	2	*2	90°	30°	2
	(24)		X			30°	90°	2	*2	30°	90°	2
	(25)		X	X		15°	15°	1	$2\frac{1}{4}$	15°	15°	
	(26)	X	X	X	X	$\frac{50}{90}$	50°	$2\frac{1}{4}$	3	$\frac{50}{90}$	50°	$2\frac{1}{2}$
	(27)		X			15°		$1\frac{1}{4}$	2	15°	20°	
	(28)		X			30°	20°		$4\frac{1}{2}$	30°	20°	
	(29)		X	X		40°	90°	$2\frac{1}{2}$	$2\frac{1}{4}$	40°	90°	$2\frac{1}{2}$
	(30)	X	X	X	X	90°	90°	$2\frac{3}{4}$	$6\frac{3}{4}$	90°	90°	$2\frac{3}{4}$
	(31)	X	X	X	X	$\frac{50}{90}$	50°	$2\frac{1}{4}$	3	65°	60°	$1\frac{3}{4}$
	(32)		X			35°	90°	$1\frac{3}{4}$	5	35°	90°	$1\frac{3}{4}$
	(33)	X	X	X	X	65°	60°	$1\frac{3}{4}$	3	65°	60°	$1\frac{3}{4}$
	(34)	X	X		X	90°	90°	$1\frac{3}{8}$	*2	90°	90°	$1\frac{3}{8}$
	(35)	X	X	X	—	90°	90°	2	7	90°	90°	2
	(36)	X	X	X	X	30°	15°	$1\frac{1}{2}$	2	20°	20°	
8 × 10	(1)		X			$\frac{30}{50}$	30°	$\frac{1}{2}$	4	$\frac{25}{55}$	15°	$1\frac{1}{4}$
	(2)		X			90°	90°	2	5	30°	30°	2
	(3)		X			90°	90°	2	5	30°	30°	2
	(4)	X	X	X		90°	30°	2	*2	90°	30°	2
	(5)		X			30°	20°		$6\frac{1}{2}$	30°	20°	
	(6)		X			$\frac{15}{90}$	20°	$\frac{1}{2}$	$3\frac{1}{2}$	$\frac{15}{90}$	6°	
	(7)		X	X		45°	90°	3	3	45°	90°	3
	(8)	X	X	X	X	90°	90°	$2\frac{3}{4}$	$6\frac{3}{4}$	90°	90°	$2\frac{3}{4}$
	(9)		X			30°	90°	2	*2	30°	45°	1
	(10)		X			35°	90°	$1\frac{3}{4}$	5	35°	90°	$1\frac{3}{4}$
	(11)	X	X	X	X	$\frac{50}{90}$	50°	$2\frac{1}{4}$	3	65°	60°	$1\frac{3}{4}$
	(12)	X	X	X	X	65°	60°	$1\frac{1}{2}$	3	65°	60°	$1\frac{3}{4}$
	(13)	X	X		X	90°	90°	$3\frac{1}{8}$	$6\frac{1}{8}$	90°	90°	$2\frac{1}{2}$
11 × 14	(1)		X			30°	20°		6	30°	20°	

Size	Price	Tilts, Swings, etc.								Lens Boards and Lens Attachments				
	(1)	57	58	59	60	61	62	63	64	65	66	67	68	69
	Price category	Rising-falling back, total	On-axis tilts, front and back	Click-stops: X (all adjust: XX)	Calibrated tilts and swings	Calibrated lateral adjustments	Spirit level on back standard	Spirit level on lens standard	Spirit level on bed or runner	Lens board dimensions	Smaller lens boards	Reversible lens board	Universal shutter	Recessed lens board
2¼×3¼	(1)		X							5		X		
	(2)	2¼	*4				X	X	X	4½		X		X
	(3)			XX						3¼		X		
	(4)			XX						3¼		X		
	(5)	*2	X	XX	X	X	X	X		5				X
	(6)			XX						—				X
4 × 5	(1)		X	XX			X			4	X	X		X
	(2)									3⅞	X			
	(3)		X	XX			X			4	X	X		X
	(4)									—				
	(5)		X	XX			X			4	X	X		X
	(6)		X	XX			X			4	X	X		X
	(7)		X	XX			X			4	X	X		X
	(8)	3½	X	X	X	X	X			6⅓	X	X		
	(9)													
	(10)									3⅞	X			
	(11)									—				
	(12)		X	XX			X			4	X	X		X
	(13)	2¼					X	X	X	6¾	X	X		X
	(14)	2¼	X				X	X	X	6¾	X	X		X
	(15)									4½	X			
	(16)	3½	X	X	X	X				6¼	X	X		X
	(17)	2¾	X	X	X	X	X			—	X	X		X
	(18)	2¼	*5				X	X	X	6¾		X		X
	(19)													X
	(20)									4¼				X
	(21)	3½	X	X	X	X	X	X		6¼	X	X		X
	(22)	5			X	X	X			6½	X			X
	(23)		X	XX	X	X				5½				
	(24)	*2	X		X	X	X	X		6½				X
	(25)		X	X						3¾				X
	(26)	3		XX	X		X	X	X	5¼	X		X	X
	(27)						X							X
	(28)									4	X		X	X
	(29)	2¼	*5		X		X	X	X	6¾		X		X
	(30)	6¾	X	X	X	X	X	X		—	X	X		X
	(31)	3	*6	XX	X	X	X	X	X	5¼	X		X	X
	(32)	5		X	X	X	X	X	X	6½	X			X
	(33)	3	*7	XX	X	X	X	X	X	5¼	X		X	X
	(34)	*2	X	X	X	X	X	X		5½	X			X
	(35)	7	*8	X	X	X	X	X		—	X	X	X	X
	(36)			XX						—				X
8 × 10	(1)		X							4½	X			
	(2)		X				X			6	X			X
	(3)		X				X			6		X		X
	(4)	*2	X	XX	X	X				5½				
	(5)		X		X					6	X	X	X	
	(6)									6¼				X
	(7)	6½	*5		X	X	X	X	X	6¾	X			X
	(8)	6	X	X	X	X	X	X		—	X	X	X	X
	(9)	*2	X	XX	X	X	X	X		6½	X			X
	(10)	3¾		X	X	X	X	X	X	8	X			X
	(11)	2	*6	XX	X	X	X	X	X	5¼	X		X	X
	(12)	2	*7	XX	X	X	X	X	X	5¼	X		X	X
	(13)	6⅛	X	X	X	X	X	X		5½	X			X
11 ×14	(1)									6	X	X	X	X

245

Size	Price	Lens Boards and Lens Attachments									Misc.			
	(1)	70	71	72	73	74	75	76	77	78	79	80	81	82
	Price category	Adjustable lens hood	Universal filter holder	Matte box	Attached holder for closeups	Attached copy board	Attached mirror holder	Microscope adapter	Remote control shutter	Remote control diaphragm	Weight (pounds)	Carrying handle	Carrying case	Usable as hand-held camera
$2\frac{1}{4} \times 3\frac{1}{4}$	(1)								X		$2\frac{3}{4}$			
	(2)	X	X	X		X			X	X	$3\frac{1}{4}$	X	X	
	(3)								X		$4\frac{1}{2}$	X	X	
	(4)								X		$4\frac{1}{2}$	X	X	X
	(5)	X	X	X	X	X			X		$6\frac{1}{2}$	X	X	
	(6)	X	X	X				X	X		4	X	X	X
4×5	(1)	X	X						X		$8\frac{1}{2}$	X	X	
	(2)								X		$2\frac{1}{2}$	X		
	(3)	X	X						X		$8\frac{3}{4}$	X	X	
	(4)								X		11	X		
	(5)	X	X						X		$8\frac{1}{2}$	X	X	
	(6)	X	X						X		$8\frac{3}{4}$	X	X	
	(7)	X	X						X		8	X	X	
	(8)								X		$8\frac{3}{4}$		X	
	(9)								X		$3\frac{1}{4}$			
	(10)								X		$2\frac{1}{2}$	X		
	(11)								X		8			
	(12)	X	X						X		8	X]	X	
	(13)	X	X	X					X	X	6		X	
	(14)	X	X	X					X	X	6		X	
	(15)	X							X		$9\frac{1}{4}$			
	(16)	X							X		$7\frac{1}{4}$		X	
	(17)	X	X	X				X	X	X	—		X	
	(18)	X	X	X					X	X	6		X	
	(19)								X		$5\frac{1}{4}$			
	(20)	X							X		$5\frac{1}{4}$		X	
	(21)	X							X		$7\frac{1}{4}$		X	
	(22)								X		—		X	
	(23)	X							X					
	(24)	X	X	X	X	X			X		$9\frac{1}{2}$		X	
	(25)								X		$6\frac{1}{4}$	X	X	X
	(26)	X	X	X	X	X	X	X	X	X	$6\frac{1}{2}$		X	
	(27)	X							X		$6\frac{1}{2}$			
	(28)								X		7	X	X	
	(29)	X	X	X					X	X	7		X	
	(30)	X	X	X	X	X	X	X	X	X	—		X	
	(31)	X	X	X	X	X	X	X	X	X	9		X	X
	(32)	X	X	X				X	X	X	6		X	
	(33)	X	X	X	X	X	X	X	X	X	$11\frac{1}{2}$		X	X
	(34)	X	X	X	X				X	X	$8\frac{1}{2}$		X	
	(35)	X	X	X	X	X	X	X	X	X	13.5	—	X	
	(36)	X	X	X				X	X	X	6	X	X	X
8×10	(1)	X							X		9.3			
	(2)	X	X						X		14	X	X	
	(3)	X	X						X		14	X	X	
	(4)	X							X		—			
	(5)								X		12	X	X	
	(6)	X							X		14		X	
	(7)	X	X	X					X	X	13		X	
	(8)	X	X	X	X	X	X	X	X	X	—		X	
	(9)	X	X	X	X	X			X		15		X	
	(10)	X	X	X				X	X	X	6		X	
	(11)	X	X	X	X	X	X	X	X	X	10		X	
	(12)	X	X	X	X	X	X	X	X	X	12		X	
	(13)	X	X	X	X			X	X	X	18			
11×14	(1)								X		$12\frac{1}{2}$	X	X	

10

EVOLUTION OF THE VIEW CAMERA

If the crude early camera that consisted of a tripod-mounted box containing a lens and a ground glass is considered to be the prototype of the modern view camera, one of the first refinements was a device for changing the lens-to-plate distance. Telescoping metal tubes on the lens mount, with a simple set screw or a rack and pinion device, enabled the photographer to focus on objects at different distances.

An 1857 camera with this focusing adjustment is illustrated in Fig. 259. This camera also has the unusual feature for a box camera of being collapsible.

The importance of being able to make more drastic changes in lens-to-plate distance to accommodate different focal length lenses was recognized by many of the early camera makers. Two telescoping boxes provided this feature on the camera shown in Fig. 260, built during the 1850's. Additional refinements of a folding bed and a carrying handle are found on the even earlier French Daguerrotype camera of 1842 in Fig. 261. Other methods used during the 1880's to increase lens-to-plate distance were the lens cone (Fig. 262), the extension back, and the extension bed (Fig. 263).

Triple-extension bellows and telescoping tracks on the 1905 folding camera in Fig. 265 provided the photographer with considerable freedom in his choice of lenses, and the ability to focus on small objects close to the camera.

The collapsible box camera mentioned above exemplifies the importance placed on compactness of early cameras, at a time when the

Fig. 259. 1857 folding camera, with the unusual feature for a box camera of being collapsible *(below)*

247

Fig. 260. Box camera of the 1850's used telescoping boxes for coarse focusing, and rack and pinion on the lens mount for fine focusing.

Fig. 261. French Daguerrotype camera of 1842 featured a folding bed and a carrying handle

Fig. 262. Lens cone increased lens to film distance on 1887 camera.

Fig. 263. Extension bed on a view camera produced by the Rochester Optical Company during the 1880's.

Fig. 264. Wire frame Le Stereographe camera, made by Dubroni of Paris in 1878 in operating position and in collapsed position

transportation of bulky cameras was more of a problem than it is today. A flexible canvas bellows on the unusual 1878 wire-frame camera by Dubroni of Paris made it possible to collapse the camera to a fraction of its operating length (Fig. 264). An accordion bellows was used on the 1905 triple-extension camera, enabling it to be folded into a relatively thin self-contained carrying case (Fig. 265).

Besides the controls over lens-to-plate distance, the adjustment found most frequently on early view cameras was the rising-falling front—and on many cameras this was the only other adjustment. Photographers were mostly concerned with retaining parallelism of vertical subject lines, and the rising-falling front enabled them to control image placement while keeping the camera bed level, with the back perpendicular to the ground. Overlapping lens boards, with a cutout opening in the rear board, served as a light-trapping device, allowing the lens to be raised or lowered without involving movement of the camera bellows. Although the 1878 Dubroni camera had both vertical and lateral movements on the lens, the cloverleaf cutout behind the lens (Fig. 267) suggests that the photographer was not expected to use both movements simultaneously. He could, however, keep vertical subject lines parallel with either vertical or horizontal format photographs.

A unique double vertical bellows arrangement on the lens board of the Koch and Wilz dry-plate camera of the 1870's eliminated the need for overlapping lens boards, while allowing the main camera bellows to be attached to the stationary lens standard (Fig. 268). Another unusual feature of this camera was the remote control

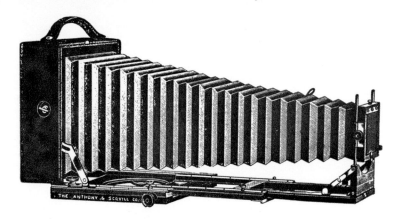

Fig. 265. 1905 A and S leather cov-
ered "Compact" camera in fully ex-
tended position *(left)* and in closed
position *(right)*.

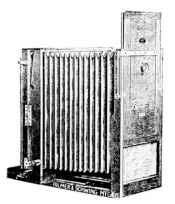

Fig. 266. Extensive rising front on the
1901 Folmer and Schwing "Skyscra-
per" camera.

Fig. 267. Clover-leaf cutout on 1878
Dubroni camera permitted vertical
or lateral movement of lens board,
but not both simultaneously.

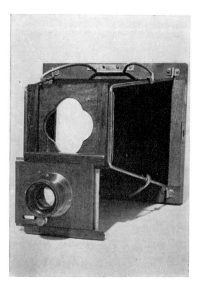

focusing with a threaded rod that ran through the bed of the camera,
moving the lens standard as a key at the back of the camera was
turned.

One of the most extensive rising fronts on the early view cameras
was that of the 1901 Folmer and Schwing "Skyscraper" camera,
utilizing the overlapping lens board principle (Fig. 266). Additional
correction could be obtained through the moderate tilt and swing
movements of the back. It is interesting to observe that while this
camera, the 1880 Rochester Optical Company's view camera and
some other cameras of this period used the on-axis pivot position
for the tilt back, many later view cameras manufactured during the
first half of the twentieth century pivoted at the bottom of the back.

Another unusual method of raising and lowering the lens was
used on the Royal Ruby Triple camera of the early 1900's (Fig. 269).
In addition to a conventional rising-front adjustment, the entire
lens standard was supported on pivoted arms that moved up and
down. This device was referred to as a "fall-over" front, and in the
bottom position the lens board was lower than the bed of the camera.
A similar device is employed on a view camera currently being manu-
factured, for the purpose of placing the lens closer to the film than
the lens standard with short focal length lenses, and farther from the
film with long focal length lenses.

Of all the adjustments on the more versatile modern view cameras,
the tilt and swing movements of the lens, and the rising and shifting
movements of the back were the last to be widely incorporated by

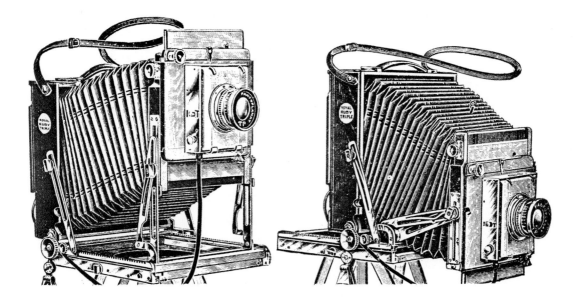

Fig. 269. Royal Ruby Triple camera with "fall-over" front, made in the early 1900's.

view camera manufacturers. Absence of rising and shifting movements on the back did not impose much of a handicap on the photographer if the camera had generous corresponding movements on the lens, but the inability to control the plane of sharp focus by tilting or swinging the lens made it necessary for the photographer to depend on the large depth of field obtained at small lens openings when the back was tilted or swung for perspective purposes.

Fig. 268. Rising-falling lens board with vertical bellows on Koch and Wilz (Paris) dry plate camera of the 1870's.

Although a few early view cameras were constructed in such a way that they could be used conveniently only for vertical format photographs, dual tripod sockets enabled some cameras to be rotated to obtain vertical or horizontal photographs, and reversible backs were used quite widely. An unusual method for reversing the back was used on Anthony's Patent Novel View Camera of 1887 (Fig. 271). To change the orientation of the film, the back standard was first detached from the camera bed. A circular board on the lens standard provided the means for rotating the camera back and the attached bellows 90 degrees. Since there was no provision for using the back in intermediate positions, the major advantage of this system was that a smaller rectangular bellows could be used in place of the square bellows that would be needed if only the back revolved. A full 360° revolving back was available at approximately the same time on Flammang's Patent Revolving Back Camera of 1889, and on the American Optical Company view camera (Fig. 272). The latter camera had only two of the eight possible lens and back adjustments, however: a tilting back and a rising-falling front.

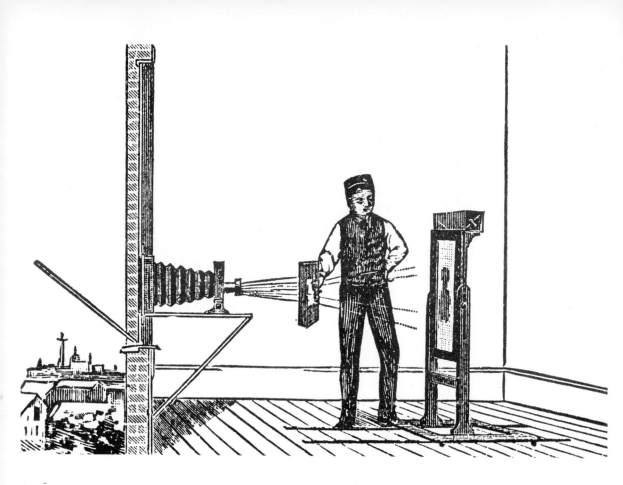

Fig. 270. Early enlarger used daylight as a light source.

Fig. 271. 1887 camera had a unique method for reversing the back

Negative size

Before projection printing was widely used, photographers had to make their negatives correspond to the desired final print size. Consequently there was more emphasis on the larger formats, and camera manufacturers offered a larger variety of camera sizes than they do today. Flammang's Patent Revolving Back Camera, for example, was made with 13 different negative formats, ranging from

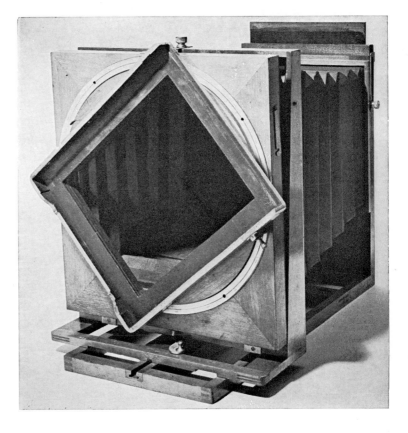

Fig. 272. Full revolving back on an 8×10 view camera made by the American Optical Co. in 1889.

4×5 in. to 20×24 in. The largest camera ever made produced a negative 8 ft. by 10 ft. The camera was made in 1899, was 20 ft. long, and weighed 1400 lb.[1] There were some demands for small view cameras, however, due to the problems involved in transporting 8×10-in. and larger cameras. A $3\frac{1}{4} \times 4\frac{1}{4}$-in. view camera manufactured by Scovill in 1887 was named "Petite", and an advertisement for the camera stated, "This camera was made to suit the refined taste of one of Vassar's fair students. The design on the part of the manufacturers was to reduce the impedimenta for an outing to a minimum." The advertisement also mentioned that the $3\frac{1}{4} \times 4\frac{1}{4}$-in. negatives were suitable for making lantern slides, or they could be used in conjunction with an "enlarging camera. "Fig. 270 shows an early enlarger, in the 1860's, mounted in an opening in a wall to take advantage of sunlight as a source of illumination.

It has always been easy to modify cameras to make smaller negatives than the cameras were originally designed for. The reverse situation is occasionally desired, and this problem was solved as early as 1887 by Blairs Patent Extension. This was a wood device that could be attached to the back of the camera so that 8×10 inch negatives could be made on a 5×8 inch camera (Fig. 274). Extensions for two other size combinations were also available. Another extension (Fig. 273) used a flexible bellows and was made for eight

[1] *Believe It or Not,* April, 1965

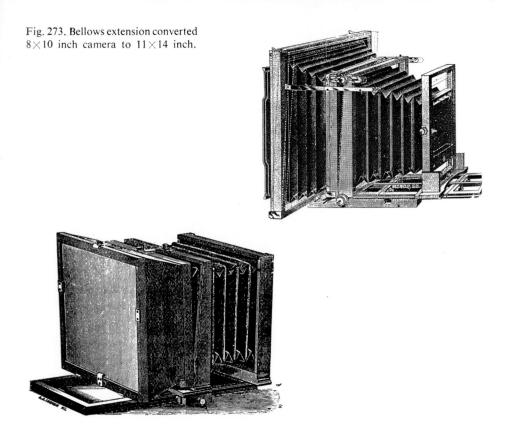

Fig. 273. Bellows extension converted 8×10 inch camera to 11×14 inch.

Fig. 274. Blairs Patent Extension of 1887 converted 5×8 inch camera to 8×10 inch.

different size combinations. A camera currently being manufactured offers an accessory rigid type extension back to convert the camera from $2\frac{1}{4} \times 3\frac{1}{4}$ to 4×5-in. film.

Ground glass and film holders

Various methods have been used during the evolution of the view camera for replacing the ground glass with the light-sensitive plate or film after completing the composing and focusing operations. On the earliest view cameras, the ground glass was generally held in position with grooves or clasps, and was completely removed from the camera before making the exposure. The 1841 American Plumbe Daguerrotype camera (Fig. 275) used grooves to hold the ground glass and the plate holder in position. An unusual feature of this ground glass was the attached hinged mirror that enabled the photographer to view the image right side up.

Risks of misplacing or breaking the ground glass were reduced with the introduction of the simple hinged back (Fig. 276). An improved double hinge allowed the ground glass to be folded over the top or around the side, flush with the bellows, reducing the bulk of the camera (Fig. 277). Sliding backs were available in the 1880's, but were used mostly on studio cameras because of their size (Fig. 278). The spring back shown on an 1887 Blairs Improved Reversible Back Camera in Fig. 279 was similar to current spring backs. Modern uni-

254

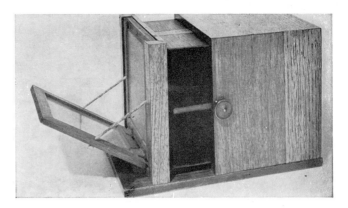

Fig. 276. Hinged ground glass on an early view camera.

Fig. 277. Double hinge allowed the ground glass to be folded over the top or around the side of the camera.

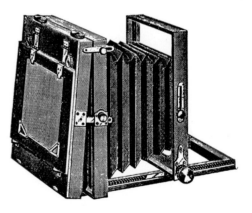

Fig. 278. Sliding back made in the 1880's.

Fig. 279. Spring back on an 1887 Blairs Improved Reversible Back Camera.

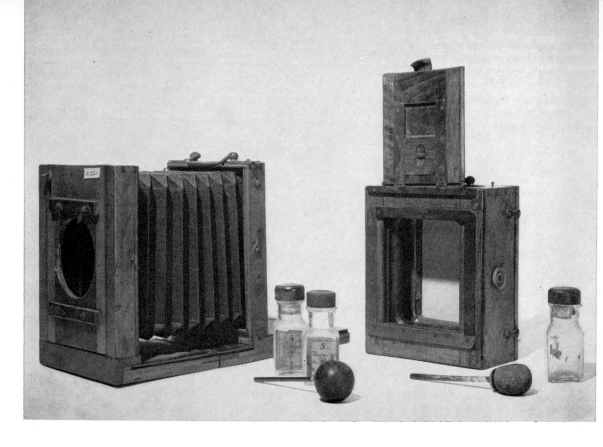

Fig. 280. 1843 French Dubroni wet collodion camera. Dark slide was hinged, and plate could be processed in the holder.

versal type backs have overcome the most serious objection to the conventional spring back by providing for easy removal of the ground glass frame, thereby permitting use of thicker film holding devices and other accessories while retaining the convenience of the spring back. Another improvement in spring backs is the tension-release lever that minimizes the danger of accidentally moving the camera while inserting or removing film holders.

Early plate holders generally held a single glass plate. A holder of this type with a roller blind dark slide is illustrated in Fig. 281. Rigid dark slides on plate holders were often hinged so they could be folded over the camera while making the exposure, without completely removing the slide from the holder. A hinged slide is shown in the unfolded position on a plate holder for an 1843 French Dubroni wet collodion camera in Fig. 280. This holder was constructed so that the plate could be processed in the holder by injecting the solutions through a light-trapped aperture in the side of the holder with syringes. Dissatisfaction with the need of having a separate holder for each exposure led to the development of the double plate holder, which evolved into the currently popular double sheet film holder, and a series of other multiple exposure devices.

Le Touriste, an 1885 view camera, used an 8 plate magazine (Fig. 282). Composing and focusing for each of the 8 plates was accomplished by inserting the ground glass progressively through a series of 8 slots in the side of the holder, so that for each exposure, the ground glass was in the same plane as the corresponding plate.

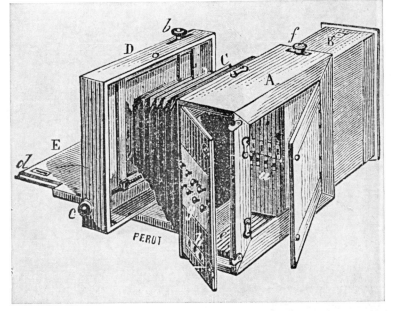

Fig. 281 *(above)*. Roller-blind slide on 1887 plate holder.

Fig. 282 *(above right)*. Eight-plate magazine on 1885 Le Touriste view camera.

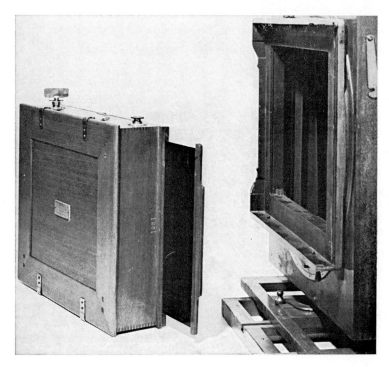

Fig. 283 *(right)*. Roll holder for paper negatives made by the East-man Dry Plate and Film Co. in 1886.

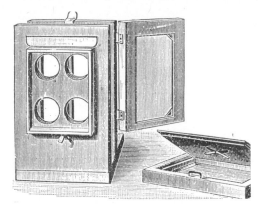

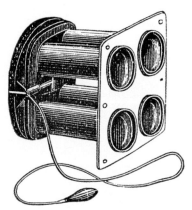

Fig. 284. Four exposures could be
made simultaneously through four
lenses with Anderson's Gem camera
of the 1880's.

A predecessor of the modern roll-film holder (Fig. 283) was manufactured by the Eastman Dry Plate and Film Company in 1886. Owners of various brands of view cameras were able to use this roll holder by sending their cameras to the Eastman Company for modification. Forty eight exposures could be made on each loading of the holder. Divided backs that enabled the photographer to make two or more exposures of different views on a single plate were available for some of the early view cameras.

Multiple lens cameras

Multiple lens cameras that produced two or more exposures of the same view simultaneously on the same plate were popular during the 1880's. Anderson's Gem camera (Fig. 284) was supplied with sets of lenses with 2 to 8 lenses each, with corresponding masks for the film plane. The shutter was advertised as the first shutter for multiple lens cameras. Stereo cameras, another type of multiple lens camera, also became popular during this period. The 1895 Anthony dry plate stereo view camera (Fig. 285) had a rising front and a tilting back.

Two different focal length lenses could be fitted on the long, narrow turret lens board of the $3\frac{1}{4} \times 4\frac{1}{4}$-in. view camera shown in Fig. 286 with a blank lens board. Only one lens was used at a time. The desired lens was brought into position by sliding the lens board from side to side.

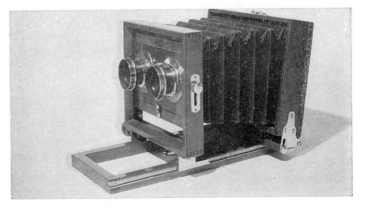

Fig. 285. 1895 dry plate stereo view camera by E and H. T. Anthony and Co., New York City.

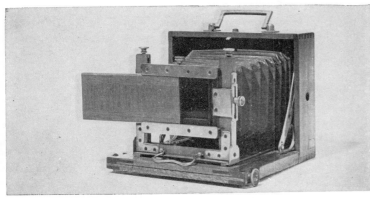

Fig. 286. $3\frac{1}{4} \times 4\frac{1}{4}$ inch view camera with a turret lens board to accommodate two different focal length lenses.

Shutters and diaphragms

Slow lenses and slow sensitized materials used with early view cameras precluded the need for instantaneous shutters, and the exposure time could be controlled with sufficient accuracy by removing and replacing the lens cap. A refinement of this method was incorporated into the 1842 French Daguerrotype camera in Fig. 287. A pivoted lens cover was raised at the beginning of the exposure, was held open by friction, but quickly fell to the closed position when tapped with the finger. As the need for shorter exposure times increased, a wide variety of instantaneous mechanical shutters, such as the guillotine, rotary, flap, bellows, and roller blind shutters came into use, with the prototype of the modern between- the lens shutter appearing around 1880.

Screw-on stops were used on the Daguerrotype camera in Fig. 287. Changing openings was a troublesome process since it was necessary to remove the threaded lens cap each time a different stop was used. Individual, gang, and wheel type Waterhouse stops (Fig. 288) progressively simplified the task of changing the aperture size, but none of these offered the gradual control obtained with the modern iris diaphragm.

Fig. 287. Screw-on Waterhouse stops and pivoted lens-cap shutter on an 1842 French Daguerrotype camera.

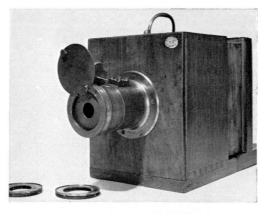

Fig. 299 (below) 1870 monorail view camera.

Fig. 300 (bottom). Doublerail camera made in the 1940's.

Fig. 288. Evolution of Waterhouse stops.

TRY ONE AND BE HAPPY.

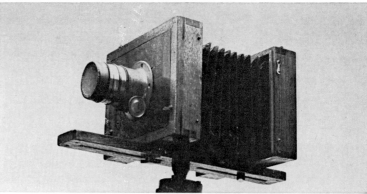

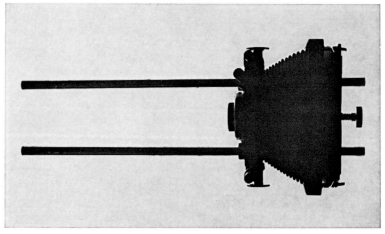

Miscellaneous

Although most early view cameras were of the flat bed type (rigid, folding, telescoping, and with separate extensions) the monorail camera is not a recent development. A monorail view camera on display in the International Museum of Photography at George Eastman House in Rochester, New York was made in 1870 (Fig. 299) and other monorail view cameras have appeared during the intervening years.[1]

[1] All of the photographs of cameras in this chapter were made in the International Museum of Photography, and the other illustrations were provided through the courtesy of the IMP Library

11

APPLICATIONS OF VIEW CAMERAS

Photographs, like other communication media, are used for many different purposes. Although it is not possible to make a comprehensive list of all of the applications of photography, many are so universal that they have become classified and are generally recognized as areas of specialization within the broad field of professional still photography. Categories have evolved mostly on the basis of three criteria: the use to which the photograph is to be put—advertising, for example; the nature of the subject photographed—landscape; and the photographic technique or medium—photomicrography. Boundaries overlap considerably among the categories. Portraits, for example, are used not only for personal reasons, but also in such other areas as advertising, editorial, photojournalistic, and theatrical photography.

A partial listing of the areas of specialization follows:

ADVERTISING	FOOD	PHOTOCOPYING
ANIMAL	ILLUSTRATION	PHOTOJOURNALISM
ARCHITECTURE	INDUSTRIAL	PHOTOMICROGRAPHY
CATALOGUE	INSTRUCTIONAL	PICTORIAL
COMMERCIAL	LANDSCAPE	PORTRAITURE
DISPLAY	LEGAL	POSTCARD
DOCUMENTARY	MEDICAL	PUBLICITY
EDITORIAL	MICROPHOTOGRAPHY	RESEARCH
EXHIBITION	MUSEUM	SCIENCE
EXPRESSIVE	NATURE	THEATRICAL
FASHION	NEWSPAPER	TRAVEL
FINE ARTS	NUDE	

Consideration will be given in this chapter only to a representative sampling of situations in a few of these areas where view cameras can be used effectively to solve photographic problems.

Architecture

There is probably no subject better suited to the characteristics of the view camera than architectural subjects. The inevitable vertical lines require the rise and tilt adjustments for an appropriate rendering. The stationary nature of the subject lends itself to the precise control of the arrangement and the cropping that is possible when

Fig. 301. Form is revealed best by selecting a viewpoint that shows the front and one side of the building.

viewing the image on the large ground glass. Limitations in the placement of the camera that are often imposed on the photographer by obstructions and the nature of the surroundings can often be dealt with satisfactorily by substituting a different focal length lens and by using the camera adjustments. Perspective, which is so important to architectural subjects, can be controlled by simultaneously changing the camera to subject distance and lens focal length, and by using the swing adjustments on the camera back.

Camera placement for architectural exteriors is determined by a combination of factors. Since the best position for two different factors, such as arrangement and lighting, may not be the same, compromises are often necessary. Form is best revealed by selecting a viewpoint that makes one side of the building visible, as well as the front, but with emphasis remaining on the front. Ideally, the lighting should also emphasize the front of the building, and the three-dimensional appearance of the building can be enhanced by having a shadow on the side that is visible from the camera (Fig. 301). A top-view sketch of the building that is to be photographed, including a north arrow, is useful in determining the time of day when the lighting is best (Fig. 302). Buildings that face east must be photographed during the morning hours to have the sun on the front, with the camera located in a northeasterly direction from the building (in the northern hemisphere) to include the shadow side. Southfacing buildings offer the most flexibility in camera placement, since they may be photographed during the morning from

Fig. 302. Top-view sketches assist in selecting camera viewpoint and in anticipating lighting effects.

262

Fig. 303. Use of diffused light to obtain a mood effect – *Neil Montanus*

the left front and during the afternoon from the right front. Difficulty is often encountered with the lighting on north-facing buildings. If the sun doesn't illuminate the front of the building during the early morning or late afternoon hours, it may be advisable to wait for a lightly overcast day when the lighting ratio is lower.

A softer lighting is often more flattering to buildings surrounded by trees that cast distracting shadows with direct sunlight, and it also may produce an interesting mood effect (Fig. 303). A popular dramatic lighting that puts more emphasis on mood and outline shape of the building than on form is obtained at dawn or dusk, when there is still sufficient light in the sky to provide tonal separation between the building and the sky. This lighting is especially effective when the building's interior illumination shows through the windows, or when supplementary flood or flash illumination is used on the exterior (Fig. 304). Since this technique often requires two or more separate exposures — one for the sky and one for the supplementary lighting — an extremely sturdy tripod is required to avoid camera movement and out-of-register images. The use of a tripod at each end of the bed is recommended with cameras that will accommodate a second tripod block.

Limitations are often imposed on the placement of the camera by poles, wires, signs, trees, and other obstructions. Unless the obstructions are close to the building, they can possibly be eliminated from the photograph by placing the camera between the obstructions and the building, and using a shorter focal length wide-angle lens to

Fig. 304. Photograph made at dusk, effectively utilizing daylight and tungsten illumination–*Lawrence S. Williams*

provide a sufficiently large angle of view to include the entire building. The two photographs in Fig. 305 show (a) the unsatisfactory inclusion of distracting objects when a camera with a normal focal length lens is placed at a distance that will produce the desired image size of the building, and (b) elimination of the foreground objects by moving the camera closer to the building, and substituting a shorter focal length lens to obtain the desired image size and angle of view. The same procedure can be followed to include an object in the foreground intentionally. If a tree is to be placed in the foreground as a framing device, the camera is first set up in the position that will produce the desired framing effect and then the lens is selected that will produce an appropriate image size (Fig. 306).

Assuming that the camera distance is not determined by obstructions or framing devices, the photographer is free to use this variable to control perspective. There are no rigid rules concerning when to use weak and strong perspective. Conservative architectural subjects tend to appear more attractive with normal to weak perspective, while some modern architecture lends itself to the more dramatic strong perspective (Fig. 307). Such generalities should not be considered as substitutes for a discerning eye, however. As the camera is moved closer to a building, strong perspective may become apparent in three ways: (a) near parts of the building, and objects such as shrubs in front of the building, appear inordinately large, (b) horizontal lines on the front and the side of the building converge rapidly, and (c) if the building has a sloping roof, as most homes

264

Fig. 305. Elimination of distracting foreground objects by moving the camera closer to the building and substituting a shorter focal length lens.

Fig. 306. The procedure for framing a building with a foreground object is – (1) selection of the camera viewpoint, and (2) choice of an appropriate focal length lens – *Lawrence S. Williams*

Fig. 307. Effective use of weak perspective with conservative architecture and strong perspective with modern architecture – *Toni Sneiders and Robert Golding*

do, the roof will appear shallow, and may disappear entirely when the camera is extremely close (Fig. 308). Swinging the camera back will alter the convergence of horizontal lines, but any decrease in the convergence of the lines on the front of the building will result in an increase in the convergence on the side of the house, and vice versa. Although swinging the back is not a substitute for changing the camera distance, it is a useful control. Since the front of the building is more important than the side, the swing should be used to obtain an appropriate effect on the front.

Vertical line control in architectural photography consists basically of keeping the back of the camera perpendicular to the ground. The most common problem encountered is in placing the lens in the position that will yield the desired image placement on the film. There are five techniques for obtaining parallel vertical lines and correct image placement. Only the first needs to be used with buildings of moderate height with most view cameras.

Rising-falling front and back. The maximum vertical movement of the lens on 4×5-in. view cameras ranges from $1\frac{1}{2}$ to $6\frac{1}{2}$ in., and more on some cameras with accessories. Approximately half of these cameras have the corresponding adjustment of the back also.

Off-centre lens board. Mounting the lens off-centre on a lens board will extend the possible displacement of the lens from the normal position. Off-centre lens boards are useful even on cameras that have

Fig. 308. Use of a normal focal length lens shows more of the roof than a short focal length lens from a closer viewpoint – *William Apton*

267

Fig. 309. The procedure for keeping the vertical lines parallel and obtaining an overall sharp image is to place the back perpendicular to the ground and tilt the lens forward – *Robert Golding*

Fig. 310. Two or more overlapping photographs can be combined when the entire subject is too long or too tall to include on a single photograph.

extensive rising-falling movements when bellows bind prevents short focal length lenses from being raised or lowered sufficiently.

Tilt bed. Tilting the camera upward and then tilting the lens and back to their vertical positions produces the same effect as the rising front, but requires three adjustments rather than one. (Optical or mechanical limitations of the first three techniques may require consideration of the following two.)

Elevated camera position. Raising the entire camera lessens the amount the lens must be displaced from the normal position. When the height limitations of conventional tripods have been reached, a higher viewpoint can be obtained with a sturdy stepladder, a shooting platform on the roof of a car or truck, or in some situations by shooting from the roof or window of another building. Vehicles designed for warehouse, repair, or construction work, with platforms that can be raised to high positions, have also been used by enterprising photographers.

Tilted easel. Although rectification by tilting the easel involves an additional darkroom operation, there are situations where the alternatives are less attractive with respect to effectiveness of the final photograph, convenience, time, and expense. Elongation or compression of the image should be avoided by the appropriate choice of lens for the enlarger, unless such an effect is desired.

A variety of focal length lenses should be available to the archi-

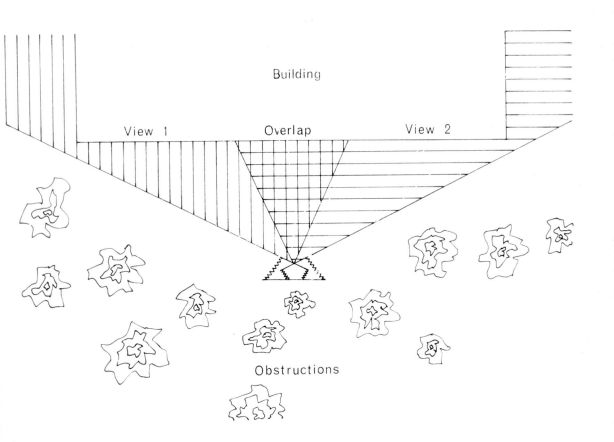

Building

View 1 Overlap View 2

Obstructions

tectural photographer so he can select the camera viewpoint on the basis of factors that influence the effectiveness of the photograph rather than having the camera placement dictated by the image size produced with a given focal length lens. Emphasis should be on the shorter focal lengths, since the photographer is often forced to place the camera relatively close to the subject—especially with interior views. Wide-angle construction is essential for the shorter focal lengths, and is strongly recommended even for the normal range due to the extensive use of camera adjustments.

Paste-up prints from two or more negatives are occasionally made when the entire horizontal or vertical dimension of a building cannot be recorded on a single negative (Fig. 310). The task of printing the negatives so that the perspective on the final print appears normal is simplified if the camera back can be kept parallel with the front of the building as the camera is panned or tilted. If this is not possible, rectification must be obtained by tilting the easel during printing.

Indoor architectural photography frequently involves lighting problems that the view camera is especially capable of coping with. Inequalities in brightness of various areas, such as luminous ceilings that are relatively bright in comparison with the floor and walls, can be minimized with camera dodging. Black cards attached to a matte box or adjustable lens shade will hold back the light from the bright areas (Fig. 311). Precise positioning of the cards is possible by examining the image on the ground glass, and the extent of dodging is

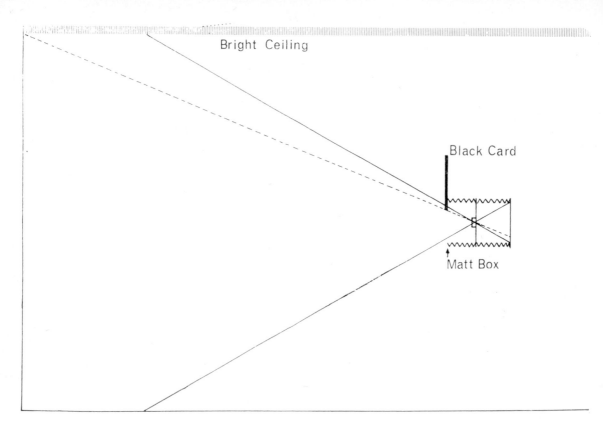

Bright Ceiling

Black Card

Matt Box

Fig. 311. Camera dodging with black card attached to matte box for part of the exposure time.

controlled by varying the proportion of the total exposure time that the card is left in position. A rigid camera and tripod are essential; and the card should be held in position in a way that will permit its removal with a minimum of danger of camera movement. Variations in blending between the dodged and undodged areas can be achieved easily with bellows type lens attachments by altering the distance between the card and the lens. An alternate technique is to hold the card and move it during a time exposure, using markings on the lens attachment as a location guide.

Although the large exposure latitude of some films will record satisfactory detail with a straight camera exposure, permitting corrective dodging during printing, there are several advantages in the camera dodging technique. Flare light from bright areas for example is less likely to degrade the image in other areas. It is not necessary to dodge each print when a quantity of prints is to be made, and, in any event, there is not always a subsequent printing step during which the correction can be made, as with reversal colour transparencies made for direct viewing.

Interrupted exposures are frequently used for interior views when existing light and supplementary flood or flash are combined. At night, the shutter can remain open while the interior is "painted" with a flood, or a series of flashes are added with a conventional or an electronic flash unit. If there is considerable existing light, as from windows during the daytime, the open shutter method will result in overexposure of these areas. A more satisfactory method is to make

270

Fig. 312. Balanced exposures for outdoor daylight and indoor bounce electronic flash by the selection of an appropriate combination of f/number (for the electronic flash) and shutter speed (for the daylight) – *Norman Kerr*

one or more separate exposures at high shutter speeds with synchronized electronic flash. Most of the light from the electronic flash is used, the same as with a time exposure, but the total exposure time for the existing light is reduced to the product of the shutter speed and the number of times the shutter is tripped. Thus, twenty exposures at 1/200 second are approximately equivalent to one exposure at 1/10 second. (The resulting densities may not be exactly the same due to differences in shutter efficiency at the two settings, and due to the intermittency effect.) Equipment requirements for this type of work are a synchronized shutter, fast shutter speeds – preferably up to 1/500 sec. – and a rigid camera and tripod that will permit repeated recocking of the shutter. A second cable release can be attached to the lens board to recock the shutter without touching the camera, to minimize the danger of moving the camera.

Inclusion of people or other non-stationary objects in the scene eliminates the possibility of using the interrupted exposure technique. Since variations in exposure time can be used to control the exposure to the daylight while having little or no effect on the electronic flash, a good balance between the indoor and the outdoor parts of the scene can be obtained with an appropriate choice of shutter speed (Fig. 312).

Fig. 313. Strong perspective is inappropriate for most studio type portraits.

Portraiture

View cameras are most valuable in portrait situations where the subject can be posed, rather than photographed candidly. These include a wide variety of portraits made in homes, offices, industries, schools, and other indoor and outdoor locations in addition to professional portrait studios. The word "posed," however, need not be associated with the word "static." Animated portraits used for advertising purposes, for example, are usually carefully posed (Fig. 314). Lens and view camera manufacturers are giving attention to the need for quick and convenient control of the shutter and diaphragm, and photographers are using view cameras effectively with such difficult-to-control subjects as animals and young children.

Strong perspective is so destructive to the attractiveness of portraits (Fig. 313) that professional portrait photographers are careful to avoid it unless a caricature or unusual dramatic effect is appropriate

Fig. 314. A carefully posed "animated" fashion type portrait.
— *Lee Howick*

for the specific use of the photograph. The only way strong perspective can be prevented is to keep the camera at a reasonably large distance from the subject. This makes a longer focal length lens desirable for portraiture.

RECOMMENDED FOCAL LENGTHS FOR PORTRAITURE

Film Size (in.)	Focal Length (in.)	Film Size (in.)	Focal Length (in.)
$1 \times 1\frac{1}{2}$	$3 - 3\frac{1}{2}$	5×7	$14 - 17$
$2\frac{1}{4} \times 3\frac{1}{4}$	$6\frac{1}{2} - 8$	8×10	$20 - 26$
4×5	$10 - 13$	11×14	$28 - 36$

273

Fig. 315. An appropriate use of strong perspective in a portrait of two people used for advertising purposes – *Norman Kerr*

Fig. 316. Wide-angle lenses become portrait lenses when space limitations dictate the use of a short focal length lens or when a dramatically strong perspective is desired. – *Horn-Griner*

These recommendations are for head and shoulder views. Somewhat shorter focal length lenses can be used satisfactorily for full length and group portraits. Since the portrait photographer cannot always place his camera as far from the subject as he would like, he must have a variety of focal length lenses available. Short focal length wide-angle lenses are not thought of as portrait lenses, and they are rarely used for individual portraits, but they are called upon to provide the large angle of view **required to photograph groups** where space is limited (Fig. 316).

The additional problem of wide-angle distortion, which causes the heads near the edges of the photograph to be stretched out of shape, is sufficient reason to induce portrait photographers to reserve wide-angle lenses for emergency use. Although abnormally weak perspective can result from use of long focal length lenses at large distances from the subject, this is much less of a problem than too strong perspective. Comparison portraits made for dental or medical purposes must be free of unusually strong or weak perspective. An appropriate perspective is especially important when making portraits of two or more people who are not at the same distance from the camera (Fig. 319).

A concomitant benefit of using long focal length lenses and large film sizes for portraits is the relatively shallow depth of field produced. A shallow depth of field is considered desirable for head and shoulder portraits because it enhances the three-dimensional quality that the skilled photographer creates with the lighting. The plane

of sharp focus should include the eyes and the front of the face (Fig. 317). Slight adjustment of the swing and tilt of the lens is normally all that is required to obtain appropriate sharpness without stopping the lens down so far that the ear and back of the head become sharp.

Although maintaining correct focus is not a major problem with most portrait subjects, various techniques have been employed to minimize the time required behind the camera, so the photographer can concentrate on the lighting, pose, and expression. Camera assistants assume responsibility for all work with the camera except tripping the shutter for many professional portrait photographers and

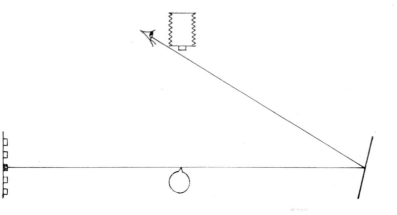

Fig. 318. Use of a mirror to detect movement of the subject from the plane of sharp focus.

Fig. 319. An example of effective perspective in a formal portrait of two people – *Karsh, Ottawa*

advertising photographers who use models. One method for determining when a subject moves out of the plane of sharp focus is to place vertical lines on the wall on one side of the subject, and a mirror at an angle on the other side (Fig. 318). From the camera, the photographer can note the position of the subject when the camera is focused, and subsequently detect any change. Some photographers have found it easier to photograph young children and animals by pre-focusing the camera and then moving the subjects, on a roller mounted support, to keep them at the correct distance. A narrow beam of light aimed at the subject from the side has also been used as a focus indicator. When used with electronic flash, the projected light on the subject is overpowered by the flash and is not visible on the portrait.

Devices that are now available to simplify focusing with view cameras include a non-cocking universal shutter with a wide range of automatic speeds that can be set from behind the camera, and an aperture control that stops the diaphragm down to a pre-selected f-number when the film holder is inserted and opens again when the holder is removed. Double-lens reflex view cameras can be assembled with some modular type camera units, enabling the photographer to focus and compose with the film holder in position (Fig. 320). When large film is not required but the photographer wants to use the view camera adjustments and lenses, a single-lens reflex camera body can be attached to the back of some view cameras (Fig. 321).

High image definition, a desirable characteristic in many fields of

Fig. 320 *(below)*. Double-lens reflex view camera.

Fig. 321 *(below right)*. Single-lens reflex camera body attached to the back of a view camera.

photography, is not always considered desirable on portraits. Professional portrait photographers may own two or more lenses in the same focal length range because of differences in the quality of the images produced (Fig. 322). Some portrait lenses are capable of producing a range of images from extremely soft focus to commercial-sharp. The effect is usually controlled by the size of the diaphragm opening, so that both depth of field and image definition in the plane of sharpest focus increase as the lens is stopped down.

Fig. 322. Comparison portraits made with a soft-focus portrait lens for an overall diffused effect *(right)*, a commercial type lens used at a large aperture for a sharp image of the subject with unsharp foreground and background *(below)*, and a commercial type lens used at a small aperture for critical sharpness in all areas *(left) – Neil Montanus*

Fig. 323. Different vignette tones can be obtained by changing the vignetter or the illumination.

Fig. 324. The view camera is as well suited to animal as to human portraits — *John Wawro*

Vignetted photographs, on which the image gradually blends into a white surround, can be produced from conventional portrait negatives by exposing the prints through a hole in an opaque card. More sophisticated effects can be created by using a vignetter in front of the camera lens. Vignetters are available that can be attached to the camera and adjusted, while the photographer views the image on the ground glass, to obtain the desired blending effect. Tone of the surrounding area can be controlled by using different cards ranging from light to dark, or by changing the illumination on a medium gray card (Fig. 323). Translucent cutouts automatically adjust to changes in the tone of the background without using supplementary illumination on the vignetter, and therefore can be used on matte boxes and adjustable lens hoods — providing they can be placed sufficiently far from the lens to produce the desired effect.

Cameras used for portraits should be easily manoeuvrable with respect to height, tilt, distance of the camera from the subject, rotation of the film, focusing, and other camera adjustments. Since the tripod and the pan-tilt head perform several of these functions, it is just as important for these items to be well designed and constructed as it is for the camera. Features found on conventional non-portable studio portrait cameras are equalled and surpassed by the better portable view camera equipment. Tripod dollys overcome the incon-

Fig. 325. Angular cropping in printing wastes negative space. The dashed line indicates the format required for an extreme angular cropping, utilizing only one half of the negative area – *Charles Savage*

venient lack of mobility of conventional tripods (Fig. 326) and the elevation ranges on good tripods exceed those on studio portrait cameras. Fully revolving backs are desirable because angular cropping in printing requires smaller images on the negatives, with a corresponding waste in negative area (Fig. 325). Although it is seldom necessary to make drastic changes in the angle of the plane of sharp focus for portraits, it is better to make any required changes with the lens, so that image shape will not be affected. Studio portrait cameras do not normally have swing, tilt, rise, or shift adjustments on the lens.

A variety of formats are being used for portrait photography—as small as $1 \times 1\frac{1}{2}$ in. and as large as 8×10, and occasionally larger. Professional photographers should be prepared to work with any of the standard sizes of film since situations are encountered that demand use of specific formats, and when photographers have a free choice, there are advantages in using different sizes for different purposes. The following four factors are often influential in the selection of film formats by portrait photographers.

Image quality. Although photographers desire every portrait they make to be as good as possible, it is not realistic to equate a portrait that will be reproduced full page in a magazine with a passport portrait. Although the extra quality resulting from using 8×10 inch

film over the smaller sizes may be wasted when the portrait is used for a small coarse-screen reproduction in a newspaper, the difference may be vital in situations that require the best possible quality.

Retouching. Related to the image quality, is the amount of retouching that is necessary. Portraits of babies do not need as much retouching as those of older people—full length and group portraits require less than close-ups—and the final print size influences the amount and the quality of retouching needed. The difficulty in retouching so that it will not be apparent increases rapidly as negative size decreases, and as the corresponding magnification in printing increases.

Cost. Since film costs vary significantly with size, this factor must be considered in relation to the importance of the contributions of the larger film. The additional cost of the larger film is usually a low price to pay to be sure of obtaining the best possible image, but there are highly-competitive, large-volume portrait businesses where the profit per photograph is relatively small, and the higher cost of the larger film becomes more important. Roll film can also result in considerable savings over larger sheet film where larger numbers of exposures may be made to obtain one photograph that will be used, as sometimes occurs with portraits made for advertising purposes.

Fig. 326. Tripod dolly

Convenience. The important consideration here is between roll film and sheet film, rather than different sizes of sheet film. The additional steps of loading and unloading film holders are of little consequence when the quantity of photographs made is moderate, but in large volume situations, such as school portraiture, a bulk roll film holder is much more convenient to use.

Catalogue photography

Fundamentally, catalogue photographs serve as substitutes for the actual objects. A commonly employed psychological sales technique is to place the item in the prospective buyer's hands where he has an opportunity to feel it, examine it closely, and hopefully, to

Fig. 327. Box-shaped catalogue subjects are generally photographed from a viewpoint that shows three planes.

become accustomed to possessing it. Although photographs cannot appeal to the tactile senses, a good catalogue photograph should reveal details clearly — often more clearly than when the actual object is examined — and it should make the item appear attractive. View cameras, operated by competent photographers, excel in satisfying these objectives.

Fairly rigid conventions have become established in the field of catalogue photography with regard to camera viewpoint, perspective, depth of field, lighting, and a number of other factors, although it should be noted that some of the techniques used for dramatic effects in the field of advertising photography occasionally appear in catalogue photographs. A camera viewpoint is normally selected that will reveal the three-dimensional nature of the subject. This was accomplished with architectural subjects by showing the front and one side of the building. Many catalogue subjects are photographed from a high viewpoint, so that the front, one side, and the top of box-shaped objects are visible, with the emphasis placed on the most important plane (Fig. 327). Corresponding views are used for other than box-shaped objects, such as shoes, bicycles, etc., with the exact camera position selected very carefully to emphasize the most attractive features.

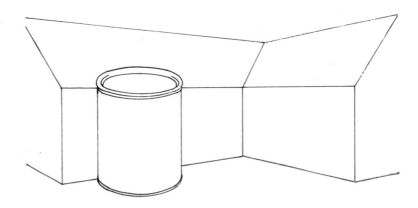

Fig. 328. Conventional camera view point for cylindrical cans.

Cylindrical cans are photographed from a position directly in front, so the label appears centred on the can, but from a position that shows the top. This convention is so strong that it is not abandoned even when the perspective is in conflict with the perspective of a background view showing the application of the product, as with the paint and the house in Fig. 328. Flexibility in the placement of the camera is required to obtain an appropriate viewpoint for every type of subject. Since most catalogue photographs are made in studios, large camera stands are practical. Some stands have counterbalances or auxiliary power so that the heaviest view cameras can be moved down to floor level and up to considerable heights directly over a subject quickly and with little effort.

Parallelism of vertical lines is as important for catalogue photographs as for architectural, but since the camera is normally higher than the subject, the required camera adjustments are a falling front and a rising back (Fig. 329). Not all view cameras have rising backs, and the falling front adjustment is seldom as large as the rising front, so the more complicated procedure of tilting the bed down and then adjusting the tilt back and the tilt lens is frequently necessary. Horizontal subject lines are seldom rendered parallel except when the subject plane is photographed straight on. The swing back is used, however, to modify the rate of convergence of horizontal lines to obtain a natural appearance, and occasionally to create the illusion that a product is longer or narrower than it actually is.

The camera-to-subject distance has an important effect on perspective in addition to the variations that can be made with the tilt and swing back. As with portraiture, the relatively weak perspective obtained with longer focal length lenses at larger distances produces a natural appearance, and is considered desirable in catalogue photography (Fig. 330). This requires a long bellows extension on the camera, especially when large images of small objects are required, and sufficient studio space to keep the camera at the proper distance when photographing large objects. Strong perspective, resulting from having the camera too close, is particularly disconcerting when the subject contains circular parts, as their images are distorted unless they are close to the centre of the photograph.

View cameras that use the larger sizes of film have important desirable qualifications for catalogue photography. Large negatives

Close-up view of part of product is used to emphasize area of special interest. The camera lens was tilted to obtain an overall sharp image. – *Dick Faust*

285

Fig. 329. A falling front and a rising back are desirable view camera adjustments for catalogue photography since it is frequently necessary to render vertical lines parallel from a high viewpoint. – A. Josephson

Fig. 330. An example of a catalogue subject that requires use of a long focal length lens with the camera relatively far from the subject to obtain a reasonable size relationship of the near and far objects, and to avoid an unnatural appearance of the circular parts. – A. Josephson

Fig. 331. Retouching, which is frequently required for catalogue photography, can be done more easily and skilfully on a large negative. *(Top)* Print from the unretouched negative. *(Bottom)* Reproduction in a catalogue.

C___-1278-60

WASHER—1238-335

SCREW—852673

NUT—1238-325

TOGGLE CLAMP ASSEMBLY— 451344

WASHER—1238-335

NUT—1238-325

FIGURE 2

produce maximum image definition, which is critical in this field of photography. Even though photographs may be reduced considerably in size on the final reproduction, faithfulness of the images produced by photomechanical reproduction on the better catalogues is such that subtle differences in definition on the original photographs are important. Retouching has always been widely employed on catalogue photographs to improve detail, to increase tonal contrast between the subject and the background, and to strengthen the appearance of form by adding highlights and shadows. This is done variously on the original negative or transparency, on a photographic print, and during the photomechanical reproduction process. A large negative or transparency is essential when the retouching is done at that stage (Fig. 331).

Fig. 331A. A black vignetter in front
of the camera lens creates the illusion
that the viewer is looking at part of a
full-length plane rather than a chopped
off display model – *Dick Faust*

Another advantage of the view camera for catalogue photography
is that the large ground glass used in conjunction with the large
film aids the photographer in the operations that precede actual
exposure of the film, such as focusing, checking parallel lines, pers-
pective, lighting, depth of field, and the overall effect. Maintain-
ing a consistent style with respect to these factors is important for
the photographs appearing in the same catalogue if an appearance
of unity is to be achieved. Although ruled lines on the ground glass
are invaluable for checking parallelism of vertical lines, some photo-
graphers find that the lines interfere with judging the arrangement
and other aspects of the image. Using a removable acetate grid is
one solution to this problem.

Landscape photography

Fig. 332. Method for determining
focal length lens needed for the
desired angle of view and image size
from a given location.

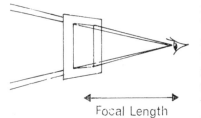

Focal Length

There are many problems involved in landscape photography over
which the photographer has little control. Scenes vary tremendously
in appearance with lighting, weather, and seasonal changes. If any
of these factors are not satisfactory, there is little the photographer
can do except to wait. Photographers who specialize in this field of
work have been known to visit a site periodically for months before
finding the combination of factors that produced the desired effect.
Timing is especially critical when making colour landscape photo-
graphs involving the turning foliage in the autumn. A photograph
that is missed either due to bad weather or lack of planning may
require a wait of an entire year. Because of these problems, it is all
the more important for the photographer to have a camera that is
versatile, dependable, and capable of producing the best possible
image.

Foreground and background of landscape scenes must often be related perceptively to obtain an illusion of three dimensions and an effective design. This limitation on the placement of the camera requires a wide range of focal length lenses to obtain the desired angle of view (Fig. 334). A negative that is large enough to permit moderate cropping without an objectionable loss of image quality is also an advantage, since photographers cannot carry enough lenses to provide the exact focal length needed for every situation. Flexibility in lens focal length can be increased inexpensively with supplementary lenses, however, to obtain the in between focal lengths. Loss of definition with supplementary lenses can be minimized by stopping the camera lens down when it is important to retain crisp detail, although soft focus landscapes are often considered attractive.

It is not necessary to use the trial and error method of selecting the lens that will yield the desired image size and angle of view from a given location. Variable focal length optical viewfinders are frequently used for this purpose. The photographer can adjust the viewfinder to obtain the desired effect and then determine the focal length from the viewfinder setting. A less expensive method for determining the necessary focal length is to cut an opening corresponding to the film size being used in a piece of cardboard. Adjust the position of the card in front of one eye to obtain the desired framing. The distance from the card to the eye will be equal to the focal length of the lens that will produce the same angle of view on the

Fig. 333. The tilting lens adjustment is valuable in obtaining the necessary depth of field on landscape photographs that include the near foreground – *Ansel Adams*

289

Fig. 334. Since suitable camera locations for landscape photographs are often limited, the photographer must have a variety of focal length lenses available to obtain the desired image size and angle of view.

film (Fig. 332). This technique can be used with subjects other than landscapes, but it is not accurate with close-up objects due to the differences between focal lengths and lens-to-film distances. A detachable focusing hood is a convenient substitute for a cutout card. With landscape scenes that allow more freedom in the placement of the camera, the best camera position for a given lens can be determined in the same way. Time and effort can be saved, and the photographer has a better opportunity to explore various viewpoints by

Fig. 335. Keeping the back of the camera in the vertical position with landscape scenes containing buildings, trees, or other tall objects such as the rock formations in this photograph, eliminates the possibility of obtaining unattractive tilted perspective effects – *Joseph Muench*

scouting with a viewfinder or viewing frame than by setting up the tripod and view camera at each position under consideration.

Swing and tilt adjustments are not used as extensively in landscape photography as in some of the other photographic fields, but there are frequent opportunities for improving landscape photographs with the camera adjustments. It is not unusual to include the foreground to within a few feet of the camera and the horizon miles away. Tilting the lens forward (Fig. 333) provides enough depth of

Fig. 336. Use of infrared film on a landscape for a dramatic effect – *Minor White*

Fig. 337. Fast film is required for some landscape photographs to enable the photographer to stop down for depth of field and also to use a fast shutter speed to stop movement – *Len Rosenberg*

Fig. 337A. Use of a tracing of the art director's layout on the camera ground glass facilitates obtaining the desired arrangement – *Dick Faust*

field even at a large aperture if there are no tall objects in the foreground. Short focal length lenses need only slight tilting due to the large inherent depth of field and the short lens-to-film distance. Although the tilting back can be used for the same purpose, it is better to reserve this adjustment for perspective control. Failure to keep the back perpendicular to the ground will not be obvious with many landscapes, but converging or tilting vertical lines on buildings, trees, and other objects can be disturbing (Fig. 335).

Sheet-film holders offer flexibility in the type of film used for landscape photography. A variety of effects can be produced with different films such as reversal and negative colour films, panchromatic film with and without filters, high contrast, and infrared (Fig. 336). Landscape photographers occasionally expose two or more different kinds of film on the same scene. An extra exposure may be made on reversal colour film in situations requiring a colour negative and print because the transparency provides a relatively quick colour image for consultations with client, printer, and others. Both colour and black-and-white may be exposed to provide for different possible uses for the photograph, and using a variety of black-and-white films and filters produces a series of prints ranging from realistic to dramatic from which to make the final choice. Even though landscapes are thought of as stationary subjects, a fast film may be needed to stop the movement of flying birds, wind-blown foliage, or other moving objects in the scene, in addition to minimizing the effect of any camera movement caused by the wind (Fig. 337). On the other hand, a slow film and a longer exposure time may be required to achieve desired effects. Waterfalls and rippled lakes appear dramatically different at fast and slow shutter speeds, blurred images of moving branches are sometimes desired, and moving cars can be made to disappear with long exposure times. Use of neutral density filters will extend the possible range of exposure times.

Advertising photography

Successful advertising photographs are those that induce the viewer to purchase the products or services advertised. To do this, the

Fig. 338. Two exposures on the same sheet of film of a model in front of a black background produce a ghost image effect only where the two images overlap – *Don Marvin*

Three exposures with object in front of a black background. Negative image was obtained by printing from a film diapositive made from the original negative – *Ray Holden*

Fig. 339 *(above)*. The effect of stopped motion is conveyed by fast shutter speeds or brief illumination from high speed flash equipment – *Len Rosenberg*

Fig. 340 *(below)*. The effect of continuous motion is conveyed by a slower shutter speed or by moving the subject between multiple exposures – *Len Rosenberg*

photographs must first catch the eyes of the potential consumers, and then convince them that the products are both necessary and desirable. This is a highly competitive field in which the advertiser is competing not only with other producers of the same product, but with all other products for which the consumer may spend his money. As a result, the demands made upon the advertising photographer with respect to ideas and craftsmanship are great. At the top level, where large amounts of money are spent on nation-wide advertising campaigns, photographers invest time, energy, and money generously in an effort to make each photograph as effective as possible. View cameras have long dominated this field, with the larger sizes being used extensively.

Although a wide variety of techniques are being used in an effort to make distinctive advertising photographs, a relatively large proportion are straightforward, depending upon models, props, arrangement, lighting, and photographic quality to produce an effect that will appeal to the viewer. The versatility of view cameras, however, makes possible the creation of many special effects when more dramatic advertising photographs are required.

Multiple exposure. An impression of motion can be conveyed to the viewer by making a series of exposures, moving all or part of the subject between exposures. This is most easily done with the subject in front of a black background (Fig. 338). All of the exposures can be made on a single sheet of film, or on separate films that are sandwiched together for printing. A large ground glass and a layout sketch on transparent or translucent material are essential for precise placement of numerous images. With a white background, the exposures must be made on separate films which are printed in sequence on the same sheet of paper. Ghost images have many applications. The impression of X-ray vision is created by making one exposure of the complete object, and a second exposure with the case or covering material removed. Rigid camera and tripod equipment are required to keep the two images in register. Successful photographs of this type have been made with objects as large as automobiles, with the engine and frame visible through the car body, down to small close-up objects. Registration problems increase as the size of

Fig. 341. Multiple exposure photograph in which the same model appears in three different positions. Three black cards were placed in front of the camera. An exposure was made with each card removed, with the model posed in the corresponding position *(top)*. The same photograph with a different background stripped in by the printer *(bottom)* – *A. Josephson*

Fig. 342. Use of strong perspective for dramatic impact on advertising photographs.

(*Left*) Convergence of the vertical lines with the camera tilted down at the subject – *United Motors Service – Div. of General Motors*

(*Right*) Convergence of the horizontal lines with the camera at an oblique side angle to the subject – *Len Rosenberg*

the object decreases, since movement of the subject or the camera results in a larger displacement of the image when the subject is close and the bellows is extended.

Motion can also be suggested with multiple exposures by exposing once with the subject stationary to obtain a sharp image, then moving the subject during a sufficiently long second exposure to record a blurred image. In some situations, it is more satisfactory to pan or tilt the camera during the longer exposure than to move the subject. Polaroid prints are helpful in determining the exposure times since it is difficult to anticipate the exact effect that will be produced. A similar effect can be obtained with a single exposure by illuminating the subject with both electronic flash and continuous illumination. A slow shutter speed will record a blurred image from the continuous illumination, with the short duration electronic flash recording a sharp image. Internally synchronized shutters close the circuit when the shutter blades reach the fully open position, which places the sharp flash image at the beginning of the action. Modifications must be made to move the sharp image to other positions.

Camera montages are effective in producing photographs in which a model or other object appears two or more times in different positions (Fig. 341). This involves multiple exposures with black cutouts placed on a matte box to limit the exposure to the desired area. Precise arrangement of various images is facilitated by using layout sketches on the ground glass.

Strong and weak perspective. Normal perspective is required when it is necessary to present a true impression of an object, as with catalogue photographs and portraits. The need for dramatic impact in

Fig. 343. Use of a large scale of reproduction with a small object. A familiar object was included to provide a size comparison for the subminiature electric bulb – *Donald L. Smith*

advertising photographs is commonly more important than realism, and strong and weak perspective images are effective methods for attracting attention (Fig. 342). It is difficult for the reader to ignore the strong-perspective photograph of the outstretched hand and the large "STOP", even though it has been used so often it has become a cliché.

Although artists have always been able to use dramatically strong perspective, the improvement in the quality of wide-angle lenses for view cameras in recent years has been partly responsible for the present popularity of this technique on photographs. There appears to be little danger of antagonizing the viewing public with radical perspective. Lenses with angles of view up to 180° are being used with increasing frequency even though the extreme wide-angle lenses cause straight lines on the subject to appear curved on the photograph due to barrel distortion.

Recessed lens boards and flexible bellows on many view cameras enable them to utilize the short focal length wide-angle lenses needed for strong perspective effects. Long view camera bellows extensions, on the other hand, make it possible to obtain weak perspective with long focal length lenses at large distances from the subject. More subjects lend themselves to the production of dramatic effects with strong than with weak perspective. Tilt and swing adjustments on the view camera back can frequently be used to enhance strong and weak perspective effects.

Large and small images. There is such a strong tendency to arrange and crop the image on photographs with a concern for balance and

Fig. 344. An unusual cropping that emphasizes the long, narrow shape of the subject – *Len Rosenberg*

a comfortable amount of space around objects that dramatic, eye-catching photographs can result from the purposeful deviation from these practices. Among the variations being employed are close-up views of portions of objects (as well as small objects in their entirety), small images of objects with large areas of space surrounding them; and unusual croppings (Fig. 343/4). Large ground glass view cameras make it easier for photographers to visualize the final effect whether they are working from layouts or are free to improvise. Revolving backs, pan-tilt heads, and a range of focal length lenses encourage photographers to explore various possibilities. When a format is specified that has different proportions than the camera ground glass, lines can easily be drawn on the ground glass to serve as a guide.

Image unsharpness. Accidental unsharpness on photographs resulting from careless focusing and camera movement is usually unattractive and gives viewers the impression of unprofessional craftsmanship. When unsharpness is employed deliberately, skilfully, and for a purpose, however, it can create an illusion of depth, motion, and a wide variety of moods, with strong eye-catching potential. The most commonly used type of unsharpness is that resulting from a shallow depth of field (Fig. 345). Most lenses produce a shallow depth of field when photographing close-up objects at a large aperture, but only the longer focal length lenses are capable of creating a drama-

298

tically shallow depth of field with more distant objects. A certain amount of control can be exercised over the nature of the out-of-focus parts of the image. Placing cutout apertures of various shapes or wire screen in front of the lens will affect the shape of unsharp light areas in much the same way that images of the diaphragm opening are sometimes captured accidentally when photographing scenes containing small bright areas (Fig. 346).

In addition to accommodating long focal length lenses for a shallow depth of field, view cameras provide photographers with flexible control over the angle of the plane of sharp focus through the swing and tilt adjustments. These two factors combined often make it possible to dramatically emphasize small portions of subjects with sharpness while allowing everything else to be rendered unsharp. Other methods of reducing sharpness either locally or overall are — using soft focus lenses, exposing through textured glass plates, petroleum jelly on glass plates, and other translucent materials, intentionally throwing the image out of focus, and moving the camera or the subject. View cameras with geared tripod blocks can produce unusual unsharp effects by moving the camera directly toward the subject during a time exposure.

Image perpetuation variations. Numerous modifications of the photographic image can be introduced at the image perpetuation stage by changing film, film processing, and printing, and by using a

Fig. 347. A variety of special techniques, including use of high contrast film, Sabattier effect, and combination printing, were employed to obtain a dramatic effect – *Raymond Holden*

variety of special techniques (Fig. 347). Most of these modifications are concerned with the destruction of the illusion of realism. This is often done by abstracting and emphasizing the most significant aspects of the image. The use of high-contrast film, for example, results in the loss of detail in many areas, while dramatically emphasizing the shape and design of light and dark tone areas. More subtle changes in contrast can be effected by modifying the degree of development of the film, or at the printing stage with black-and-white photographs. Unusual results can be obtained by purposely falsifying the rendering of subject colours by using other than panchromatic films, or by using filters. With colour films, different filters can produce changes ranging from just perceptible falsification of the colours for a subtle mood effect to the bizarre. Special treatment of negatives during processing can produce such effects as Sabattier effect and reticulation, and by making diapositive and duplicate negative images, posterized and fine-line effects and many other modifications can be obtained. Numerous controls and specialized techniques can also be used at the printing stage.

Exhibition photography

Certain types of photographs, including many personal portraits, legal, and technical photographs, are intended to be viewed by a relatively small number of people, and quantities of record photo-

graphs are placed in files and seldom, if ever, used. At the other extreme are the photographs that are reproduced in vast quantities in magazines, newspapers, books, and on television. Between these two extremes is a loosely defined category of exhibition photography, in which original photographs rather than photomechanical reproductions are used, but they are displayed in museums, lobbies, and other business and public places where they can be seen by moderately large numbers of people. Since outstanding photographic quality is required in this field, view cameras are commonly used.

Perhaps the most distinctive series of exhibition photographs in recent years have been the Kodak Colorama photographs in Grand Central Station in New York City. More vivid images than can ordinarily be obtained on paper prints result from making colour transparency prints and illuminating them brilliantly from the rear. The impressively large 18×60 ft. prints require large negatives. Consequently, all photographs used for this exhibition are made on specially designed view cameras that produce usable negative areas of 4 7/8 by 16 1/4 in. Even with this large negative, it is necessary to magnify the image 44 times in printing.

In addition to using large film, the view cameras have the conventional adjustments for controlling perspective and the plane of sharp focus. Although the camera was not tilted at an extreme angle for

Fig. 348. Colorama of the New York City skyline was made with a specially designed view camera that uses $4\frac{7}{8} \times 16\frac{1}{4}$ inch film. Tilt back adjustment was used to prevent convergence of the vertical subject lines – *Pete Culross*

Fig. 349. A Polaroid print was made on a 4×5 inch camera that was synchronized with the $4\frac{7}{8} \times 16\frac{1}{4}$ inch view camera so the arrangement of the rapidly moving subjects could be checked without waiting to process the color film – *Bob Phillips*

Fig. 350. The making of printed circuits involves both photography and the transferring of images to other materials.

the Colorama of the New York City skyline (Fig. 348), the camera adjustments enabled the photographer to maintain parallelism of the vertical subject lines. Two separate exposures were made on the film — one for the light in the sky during the twilight hour, and the other after dark for the lights in the buildings and on the streets. Thus, only one colour negative could be exposed in an evening, and extreme rigidity of the camera equipment was required to obtain exact registration of the two images.

The large ground glass on the Colorama camera facilitates visualizing the arrangement, cropping, and other aspects of the image. Artists' layout sketches are occasionally used on the ground glass to obtain precise arrangements. Scenes containing moving objects introduce additional complications, however. For the photograph of the skaters (Fig. 349), a 4×5-in. camera was synchronized with the larger view camera so that the arrangement could be checked on a Polaroid print without waiting to process the negative colour film.

Photocopying

A surprisingly large proportion of photographic work consists of making reproductions of two-dimensional subjects. The most widely used application of photocopying is to obtain multiple images that can be viewed independently by two or more people. Other reasons for making photocopies are: to change the scale, to change the tonal rendering, and to transfer the image to a different type of material. Changes in scale of the original range from microphotography, where an entire book is reproduced on a small card, to the enlargement of advertising layouts to billboard proportions. Changes in tone and color may be introduced in copying for aesthetic reasons, for functional reasons (as in converting continuous-tone originals

into half-tone negatives for photomechanical reproduction), or for informational purposes (as in certain types of industrial and crime-detection photography.) Examples of transferring images to other materials range from making plastic table tops with a photographic wood-grain image to printed circuits, where plating and etching processes are used to add or remove metal selectively (Fig. 350).

Obtaining maximum image definition is usually one of the important requirements of photocopying work. Unfortunately, it is not possible to use an optical system to form an image without introducing some degradation. This loss of definition can be prevented when the nature of the original and the requirements are such that a contact copy can be made either by exposing through the transparent or translucent original, or by exposing through the base of the sensitized material using the reflex principle. Use of view cameras, with their capacity for making large negatives, frequently eliminates the need for an enlarger and second optical system. Attention must be given to several other factors to obtain maximum definition when photocopying. Process lenses are specifically designed for this type of use and they produce significantly superior results. Focusing must be exact, which implies the use of a precision camera and focusing with a magnifier. Freedom from vibration or movement during the exposure is essential. The choice of the film-developer combination is also important, especially when the negative must be enlarged.

Uniform glare-free illumination is considered standard for photocopying, although control over the lighting is necessary for situations where texture, emphasis, or other special effects are appropriate. Since uniformity of illumination at the film plane depends upon the lens in addition to the lighting distribution on the original, the longer focal length process lenses are recommended. Other view camera features find frequent application in photocopying work. The long bellows and interchangeable lenses are needed to produce a wide range

Fig. 351. Research photography includes the recording of events that are too fast for the eye to see, such as this breaking "boule" – *Andrew Davidhazy*

of image sizes. A variety of film sizes and emulsion types can be used in sheet-film holders, and roll-film backs can be added for mass-production situations. The lateral and rising-falling movements simplify positioning the image without affecting alignment, and the ground glass allows precise measurement of image size. Special camera stands and copy easels which automatically maintain alignment between the film and the original are recommended where the volume of photocopying is large.

Research Photography

Photography is employed in research work for a variety of reasons, including obtaining information that cannot be seen or obtained as satisfactorily in other ways, keeping a visual notebook for future reference, and communicating with others for scientific or public-relations purposes.

The uses of photography to obtain research information seem to be limited only by the ingenuity of the photographer. Some of the more widely-used techniques are listed below:

Rapidly-moving objects, or events that last too short a time for the eye to see or to study, such as the breaking "boule" in Fig. 351, can often be recorded photographically.

Coloured and polarizing filters, photographic emulsions sensitized to selected regions of the electromagnetic spectrum, and high-contrast emulsions can often reveal detail that is not visible.

Whereas the eye can record only instaneous impressions (with fractions of a second prolongation due to the persistence-of-vision phenomenon), a camera shutter can be left open for varying lengths of time to record a trace of an entire event, as in time-motion studies.

A camera has unlimited patience to wait for an unpredictable event to occur, as in nature-study photographs.

A camera can be placed in locations that are normally inaccessible to humans due to high or low temperatures, limited space, radio-activity, etc.

By making a time exposure, film can accumulate illumination that is too weak to form a satisfactory visible image, as in the study of phosphorescence.

Two or more synchronized cameras can simultaneously record different views of a subject, or different but related events.

Photographs are capable of compressing time so that side-by-side comparisons can be made of widely-separated events, or an object before and after treatment.

The versatile view camera is being looked upon as an indispensable tool by many research workers. The almost instantaneous feedback of information, when used with Polaroid films, saves many hours of valuable time.

INDEX